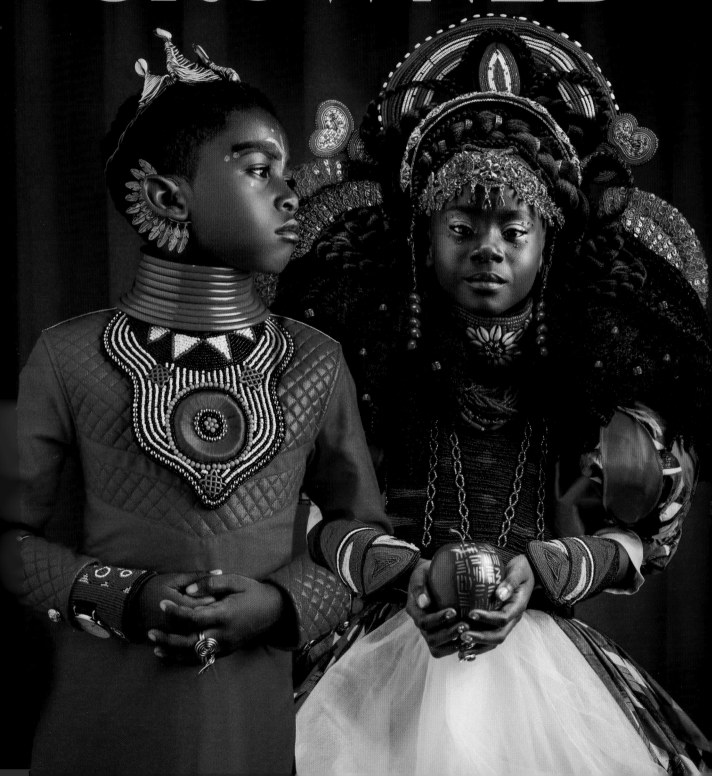

CROWNED

GLORY
MAGICAL VISIONS OF BLACK BEAUTY

CROWNED

MAGICAL Folk and Fairy TALES FROM THE DIASPORA

KAHRAN
AND
REGIS BETHENCOURT

ST. MARTIN'S PRESS
NEW YORK

First published in the United States by St. Martin's Press, an imprint of St. Martin's Publishing Group

www.stmartins.com

The Library of Congress Cataloging-in-Publication Data is available upon request.

ISBN 978-1-250-28138-8 (hardcover)
ISBN 978-1-250-28139-5 (ebook)

Our books may be purchased in bulk for promotional, educational, or business use.
Please contact your local bookseller or the Macmillan Corporate and Premium Sales Department at
1-800-221-7945, extension 5442, or by email at MacmillanSpecialMarkets@macmillan.com.

To all of the young dreamers
Never let anyone dim your light

TABLE OF CONTENTS

My work is a personal testament to my own roots. When I grew up, I heard these European fairy tales, but I didn't see them as White, I saw them as African American.

— Jerry Pinkney

FOREWORD BY SALAMISHAH TILLET

In April 2020, my then seven-year-old daughter, Seneca, incessantly began making character charts before bedtime. Her figures were familiar: all close friends and family members whom she imbued with special powers or magical abilities. She gifted me and her younger brother, Sidney, the ability to talk to Nature while she and her father were one with the Weather. By June, she had sketched these alternative selves. By October, she was in full regalia and, with our help, had obtained everything—a flowing white dress, silver wig, large wings, and a rhinestone crown—to make her vision real. And what I initially thought was a ruse to delay bedtime was in fact the deep expression of recognition. Seneca's insistence on transforming us from who we were to who we could be was always about guiding us to an alternative world in which Blackness is centered.

I had those same feelings of recognition and awe as I stared at Kahran Bethencourt and Regis Bethencourt's portraits in *CROWNED: Magical Folk and Fairy Tales from the Diaspora*. Not only do they picture Black children as the protagonists of traditional Western fairy tales, like Hansel and Gretel, Sleeping Beauty, and Little Red Riding Hood, but they do so in bold purples, royal blues, regal golds, soft pinks, and boisterous reds. Styled to pose inside their breathtaking handmade backdrops, the stories I've known all my life suddenly felt brand new.

Cast in our image, Cinderella is renamed Asha, Prince Charming is Prince Jamal, and the clear glass slipper is now a white high top sneaker. Rapunzel, after having her enchanted locks cut off by the sorceress, is still able to escape the tower in which she is imprisoned. Once free, Rapunzel's epiphany becomes the story's lesson: "All her life she'd thought the magic was in her enchanted hair, but it was always in her, and no witch or spell could ever take that away."

And, like our most revered African American children's book authors, Jerry Pink-
ney and Virginia Hamilton, who also retold African American and African folktales,
CROWNED reminds us that Black royalty is not just a figment of our imaginations, but an
inheritance. Whether they are adorned in elaborate headdresses, or their skin glistening in
zebra stripe paint, or they appear as a resplendent young John Henry, these young people
capture in posture and look the internal power Black people throughout the Diaspora have
held as we used forward-looking stories to fight for freedom.

Recently, I had the privilege of witnessing Kahran and Regis photographing my own
children and their friends. Before each photoshoot they give parents and caregivers sim-
ple instructions for hair and dress. And they ask for a picture of the child. In other words,
Kahran and Regis embrace our children's natural beauty as the inspiration for the por-
traits. The genius of their photographs also lies in their collaboration with Black stylists,
makeup artists, and hairdressers. Their studio is a space where everyone sees Black chil-
dren as worthy of celebration and adornment. This is why I was especially excited that
they included behind the scenes moments—a small window into the wonder that they
create.

There was no better way for them to end this book than with the section "New Clas-
sics: Our Stories," with heroines and heroes who are the children of hip hop, the Black
South, fantasy and lore. My wish is that these images and words become our new classics,
new touchstones from which our children's imaginations can soar. And while Seneca still
returns to the world of her own charts, she and my son, Sidney, can open CROWNED on
any day to draw inspiration, celebrate their features, and continue the work of imagining a
world that sees and loves their beauty and brilliance. CROWNED is fantasy made tangible.

This is the wish that CROWNED promises to fulfill: to make real the images that Black
children have already imagined for themselves but that society has long denied us the
capacity to see. This is magic of the fairy tale, bringing that magic to life is the gift of
CreativeSoul.

INTRODUCTION

KAHRAN AND REGIS BETHENCOURT

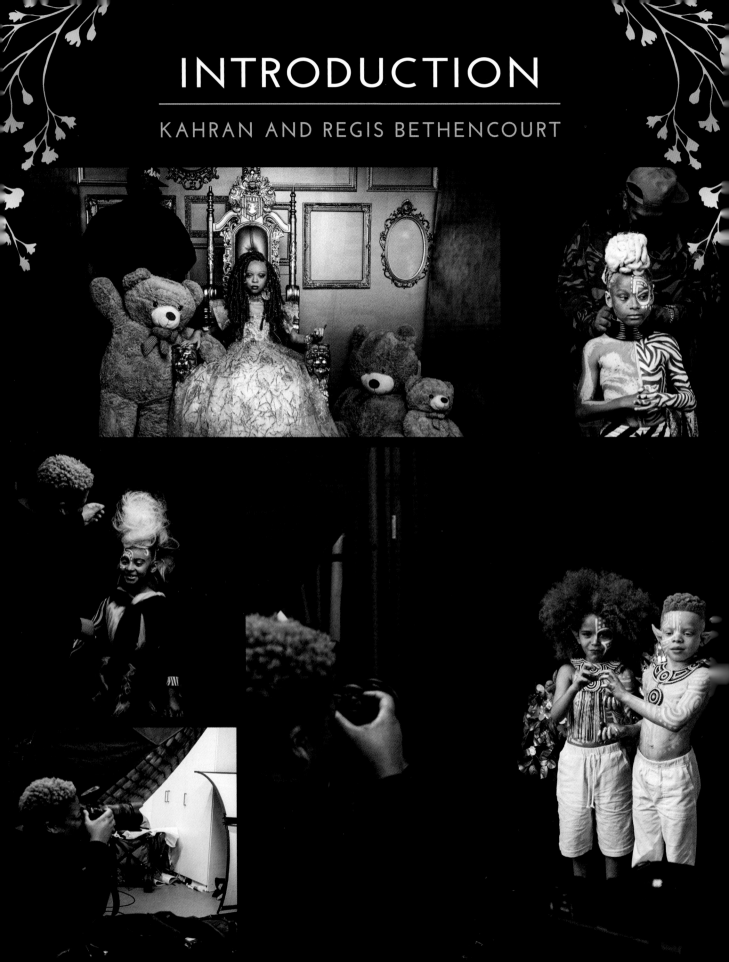

Childhood is a fleeting moment in time. It is our foundation and what helps mold us into the people we eventually become. The images that surround us on a daily basis become our subconscious standard of what "normal" looks like. In our earliest memories, some of our favorite childhood stories and fairy tales are our first sneak peeks into adulthood and what life might look like in the future. Oftentimes our first glimpse at life through the lens of our childhood fairy tales leaves us constantly trying to live up to society's standards of beauty.

We often hear from parents that their kids want to look or dress like their favorite storybook characters. While this may seem like innocent childhood fun, Black and Brown kids are often left with unrealistic standards of beauty that remain with them for years to come.

We've traveled the world and have seen how our kids are influenced by everything from stories to music, fashion, and cultural trends. In this book we wanted to reimagine some of our favorite childhood stories with our idea of what could be. We also highlight African and African American folktales because we feel that they're often left out of the storybooks. It's important that these stories are passed down to the next generation. In the final chapter we visualize a new future of fairy tales that departs from existing stereotypes and standards.

The ability to imagine things pervades our entire existence. It influences everything we do, think about, and create. Imagination allows kids to dream the impossible and equips them with the ability to overcome any obstacles that might come their way.

These magical fairy and folktales of the Diaspora bring to life past, present, and future visions of Black culture to create a society where all kids are created equally and feel empowered to move in the world as their true authentic selves.

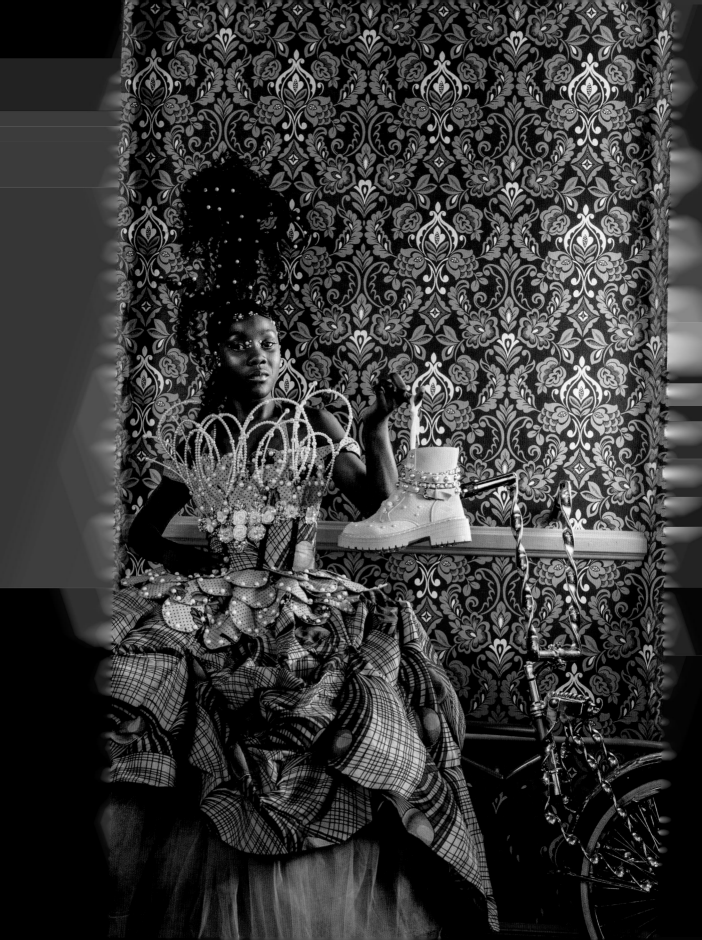

CHILDHOOD REIMAGINED

CLASSIC FAIRY TALES

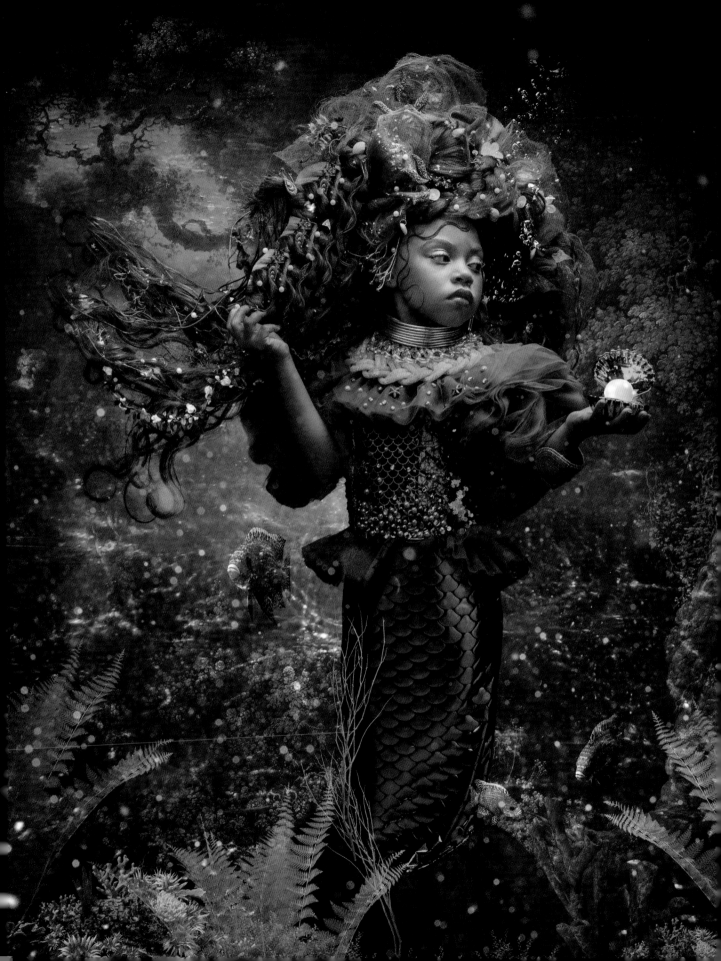

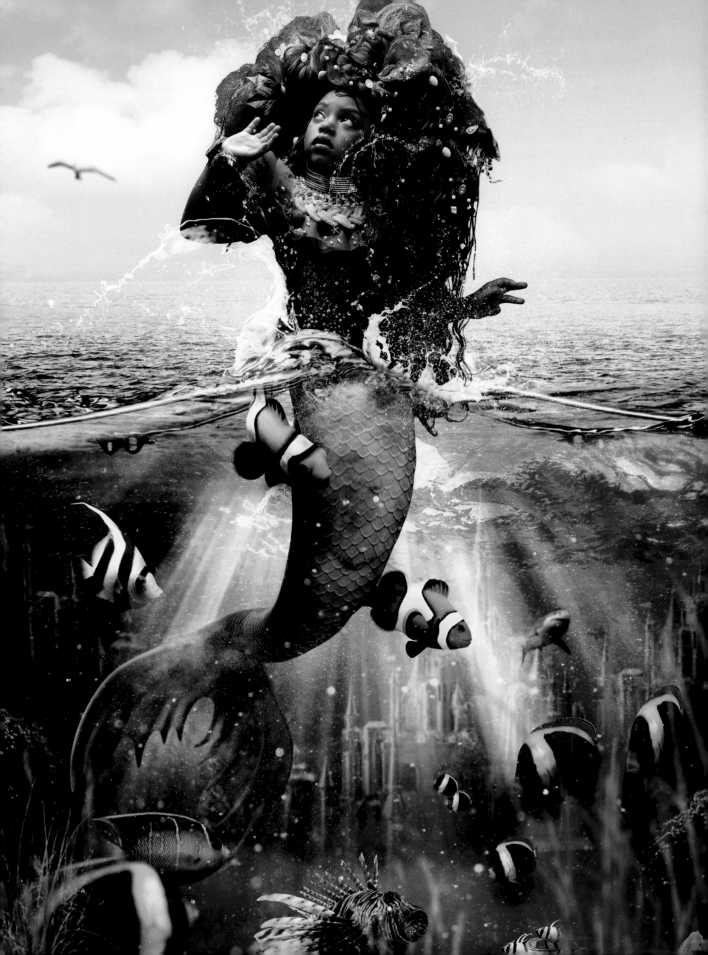

O nce upon a time when magical creatures lived in the depths of the sea, there was a little mermaid named Aliyah who loved to watch the human children on the beach. She'd hide in the waves and wish she could be with them, running and playing together. Hearing them laughing gaily made her sad and she longed for legs so she could run with them and feel the sand beneath her toes. But alas, she was a mermaid, with a fishtail and fins instead of legs and feet.

Sadness was not a feeling Aliyah was used to, for she had the whole of the sea and all its creatures to play with. But the more she longed to be human the sadder she became. She no longer delighted in the feel of the sun on her fishtail or the way the light bounced off her scales.

Aliyah swam far away, then sat upon a rock and sang a siren song of longing. Its notes pierced the waves and reached the deepest depths and the darkest caves. Not long after, the Sea Hag rose up from the inky waters.

"Little mermaid, why do you sing such a sad song?" asked the witch.

"When I watch the little humans playing together I feel an ache in my heart."

"Why is that, sea child?"

"Because I want to have legs to run on the sand and jump in the dunes with them."

"But you are a mermaid with the whole sea as your playground. You can swim with the fishes and leap with the dolphins."

"I know." Aliyah sighed. "But I do that all the time. I wish I could be like them."

"I can grant your wish. But it will come at a cost."

"You can make me human?" Aliyah asked.

"I can do that and so much more," replied the witch. "But a mermaid you will never again be. You will be human but the watery kingdom you will never again see. For that is the price of the wish I will grant thee. So think hard, because happiness is never guaranteed, regardless if you are a mermaid, a human, or anything in between."

"How do I break the spell?"

"It can only be broken by an act of true selflessness. Only then will you become, once again, a child of the sea."

"To be human is worth the cost and I will pay it," Aliyah said.

As if from thin air the Sea Hag produced a vial with a liquid as black as the darkest depths of the sea. "Drink this," she said, "then swim to land and when you touch the shore you will walk upon two legs."

Aliyah drank from the vial, then dove into the sea and swam to the shore. When she touched land she was wearing a dress and underneath were two long legs. As she ran to the children they gathered around her.

"Hi, my name is Martin, what's yours?"

"Aliyah."

"Where are you from?" asked a girl. "We've never seen you before."

Aliyah pointed to the sea.

"Have you just moved here from far away?" asked Martin.

"Something like that." Aliyah giggled.

"We're all friends," said an unkind girl. Before Aliyah appeared the children were all paying attention to her but now they weren't. "You're new. We don't have to play with you."

"Don't be mean, Layla."

"I can be whatever I want, Martin." Then she yelled, "Last one up the dune is a rotten egg!" And they all ran away, leaving Aliyah standing there all alone.

"C'mon, Aliyah, you have to run. If you're last you'll be a rotten egg," Martin said.

But the children were already at the top of the dune when she got there.

"Rotten egg, rotten egg, Aliyah's a stinky rotten egg!" Layla chanted. And all the children laughed except for Martin. He walked over to Aliyah and picked up a seashell.

"Look, Aliyah. Amazing, isn't it?"

"Yes. It's a mollusk shell. This one came from a conch."

"Don't be such a smarty-pants," Layla said, slapping the shell out of her hand.

She turned to the other children. "C'mon, my mom made lunch and you're all invited, except for you, Aliyah." Then she grabbed Martin's arm. "C'mon, Marty. Let's go or I'll tell your mom you're talking to a stranger."

When the children left, Aliyah sat and watched the waves. What was the point in having two legs if there was no one to run and play with? She saw two dolphins leaping in the waves and wished she could be with them. She was then struck by a longing for the sea. She knew all its dark caves and deep tunnels. She missed her fishtail and her scales and all the sea creatures she knew by name. That was when she heard screams. The children had gathered by the water's edge and were pointing. Out in the waves someone was struggling to swim but was being pulled out by the riptide. It was Layla.

Without a thought, Aliyah ran into the churning waters and dove in after her. She swam hard and finally reached Layla and brought her back to shore.

"Layla has been so mean to you, but you risked your life for her," Martin said. "I don't think she would've done the same for you."

"It doesn't matter what she would've done. All that matters is what I would do."

"Will you come to the beach tomorrow, Aliyah?" Martin asked.

"No," Aliyah said, gazing out to the sea. "I'm going home." And she knew she could, for her act of selflessness had broken the spell. "But I won't forget you," she said with a big

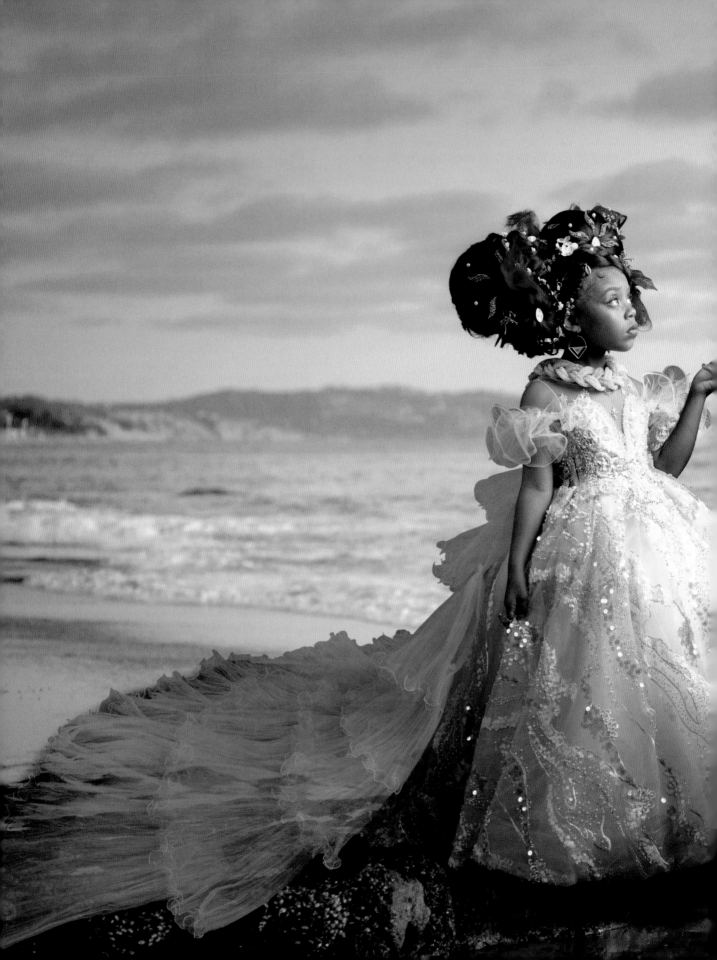

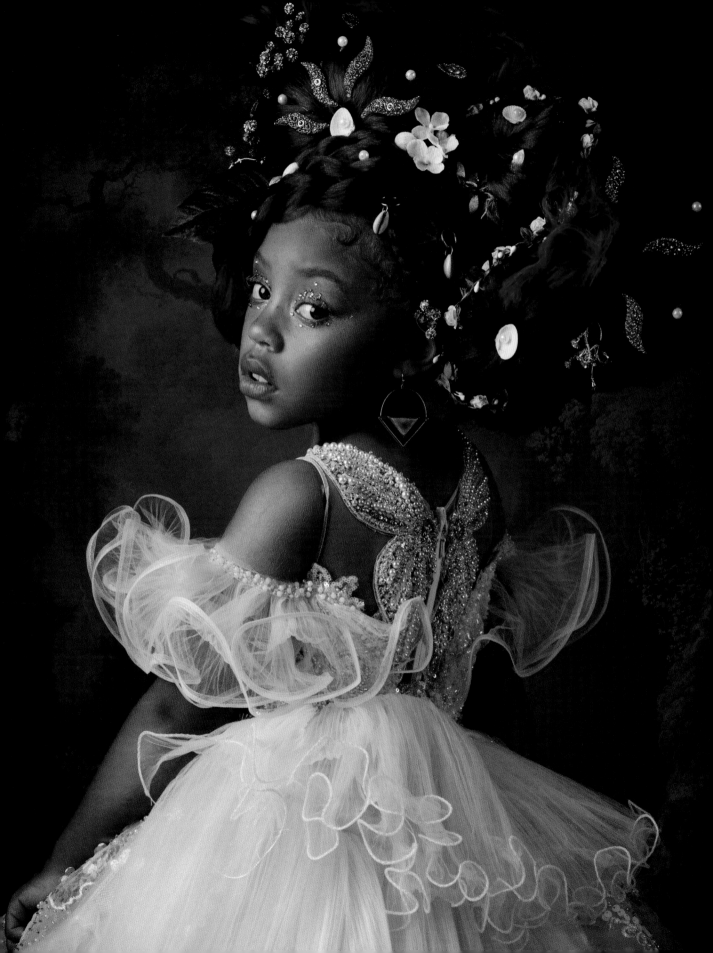

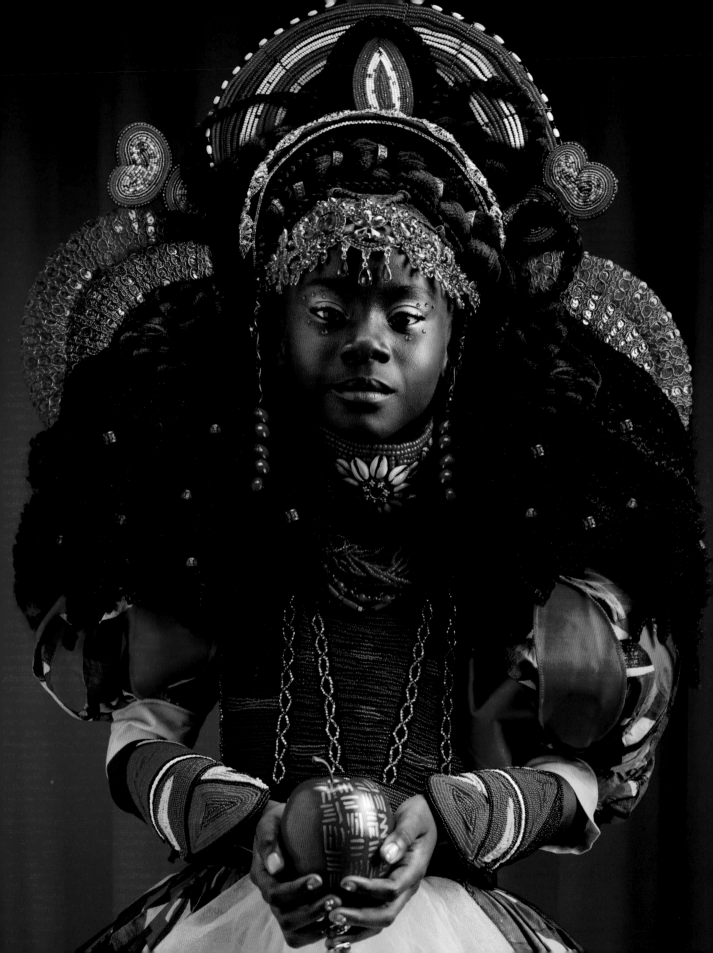

THE POISONED APPLE

Once upon a time, in a land filled with dwarves, witches, and magic, there lived a king and queen who were very much in love, and their love bore them a child. As they sat together looking out at the night sky, the king asked the queen, "What shall we name her?"

"She has lips as full as the moon, eyes dark like ebony, and hair as black as the midnight sky. Ebony Black shall be her name," said the queen.

But their happiness was short-lived because the queen died soon after. The king was heartbroken but eventually he remarried. His new wife, Sonya, didn't care much for Ebony, but she pretended to love her in the king's presence.

Sonya was beautiful but vain, and unbeknownst to the king she was a sorceress. Sonya had a magic mirror hidden in her chambers. She would look into it and ask, "Magic mirror that sees all, who is the loveliest of them all?"

And the mirror always answered, "There are many lovely maidens, it is true, but none as lovely as you."

When Ebony was two years old, the queen again asked, "Magic mirror that sees all, who is the loveliest of them all?"

The mirror answered, "There are many lovely maidens, it is true, but one is now even lovelier than you."

"Who could that be? There is no one more lovely than me!"

"Yes, mistress, it is true. There is a maiden far lovelier than you. Her beauty is rare, and sweetness she does not lack. You, mistress, cannot compare to the beauty of Ebony Black."

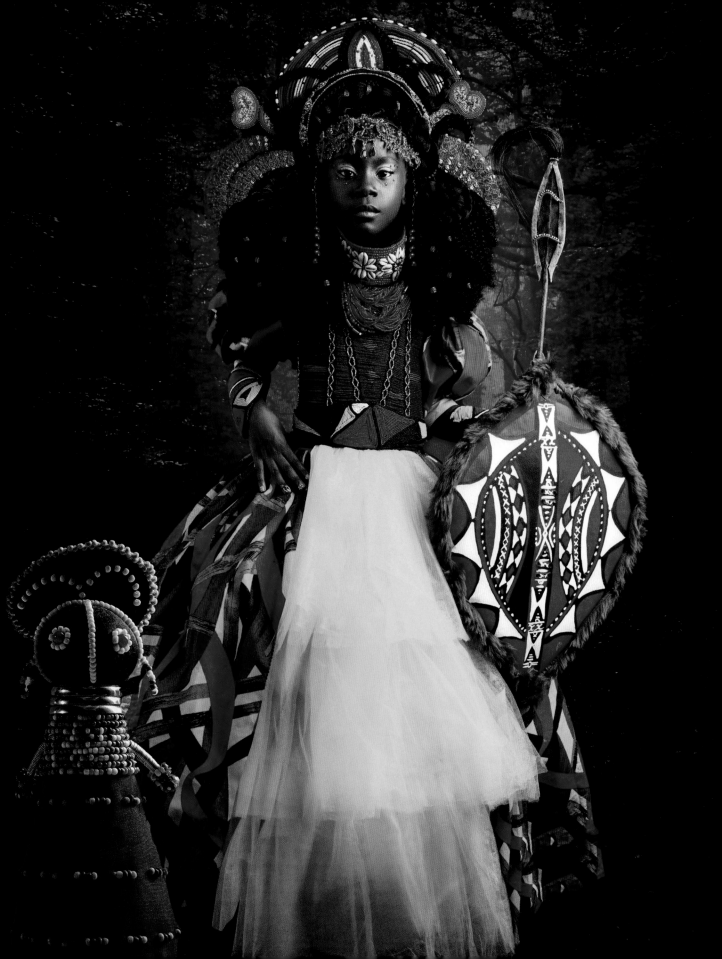

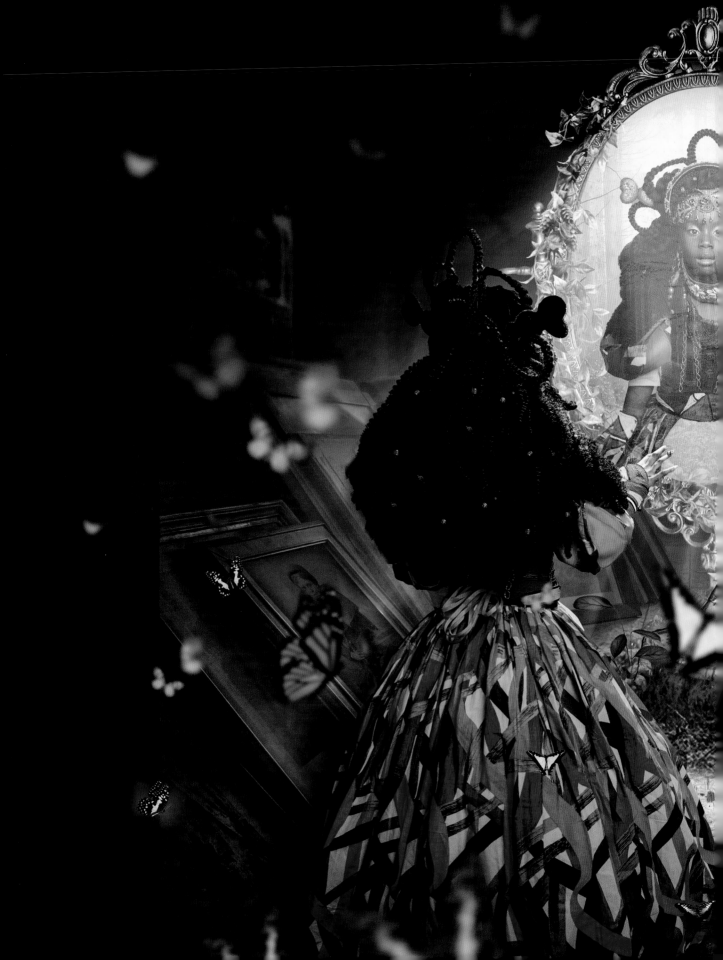

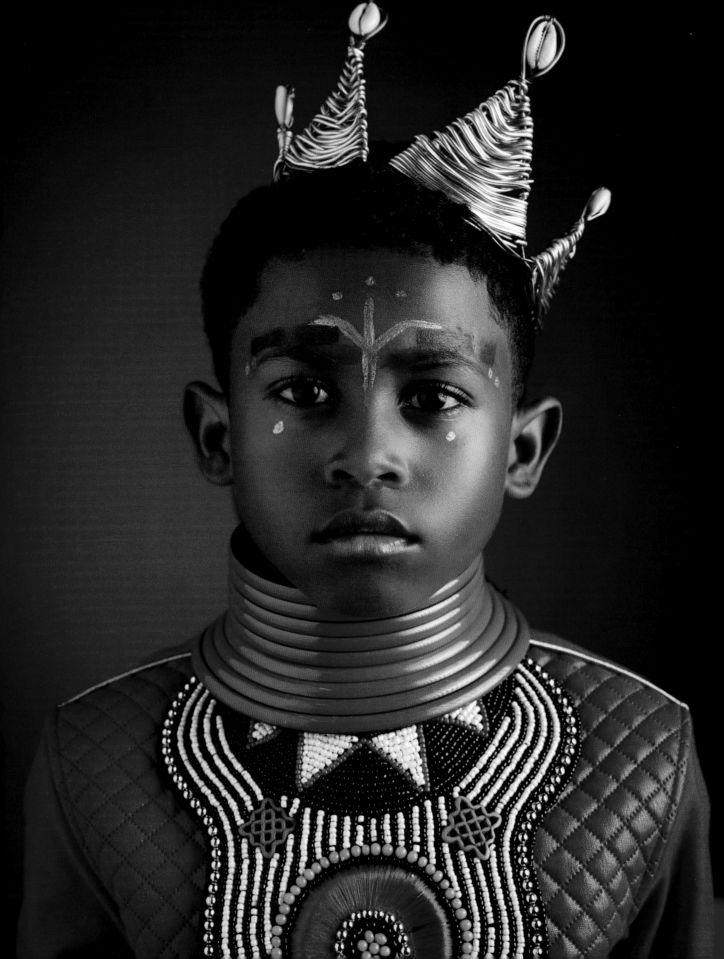

Sonya was consumed by jealousy and hatched a dark plot. She snuck into Ebony's chambers and spirited the sleeping child into the woods where she met the she-dwarf, Nayla, who would at times do her bidding.

"Take this child deep into the woods, then plunge your dagger into her heart. And do not slack, for I never again want to hear the name Ebony Black!"

"Yes, mistress," Nayla replied. She took Ebony into the deepest, darkest part of the woods, then she opened the blanket and raised her dagger. But Ebony smiled and her sweetness warmed Nayla's heart. Now she was not an evil creature, she'd only known servitude and loneliness. Nayla could not kill the child so she took her to her home in the woods, and raised Ebony as her own.

Many years passed and Nayla taught Ebony how to use a spear and shield, for she was a warrior. Ebony grew to be as lovely, sweet, and good as the mirror predicted, but she was also brave and strong. In her company the dwarf felt loved and for the first time in her wretched life Nayla was happy.

One day a young prince came upon Ebony as she was throwing her spear.

"Hello there," he said, "you are quite a skilled warrior."

"Thank you," Ebony replied. "And your spear is a thing of beauty."

"But you are more beautiful by far. I'm Prince Malik. And you are?"

"I'm Ebony, and I live here in the forest."

"May I visit you again sometime, Ebony?"

"If you'd like," Ebony said.

"I'd very much like that indeed."

Over the years, the queen pretended to grieve Ebony's disappearance. Now, as she stood preening in front of the mirror she asked, "Magic mirror that sees all, who is the loveliest of them all?"

The mirror answered, "You are lovely, that is true, but one maiden is even lovelier than you. Not only lovely but kind, brave, and true. Since these qualities you lack, you cannot compare to Ebony Black."

"Show me, mirror, that what you say is true. This I command of you!"

And in the mirror's reflection the queen saw Ebony in the woods. And she was lovely indeed, for the mirror always spoke the truth.

The queen was consumed by rage, and again she hatched a dark plot. She transformed into an old crone in a hooded robe and moments later appeared in the woods where Ebony sat under an apple tree.

"Dear me, I need to catch my breath," Sonya said.

"Hello, Grandmother," Ebony said. "Please, sit here and rest."

"Thank you, child. Whatever are you doing so deep in the woods?"

"I live here with a dwarf," she answered. "She found me abandoned in the woods and raised me as her own."

Sonya seethed inside to hear this, but she hid her anger. Instead she reached up and plucked an apple. "Have you ever seen such a red and juicy fruit?"

The moment Ebony gazed upon it she could not look away. It was the most perfect apple she had ever seen.

"Here, child, take a bite."

Ebony did as commanded. When she bit into the apple, everything went black.

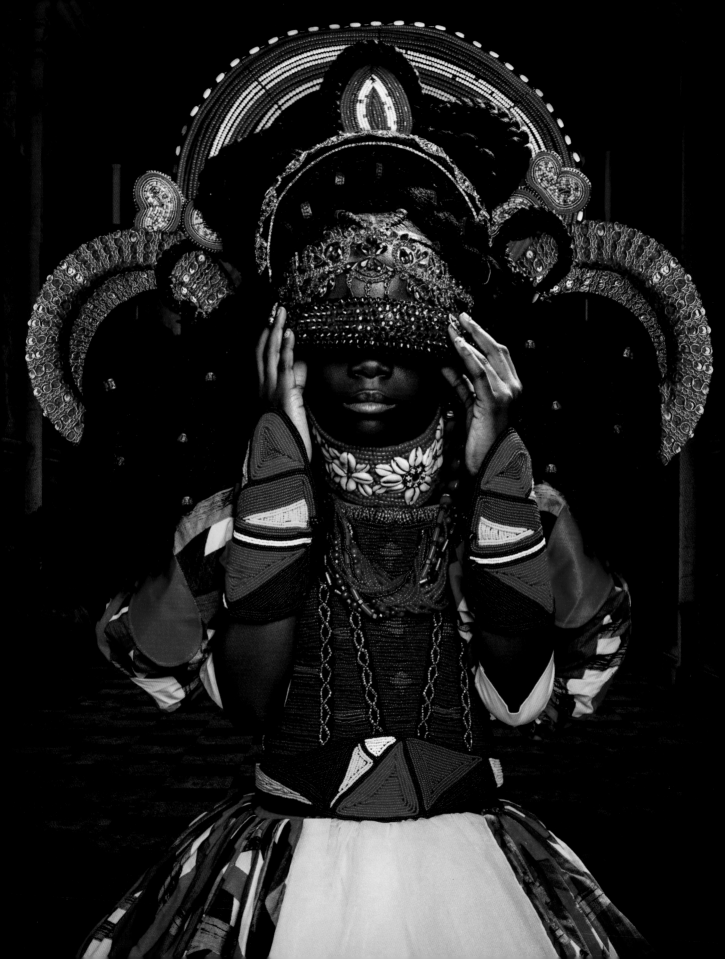

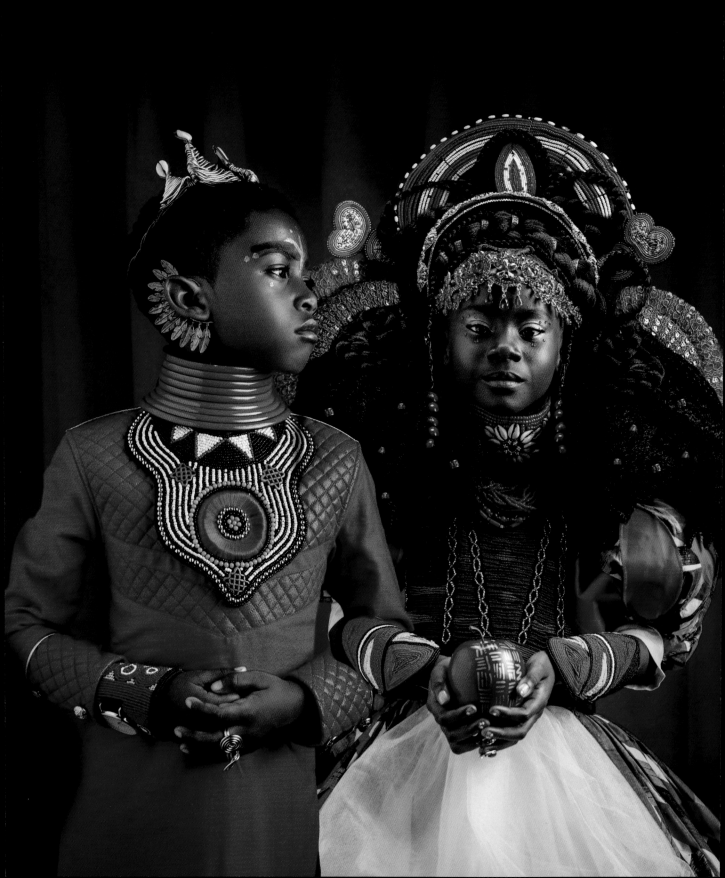

When Nayla returned she found Ebony lying lifeless on the ground with the apple in her hand. She knew it was the evil queen's doing. Just then, Prince Malik came riding through the woods.

"What has happened to the lovely maiden?" he asked, dismounting.

"A dark magic has brought this fate," Nayla answered. As she looked at Ebony a tear slid down her cheek. Filled with so much sorrow and love, Nayla hugged her tightly one last time and as she did, she dislodged the piece of poisoned apple in Ebony's throat.

"Hello, Nayla," she said.

"Ebony, you've returned to me!" she cried, helping her up.

The prince held his spear in both hands and bowed to Ebony. "Hello again, Ebony. I am at your service."

Ebony turned to Nayla. "Where is the old woman?"

"She was an evil sorceress. There is so much I have to tell you—"

Suddenly there was a blinding flash of light and Sonya appeared.

"Foolish dwarf, you've foiled me again!" she shouted, raising a dagger to strike her. But Ebony grabbed the prince's spear and struck Sonya once and that was all it took. The sorceress crumbled to the ground and shrank until she became the crone, and then she turned to dust until all that was left was her robe.

On that day, love conquered hate and Ebony saved Nayla as Nayla had saved her.

And they all lived happily ever after.

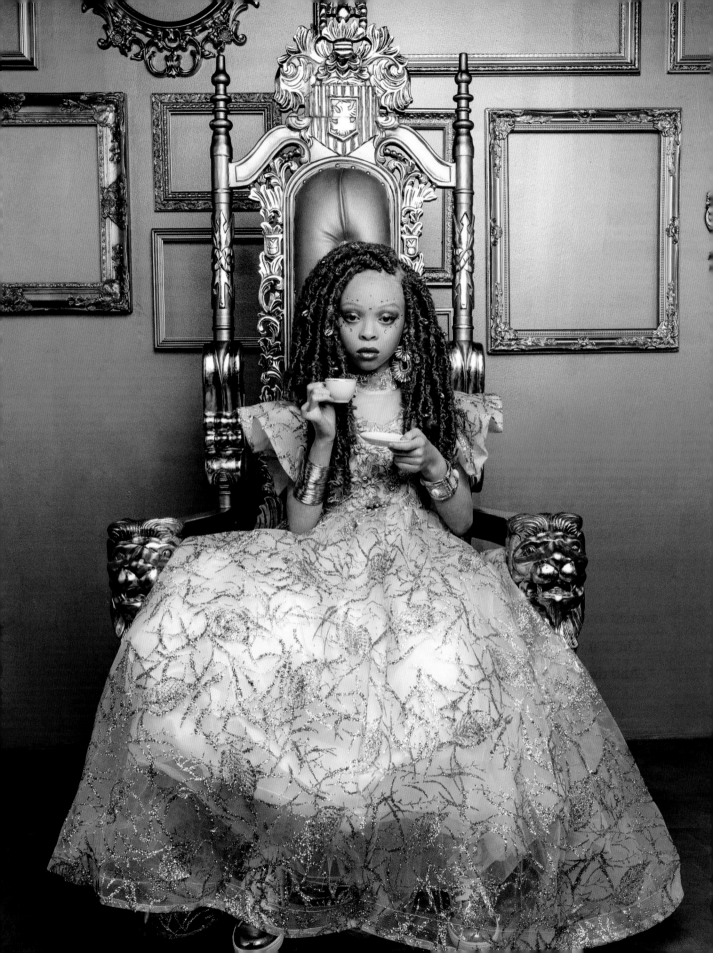

G oldi was a girl with long golden locs. She lived in a big, beautiful house with her family, the Golds, and she always had the best that money could buy, because the Golds had stacks of it piled quite high.

Their only child, she was fussed over and spoiled beyond belief. She had golden dresses, golden shoes, and her hair was adorned with gold leaf. She'd never known scarcity because nothing was out of her reach. To whatever she wanted her parents never said no. But providing for her every wish kept them busy and Goldi was often left all alone.

Goldi went out walking one lovely sunny day. She was so mesmerized by her finery and golden things that she quickly lost her way. She'd never been to this part of the woods and she was quite dismayed. She was tired and her gorgeous golden shoes were covered in dirt and grime. She pouted and stomped her feet, but there was not a soul around to pay her any mind.

She walked for hours on end until the sun peaked in the sky and started to descend. As the air grew cold and the wind whipped her golden cloak, everything around her darkened and Goldi grew less bold. Her tummy rumbled and her feet ached and she was now quite irate. It was way past her suppertime and there were no servants to bring her a plate.

She was quite helpless, with no one at her beck and call. She did not like this feeling. She didn't like it at all. Goldi wandered in the dark, huddled in her golden dress and golden cloak covering her golden hair, until at last she saw a light in the woods and she quickly hurried there.

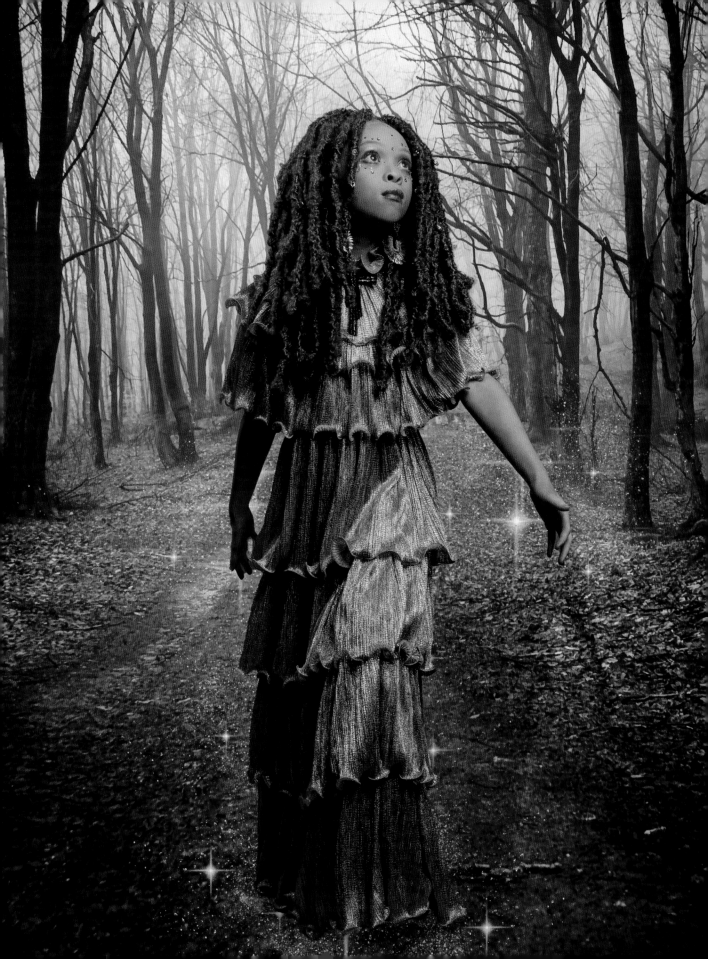

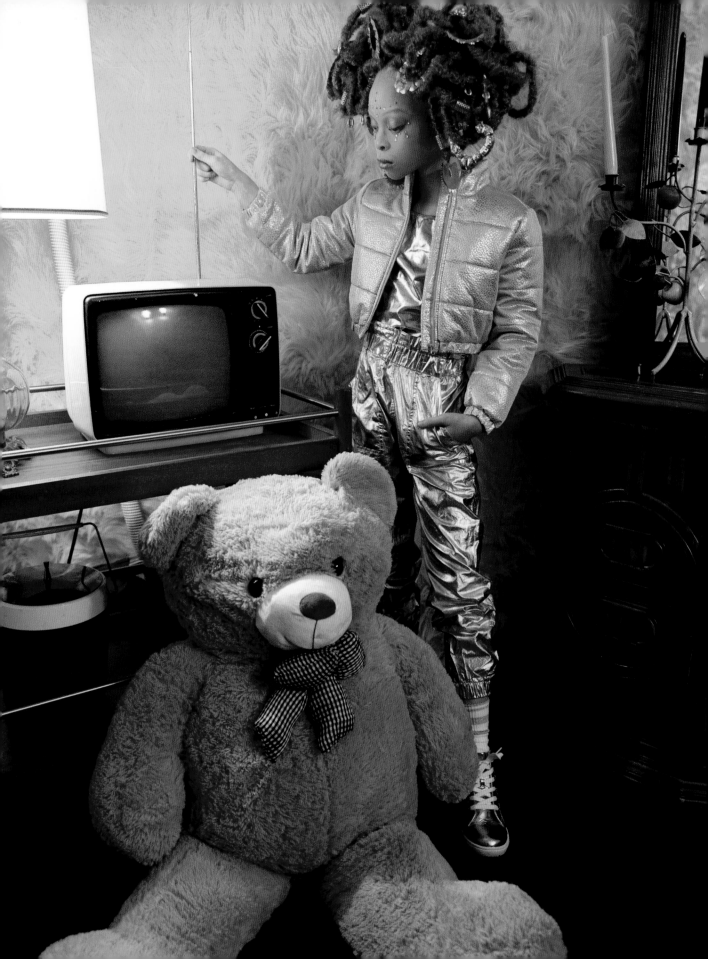

She came upon a humble dwelling, no more than a hut really. Much smaller and dingier than where she lived, and far, far less appealing. She wished for her own big house and warm rooms and the table filled with sweets and savory fare, but as she stood cold and alone in the woods, it was clear she was far from there.

The light she had spied was a fire in a hearth. Inside sat a candle on a table set with three small bowls and three wooden spoons. There was no tempting fruit, no shining silverware, no crystal goblets or lace, just three heads bowed down in grace. Goldi jumped when one of the heads looked up and eyes locked on her face.

"Oh, hello," said the girl, as she hurried to the door and ushered Goldi in. "Please, come in out of the cold. There's room for you within." It was small but warm, sparse but bright, and it felt very cozy on such a cold night. "It's lovely to meet you," said the girl. "We're the Bears. This is Mama Bear, this is Papa Bear, and I'm Lana Bear. We don't get many visitors," she said, pushing back Goldi's hood. "You must be tired and hungry after traveling so deep into the woods."

As Papa Bear made room at the table and Mama Bear hurried to get another bowl and spoon, Goldi looked around with a frown. Then without so much as a how-do-you-do, she said with a haughty air, "Is this all that you have? There isn't much here." She wrinkled her nose and disdainfully shook her head. "Where are all the meats, sweets, the cheese, and the bread?"

"Yes, this is all we have here, but we are happy to share," said Papa Bear, pulling out a chair.

Goldi looked around the small room and saw only three beds, three chairs, one table, and three bowls, until Mama Bear added another bowl and a spoon. "This is for you, dear," she said. "Please, sit down, we are happy to have you here."

"Is there another room? It is so very small. Where do you put all your things? I can't believe that this is all."

"We don't have much, but what we have we appreciate, and are happy to share. There is no finery, there are no stacks of things piled high. There is no need. We have each other and that's plenty indeed," said Papa Bear.

"Yes, all you see is what we have and it fits us to a tee," said Lana Bear. "One table, three chairs, three beds, and three bowls. Any more would be too much, you see, as it's just us three."

Goldi shook her head. "Oh, but I have many things of my own—chairs, and gowns, and shoes and hats and finery as far as the eye can see."

The Bears looked at each other, and Papa Bear said, "Well, that seems a lot for one, and even too much for three. What good are so many things, when you only use one at a time? One pair of shoes, one chair, one coat. One of each is just fine."

"But it's nice to have fine things; the more I have the happier I feel," Goldi said.

"We are happy just to be together, so it doesn't matter what we have. As long as it suits our needs," Mama Bear said. "But where are your parents, on such a dreary night? With such fine things, you must have many friends to share them with, but there are none in sight."

"Though I have beautiful clothes, and fine things, I am often home alone. My parents work very hard, you see. They have to provide all these things for me."

Lana Bear sat next to Goldi and handed her a spoon. "I would rather have fewer things, and more time with those I love."

Papa Bear placed his hand on hers and pushed in her chair. "And what is the point of having such finery if there's no one with whom you can share?"

Mama Bear filled her bowl with fragrant warm soup, and a small piece of crusty bread. She then patted her arm and said, "Eat and enjoy and when you're done, we'll sing some songs as we do every night, and it's always lots of fun."

Goldi sat between the Bears in her single chair. She took a bite of bread and a taste of soup, then ate it all, which was quite rare. With so much choice at home, she never finished a plate. Just a bite of this and a bite of that, but all of this she ate. Goldi sat back as the Bears chatted about their day and sang and laughed into the night. She then settled in bit by bit and felt their love, and she was warmed by it.

And this is how the haughty Goldi became a pleasant and thankful girl. After meeting the Bears she understood that little does not mean lack, and that sharing what we have multiplies and certainly does not subtract.

Goldi and Lana Bear became good friends indeed. She visited the Bears often and never missed her finery or golden things, because she learned that the best things in life are not things.

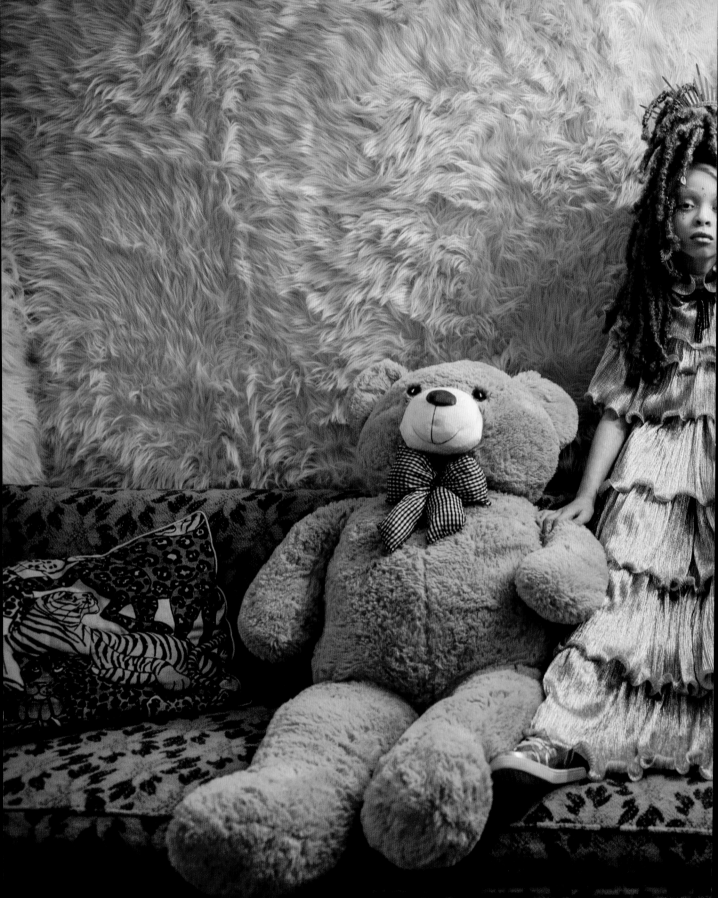

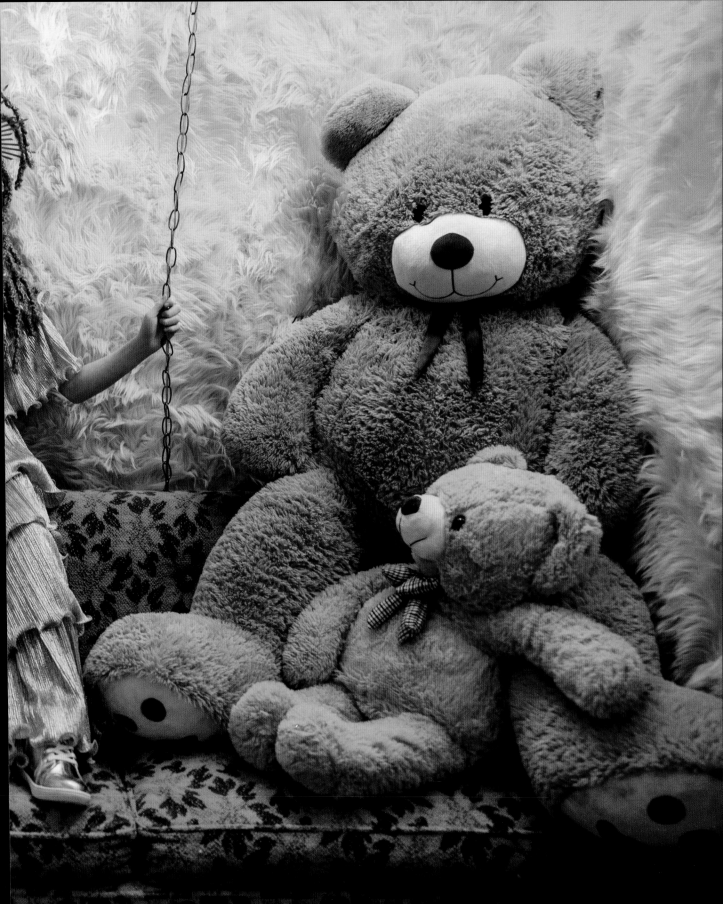

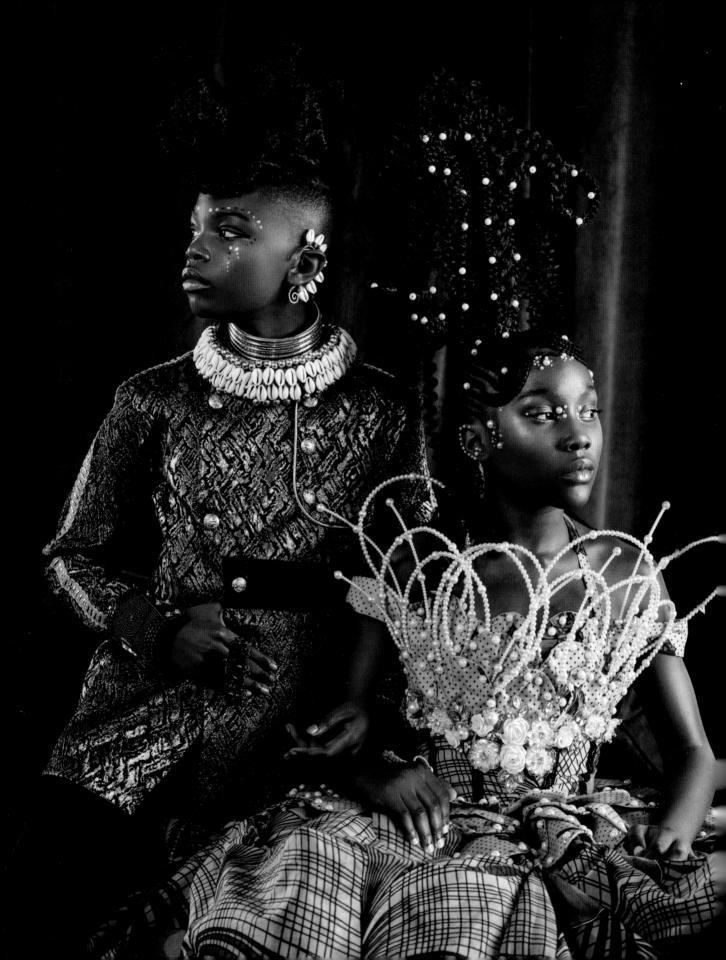

Years ago, Asha's beloved mother became ill. As she felt her end drawing close she called her only daughter to her bedside and said, "I will not be with you much longer, Asha; but my love for you is everlasting. I will always watch over you, and when you need me most, I will appear." She then passed away. Asha's father was devastated, but a few years later he decided that his daughter needed a mother so he took for his bride Rayna, a widow with two daughters named Holly and Ivy.

Asha's stepmother pretended to love her, but she was jealous of Asha's beauty and didn't want her to outshine her daughters. Not long after they wed, Asha's father also became ill. He called her to his bedside and said, "I'm sorry to leave you, daughter, but I am soon to be with your mother, my beloved wife. Our love for you is everlasting. We will always watch over you, and when you need us most, we will appear." He then passed away. After that Rayna gave away Asha's fine clothes and made her sleep in a tiny room off the kitchen so she could tend the fire and cook the meals.

Asha's mother had been a healer and her father an astronomer and there was a room in the attic where her mother had created potions and her father would gaze at the stars with his telescope. When Asha was missing them even more than usual, she would go up there at night and look at the stars. It made her feel close to her parents and less lonely.

One day the ruler of their kingdom, King Omar, decided that the time had come for his son Jamal to choose a bride. The king announced that he would throw a ball the likes of which no one had ever seen. All the unwed young ladies from across the land were invited to come and meet the prince.

As soon as Rayna heard the news she called her daughters to her chambers.

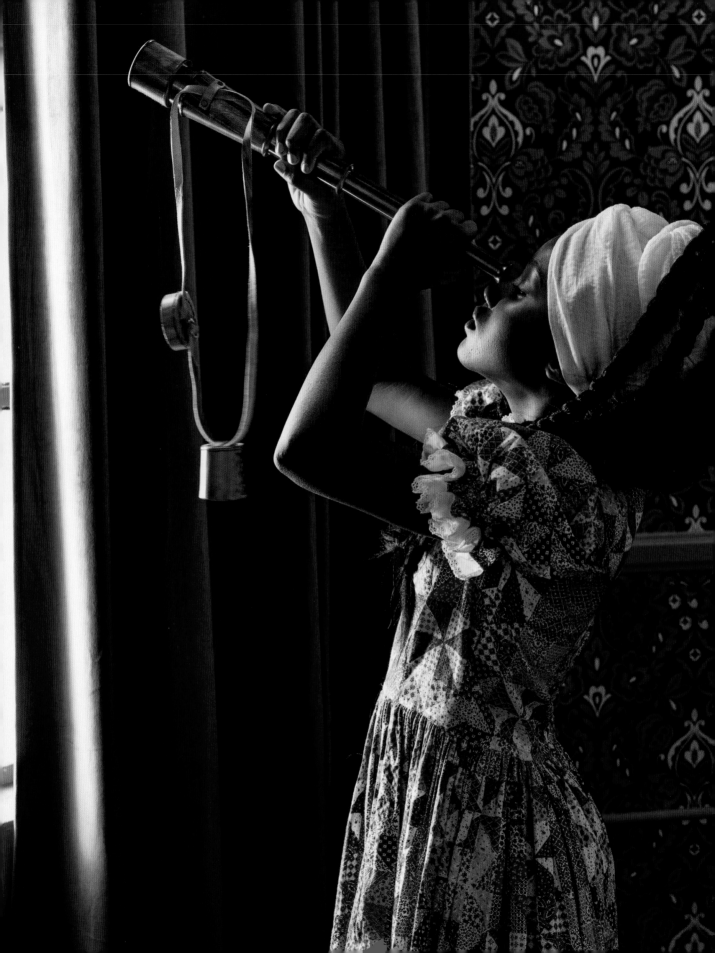

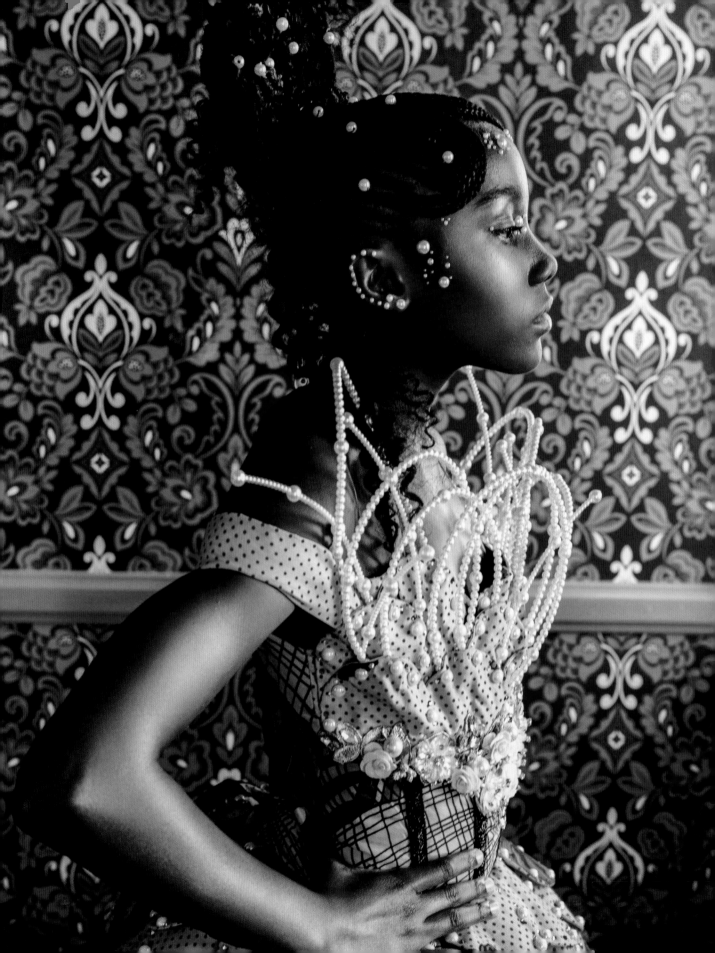

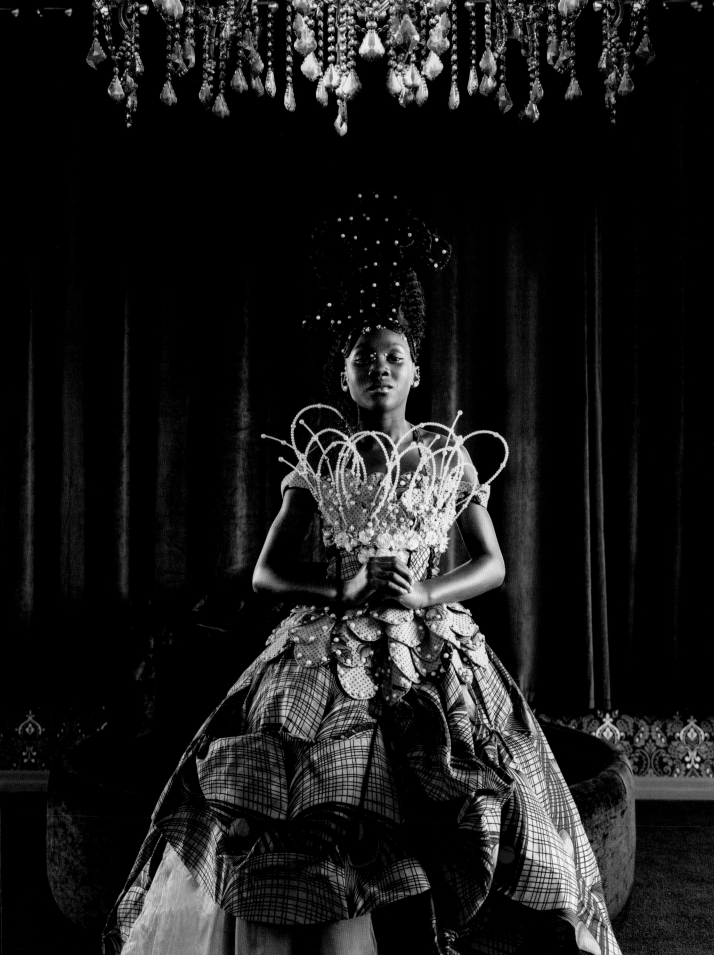

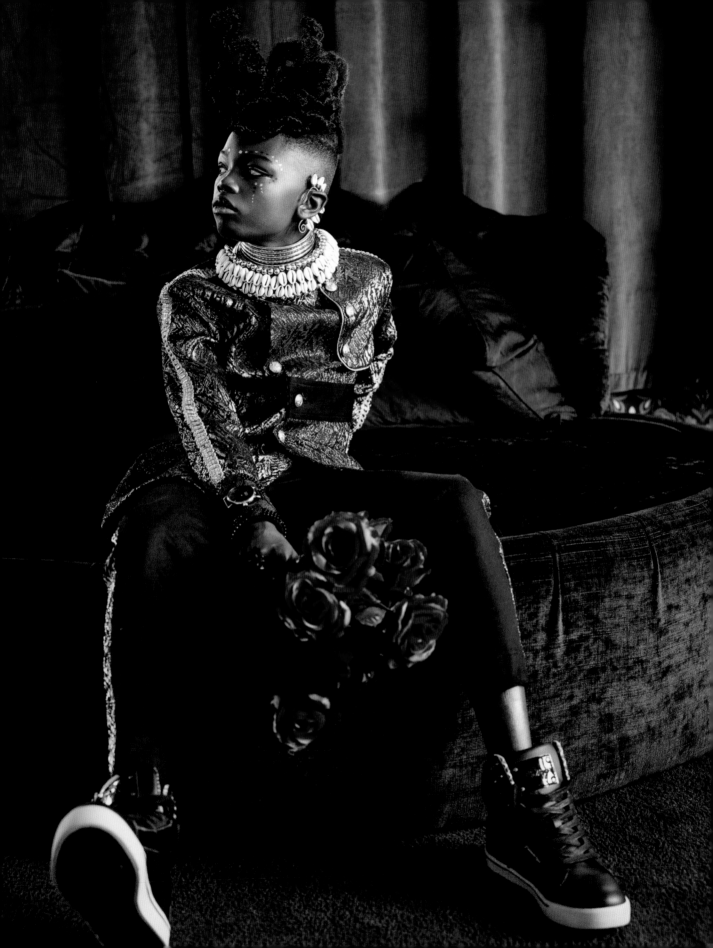

"Ivy and Ivy, you are going to a ball tomorrow and one of you'd better shag Prince Jamal." She then called Asha. "And you'll help them get ready."

"Yes, Stepmother," Asha said. "And may I go with you?"

"Absolutely not!" she said. "You're covered in ashes, your hair looks frightful, and you haven't anything to wear!"

This saddened Asha, but she helped her stepsisters nonetheless. After she watched them leave for the ball she sat in the attic room and wept. She missed her parents so much and wished with all her heart that they were still with her. A moment later she heard a voice.

"Why are you crying, daughter?"

Asha looked up and her parents were standing there. Though startled she was overjoyed to see them. "Oh, Mother and Father, I miss you so much. I wish you were here with me."

"We are here, daughter, as we said we would be," her father said. "That wish is granted. We have two more wishes for you."

"I wish I could go to the ball, but I have no fine clothes or a way to get there."

"Worry not, sweet Asha, your wishes are granted."

A bright light appeared and covered Asha and when she looked down she was wearing an exquisite blue gown made of pearls and lace. On her feet were the most wonderful white boots also covered in pearls. The soot and ashes were gone from her hands and her gorgeous ebony skin glowed. She touched her hair and felt an elaborate crown of braids gracing her head. She then looked outside and saw that her old rusted bike was now a glowing golden bicycle.

"Your wishes have been granted, daughter. You are ready for the ball. But you must be back before the last stroke of midnight for that is when the spell will be reversed and you will be as you were."

Asha hugged her parents tightly.

"We are always with you, daughter, watching over you. Our love for you is everlasting. If you ever want to see us, simply wish for it with all your heart and we'll appear."

King Omar had spared no expense. The grand ballroom was done up in royal blue, from the sofa and chairs to the lush velvet drapes. When Asha walked in it was as if she'd been transported to a magical place. The lights in the chandeliers danced like fairies and the mirrors and tables were gilded in gold. She was dazzled, but all eyes were on Asha, for she was a sight to behold. She was beautiful indeed, but it was her bright smile that most drew their eyes.

Prince Jamal was not only handsome and dashing, but also fair and kind. When Asha walked in he was mesmerized by her beauty, but as they spoke he became even more entranced. For she was charming, smart, and funny, everything a queen should be. Most pretty girls didn't say much; they expected their looks to be enough. But Asha had personality to spare—she could name the stars in the sky, and oh, how she made him laugh! They danced and talked and the hours flew by like minutes and before they knew it the clock had struck midnight and Asha slipped away from the ball. Prince Jamal ran after her, but she was already bicycling away. All that was left was one of her pearly boots. In Asha's haste to get away, it had slipped off and she didn't have time to go back and retrieve it.

Undaunted, Jamal raced after Asha and ended up at a cottage in the woods, where outside was parked a rusted old bicycle.

Jamal knocked on the door. After a few moments it was opened by a girl. Her hair was uncombed and she was wearing a dress covered in soot, but there was something about her smile.

"Hello, I'm Prince Jamal and I am looking for the owner of this boot. Would that be you?"

Before she could answer, Rayna hurried in.

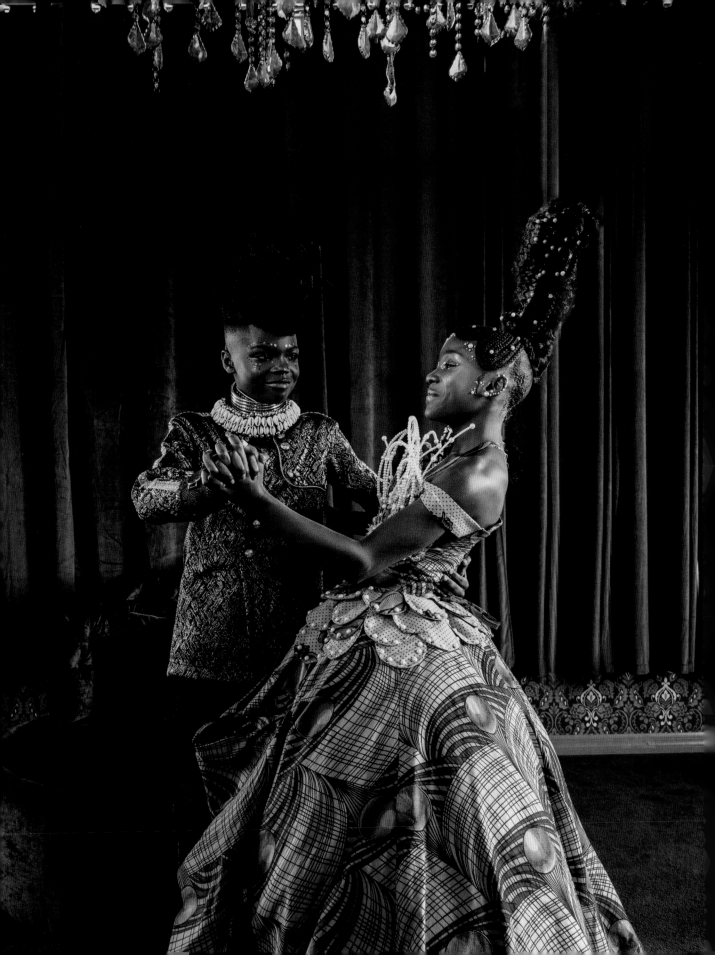

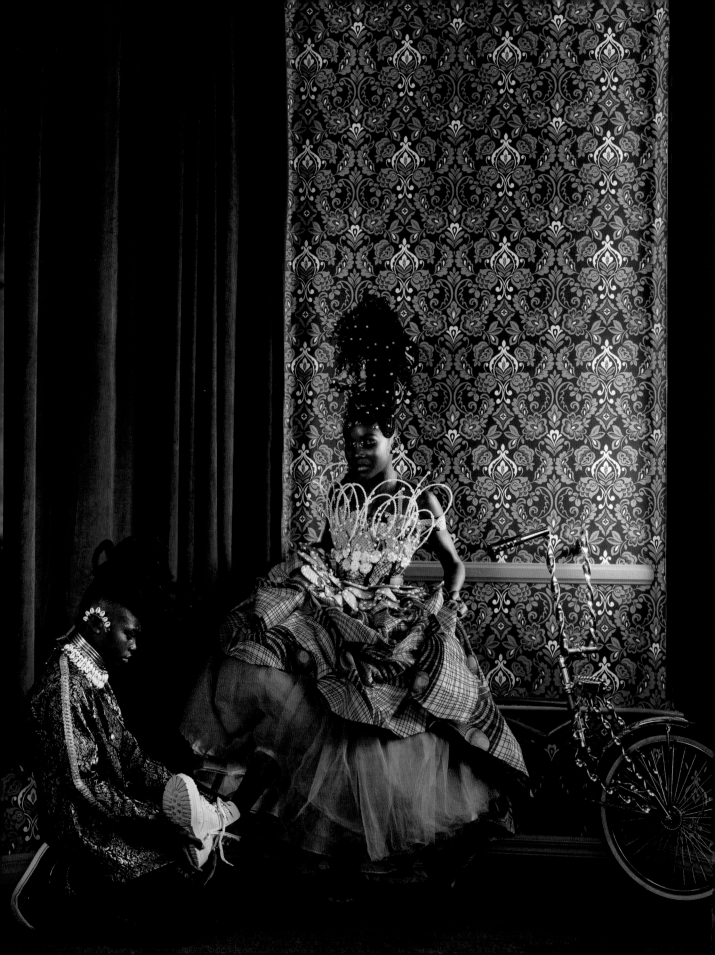

"Prince Jamal, what an honor! Have you come to meet my daughters? We were just at your ball."

But Jamal only had eyes for Asha. Though he did not know the name of the young lady he had danced with all night, he felt a connection to the girl who stood before him.

He asked again, "Does this shoe belong to you?"

When she smiled he had his answer. He sat Asha down and slipped the boot on her foot, and it fit her perfectly.

"I've found my queen. Will you have me?" Jamal asked.

"I will indeed," Asha answered.

And yes, they lived happily ever after.

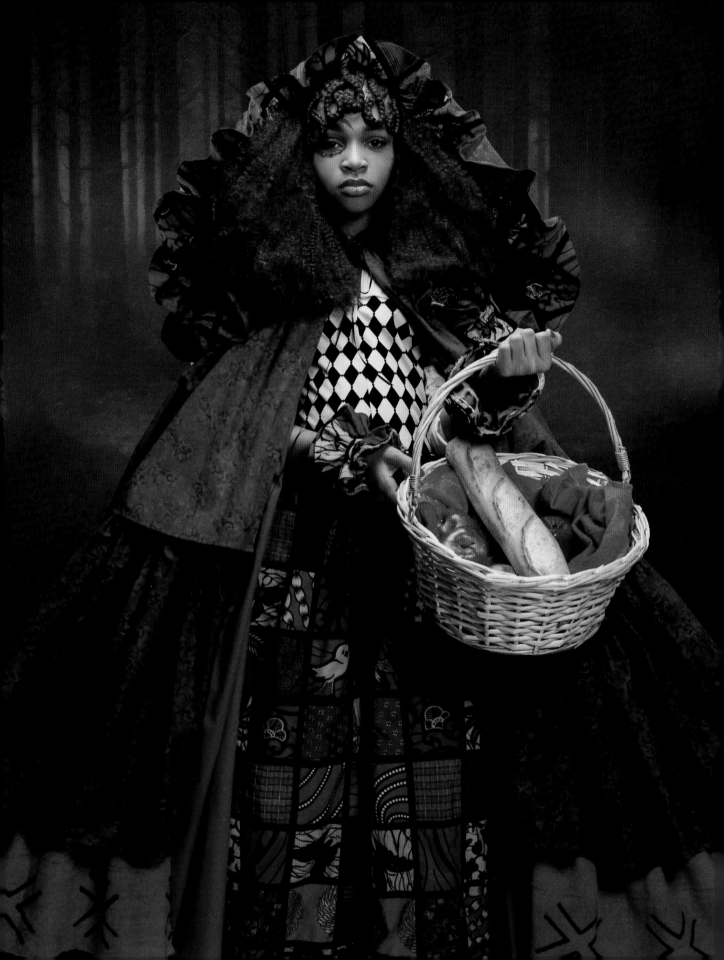

RED
RIDING
HOOD

S pring had finally arrived and it was a beautiful sunny morning as Red set out through the woods to her grandmother's house. Everyone called her Red because of her fiery red hair. Today she wore the beautiful red hooded cloak Grandma had made for her.

Red hadn't seen Grandma in a very long time and she missed her dearly. She was so excited to spend the day with her that she skipped and whistled a merry tune as she made her way through the woods. It was Red's first time visiting Grandma by herself. Her grandmother had not been feeling well, and Red's parents felt she was mature and responsible enough to take this short trip alone. Before she left, Mama had told her not to talk to anyone.

"Don't talk to strangers," Mama had said. "Especially not the Big Bad Wolf. He is cunning and will gulp you down in two quick bites."

Red had never seen a wolf, so she had asked, "What does a wolf look like?"

"Well, he's fierce and scary and has glowing yellow eyes and big teeth—oh, and a big furry tail," Mama had answered.

"Have you ever met the wolf?" Red had asked.

"Well, no, but I've heard stories that he looks fearsome, and because of that you must stay away."

Red kept the image of the big bad wolf with glowing yellow eyes in her mind as she skipped through the woods. After a while she came upon a field of daisies and decided there was no harm in picking some for her granny. As Red gathered the flowers, she heard a noise behind her. When she turned she saw a creature sitting on its haunches watching her. *Is this a wolf?* she wondered. It wasn't big, or scary, and its eyes weren't glowing or yellow.

"Hello, Red," said the wolf.

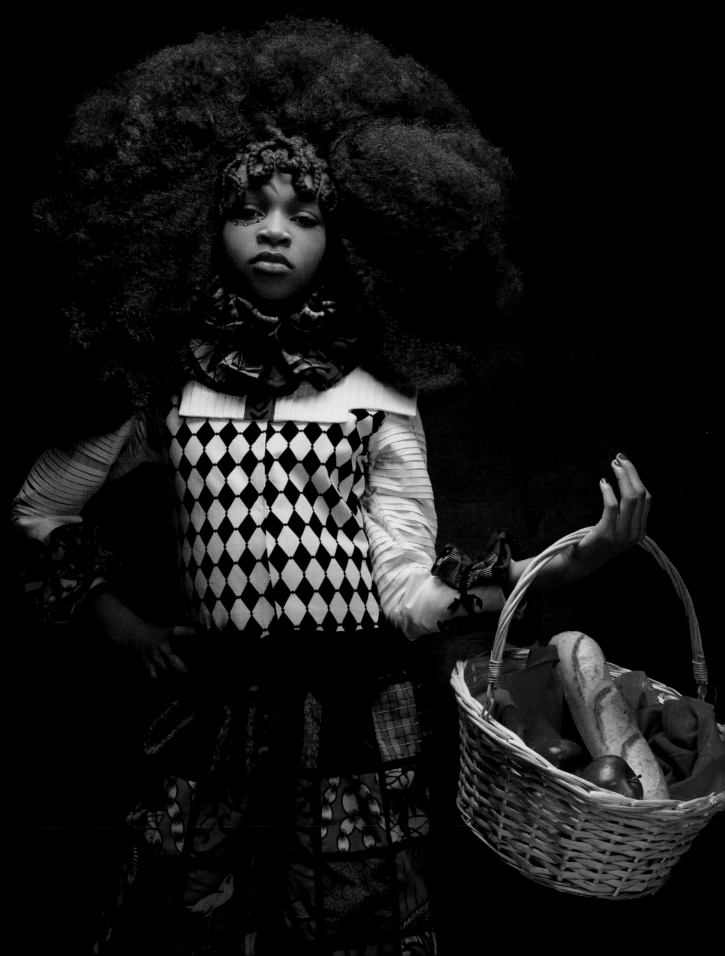

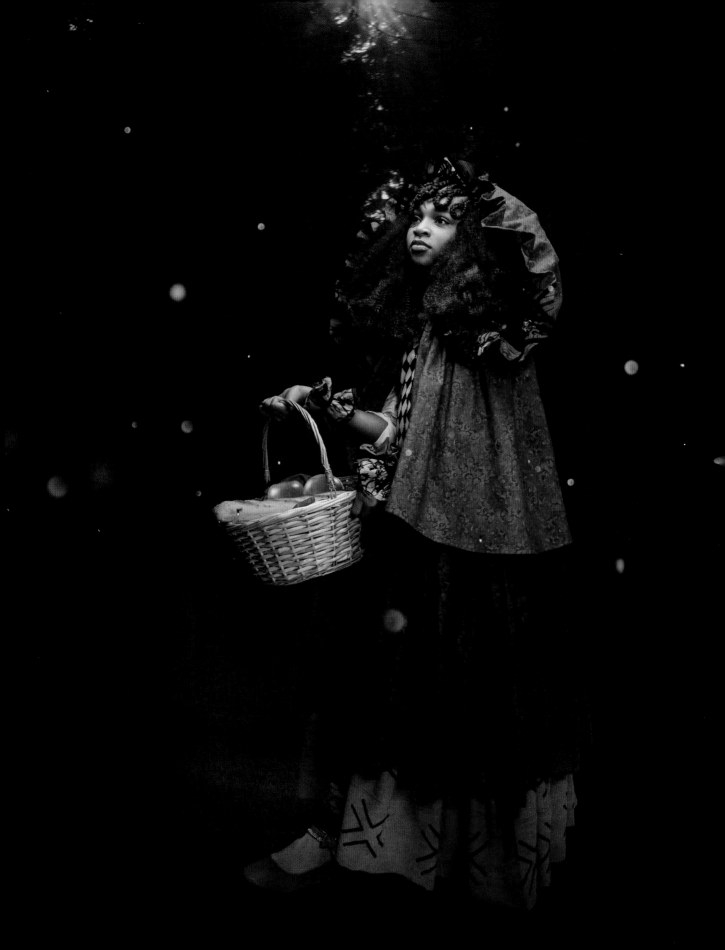

Forgetting what her mother had said about strangers and big, bad wolves, Red said, "Hello." She wasn't afraid. The beast wasn't fierce at all. The poor thing was quite thin and scraggly and looked like it hadn't had a good meal in days.

"What do you have in your basket? It smells delicious," the creature said.

"I have bread and stew for my granny," Red replied. "And mangoes and apples for dessert."

"I bet it's quite tasty. It's been a long, cold winter and there hasn't been much food for weeks." He licked his chops. "Your granny lives in the woods all alone?" he asked.

"Yes," Red answered. "I'm surprising her with these treats to help her get well."

"And where does your granny live?"

"I'm almost there. It's the cottage under the oak tree just beyond the ridge," Red answered.

"That's quite close by," said the wolf. "Well, it was nice to meet you, Red. I'll be on my way." And with that he turned and ran toward the ridge and when he did, Red saw the swish of his furry tail and knew who it was.

"Oh my, it's the wolf and I've told him where my granny lives and that she's all alone."

Red was small, but she was brave and she could run very fast. So, without a second thought, she took off after the wolf, her brightly colored skirt flying behind her. The beast raced ahead with Red hot on his tail and in no time they were at Grandma's house. Red saw the woodsman's ax in the yard. He had chopped wood for her granny and left it in a tree stump. Fast as lightning she grabbed it and blocked the door.

"You stay away from my granny, you evil wolf!" she shouted, brandishing the ax.

"*Evil?* I'm not evil," said the wolf. "Why would you think that?"

"You have great big eyes, and great big ears, and great big teeth, and my mother said to beware of you," Red answered.

" Yes, it's true. I do have great big eyes, great big ears, and great big teeth, and because of it I'm hunted all the time. But no one has ever gotten to know me," the wolf said. "Actually, I'm quite lonely."

"Then why did you race to my granny's house?"

"I don't mean any harm. I only wish for some of your delicious stew and treats. It's been a very long time since I've had anything to eat. I was hoping for some scraps when you were through."

"Well, why didn't you just say that? There's enough for you, too," Red said, lowering the ax. "It's getting dark. Come inside and we'll have a delicious meal. When we're finished you can curl up by the fire. And if you give me your word to keep my granny safe, you can stay with her. She'd love the company and she'd sleep better knowing there was a big, bad wolf protecting her."

"A good meal and curling up by the fire every now and again sounds quite nice," the wolf said. "And I'm happy to make a friend. I have too many enemies I've never met. You have a deal, Red," said the wolf. And they shook on it.

They went inside and had a lovely meal, and afterward he curled up by the fire. And the wolf was true to his word. He grew big and strong and from that day on he protected Grandma from anyone who might do her harm.

And Red learned a valuable lesson that day, which was to never judge a book by its cover.

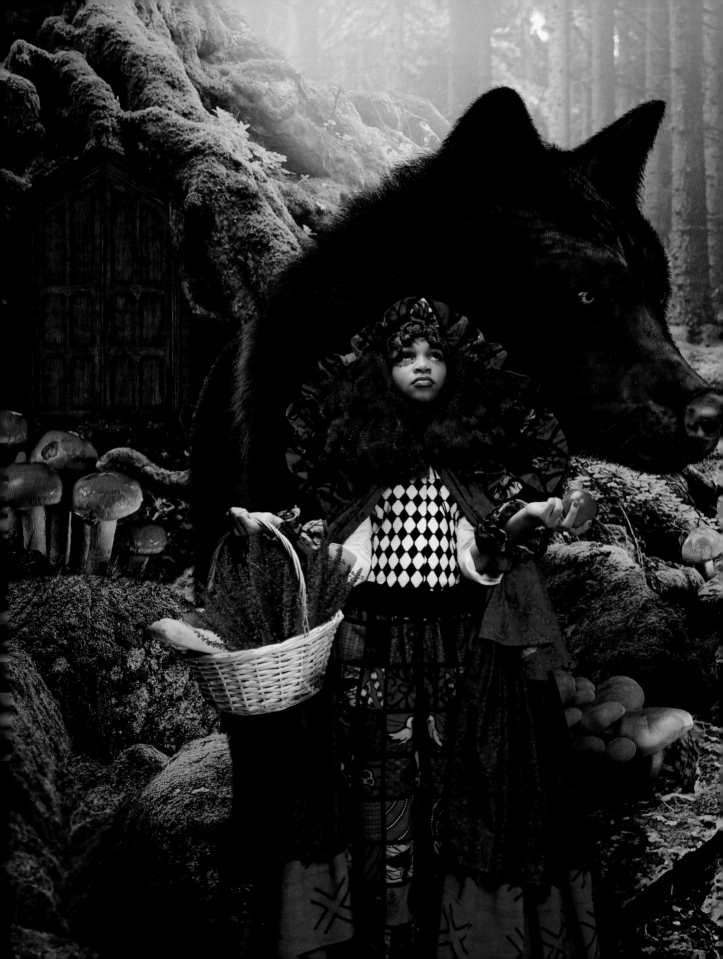

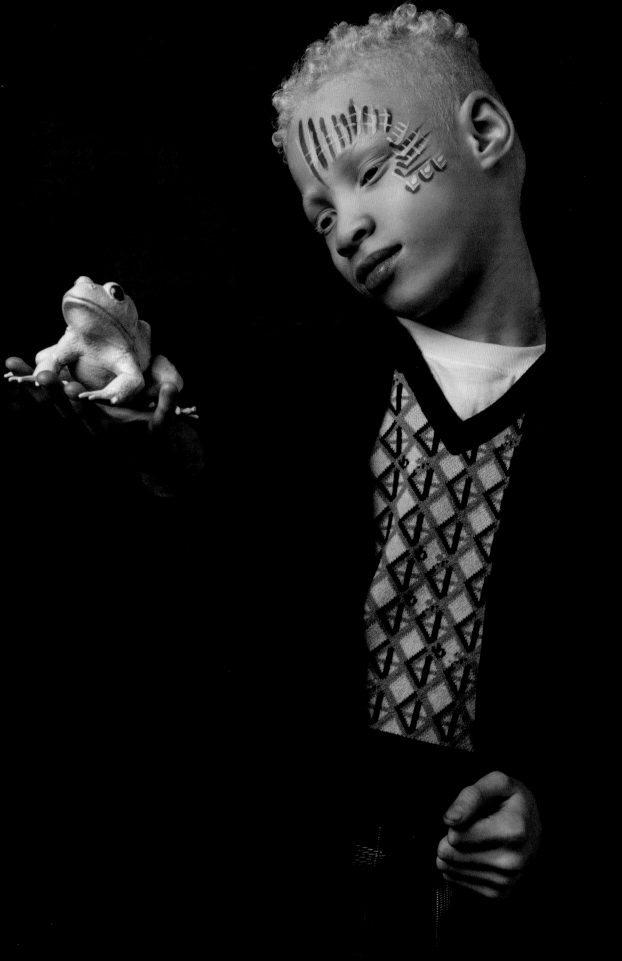

THE FROG PRINCE

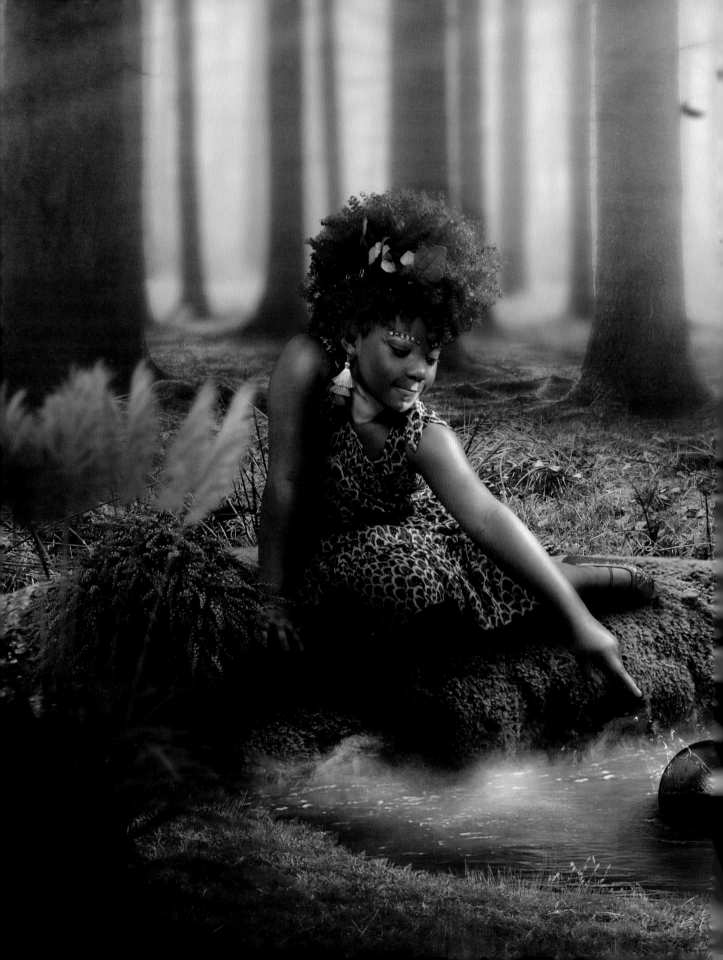

One fine morning a young princess dressed in her favorite green slippers and dress and set out to play in the castle's garden with her beautiful golden ball.

She tossed it high in the air and caught it under the canopy of trees. And every time she did, she laughed with glee. Then one toss sent it up so high that it fell and bounded toward a pond and rolled in.

"Oh no!" lamented the princess, as she sat on a rock and cried.

After a few moments the princess heard a plop on the rock next to her. It was a frog, but not an ordinary frog. It had pale pink eyes with long white lashes, and it was white, not green.

"What a strange-looking frog you are," said the princess, pushing back her hood.

"What a strange girl you are," said the frog.

The princess jumped in surprise. "You can talk?" she asked.

"Obviously. Weren't you talking to me?"

"Oh no." She shook her head. "I was talking to myself."

"Now that is very strange indeed," said the frog.

"Why do you look so odd, Mr. Frog? You're creamy white and not green."

"I'm not odd, I'm *special*," said the frog. "And thank goodness. How boring would life be if we were all the same?" Then he gave the princess a long look.

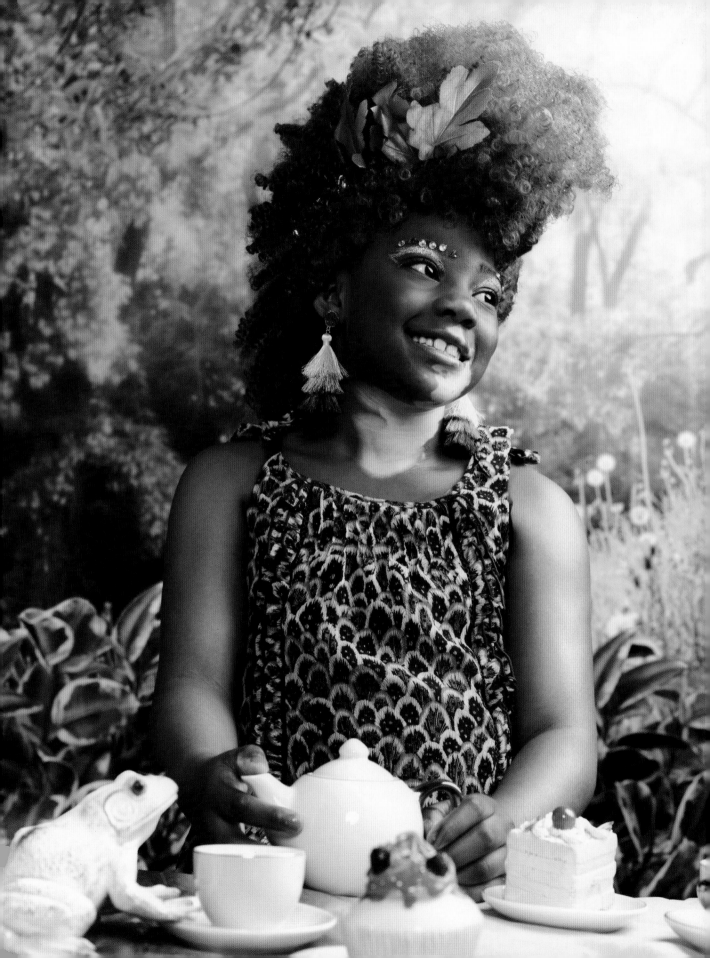

"Why are you looking at me so oddly, Mr. Frog? Is it because I look different?"

"It's because you're talking to a frog. But now that you mention it, yes, you stand out, Princess, because you're not the same as all the rest. Tell me, how has this come to be?"

"When I was born, I was all chocolatey brown, but as I grew older parts of my skin lightened and now I am chocolate and cream all over."

"I see. You don't look like everyone else, and that is a gift, to me. But back to the matter at hand, why were you crying so bitterly?"

"I have lost my golden ball. It was my favorite, but it has fallen into the pond and sunk beyond sight."

"No cause for despair," said the frog. "I will happily retrieve your favorite ball if a promise you'll make to me, just one, that is all."

"A promise," said the princess. "What use is a promise to a frog?"

"It is but a little thing to you, but it will mean the world to me."

"Fine," said the princess, "what would you have me do?"

"If I retrieve your golden ball, you'll take me home. For three days and nights, you'll spend time with me, and we'll become fast friends. Now, that's not very much at all."

The princess thought long and hard, then said, "Okay, Mr. Frog, I promise. If you bring me back my golden ball, I'll take you home with me."

With that the frog hopped high into the air and then dove gracefully into the pond. A moment later, he popped back up with the ball and tossed it to the princess, who caught it with delight.

"All right, Mr. Frog, a deal is a deal." The frog hopped on her shoulder and off to the castle they went.

As she was often alone no one thought it strange that the princess had a frog friend. That evening they dined in her room and the princess fed the frog from her plate. Later that night, the frog regaled the princess with wondrous stories of faraway lands, and they stayed up chatting quite late.

62

"How do you know such things?" she asked. "You funny little frog."

"Oh, I'm much more than I look, but aren't we all?"

That night she lay down in bed, with her frog friend on the pillow near her head, and they slept happily, as close as close could be.

The next day, they played together in the garden. The princess had not even worn her hooded cloak, which she was rarely without; instead she delighted in the feel of the sun on her face.

That evening after dinner, she fed the frog from her spoon. She then put him on her shoulder and she danced while he sang merry tunes.

The next day was much the same. They played in the garden, but this time the frog coaxed the princess outside. She hadn't left the castle grounds in many years. She was ashamed of the way she looked, but with her friend perched upon her shoulder she didn't feel the need to hide.

She basked in his warm glow and laughed the whole time. Her mirth brought smiles to all who heard. They noticed not at all the way she looked, they simply wished to be as happy as she.

That evening as usual they ate together and sang and danced merrily. That third night the princess sat her frog friend upon her pillow, happy for his company.

The next morning when she opened her eyes, it was not upon her friend the frog she gazed; instead she saw a young man standing near her bed, but she was not afraid. He had pale skin and pink eyes with long white lashes.

"Mr. Frog, is that you?" she asked in amazement.

"It is indeed, Princess," he said.

"But how are you he? The frog who was my friend is now as handsome as can be."

"Your friendship broke a cruel spell that was placed upon me. Until I met someone who saw me and loved me for who I really was, a frog I was bound to be."

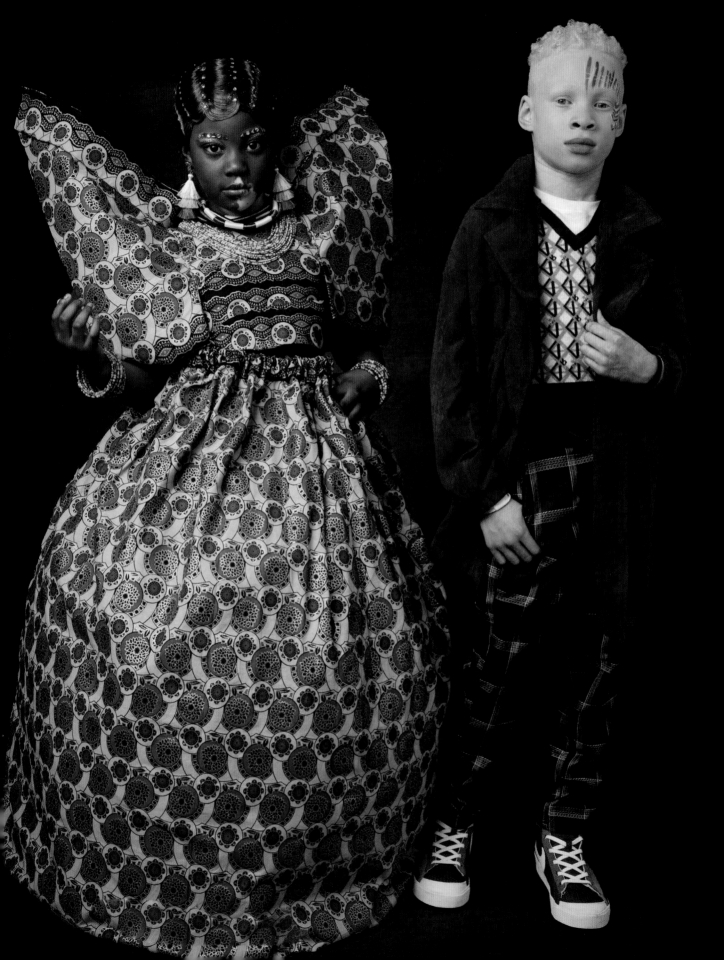

"I am happy to have broken the spell, but I'll miss my frog friend, because as handsome as you are, how can you stay with me?"

"I loved you from the moment we met and that love grew day by day. You are sweet and kind and your heart is bright, I could never go away."

He held out his hand to hers and drew the princess to his side.

"True beauty is not what we look like but in the things we do. You made a promise to me, Princess, and you kept it, which is beautiful and true."

And they stayed friends forever, even after they were wed. And years later, they taught their children that there is beauty in being different, in each and every face. It's what makes us special, and it makes the world a wondrous place.

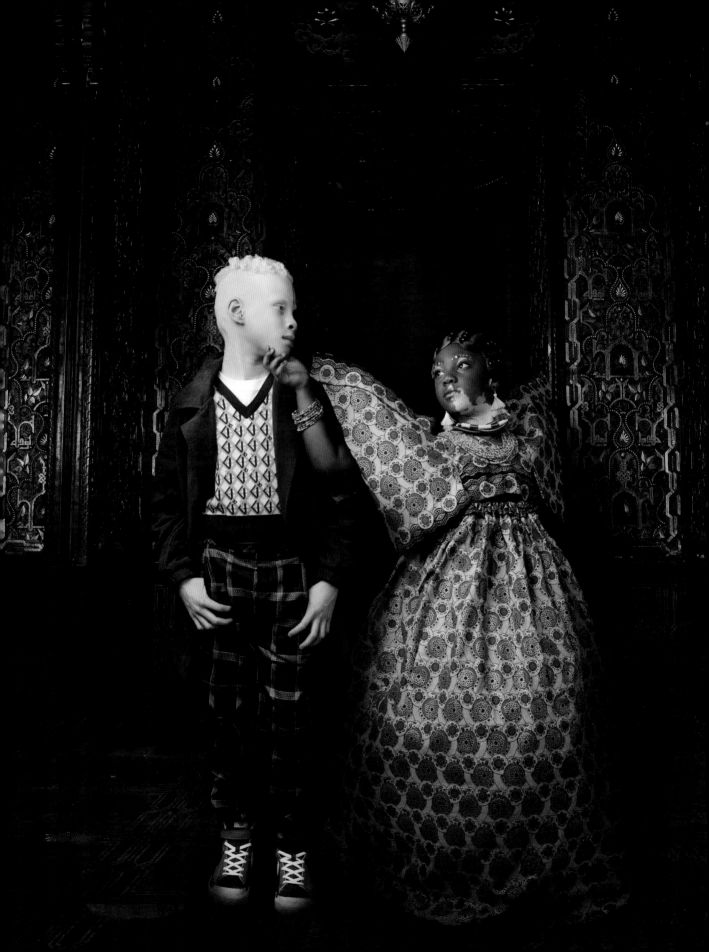

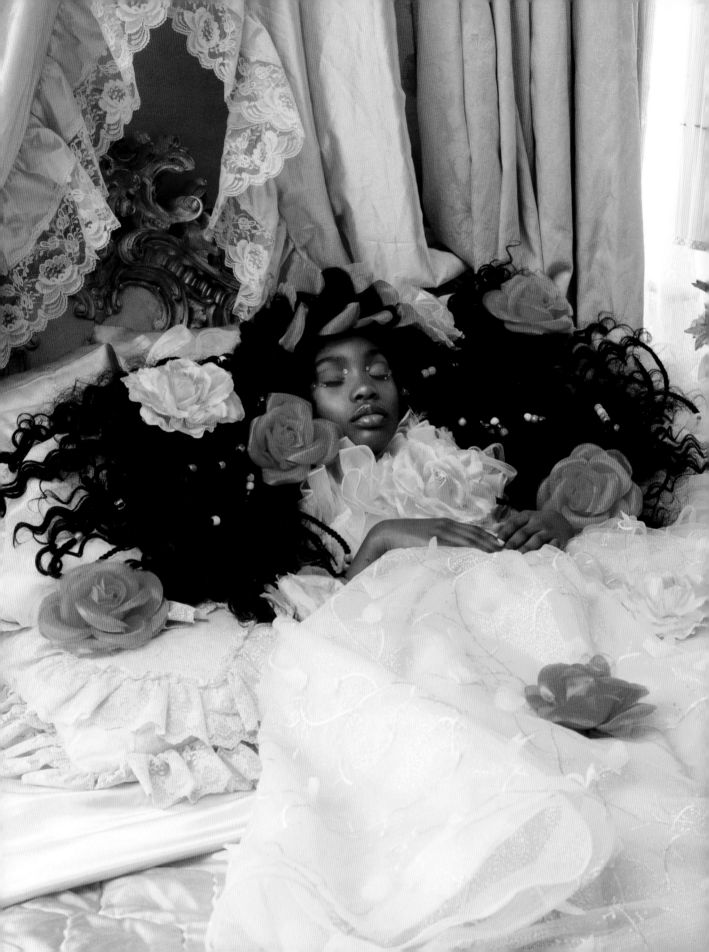

ROZI THE SLEEPING BEAUTY

nce upon a time in a glorious and enchanted realm reigned a king and a queen who were blessed with their first child, a baby girl who they named Rozi.

King Roman and Queen Sula decided to host a celebration so that everyone from across the land could meet the princess. They especially wanted to invite the thirteen fairies to bless her with their gifts. They sent word far and wide and on that special day as the throne room filled with people, the fairy progression approached the king and queen who sat with Rozi in her bassinet. The king did note, with some worry, that one fairy was missing, but the celebration had already begun.

The first fairy looked upon the child and said, "I will grant you courage to be brave and fierce."

The next fairy said, "You will be wise, and help those in need."

The next fairy gently touched her cheek and said, "You will be loving and kind, as all princesses should be." And on it went, but as the twelfth fairy approached a menacing figure appeared in the throne room. It was Grunilla, the thirteenth fairy from the darkest reaches of the kingdom. Her invitation had gotten lost on its way and, feeling shunned, she now appeared in all her maleficent indignity.

"Magnificent Grunilla, thank you for gracing us with your presence," said the king.

"I was not invited, King Roman. It was my crows that told me of your celebration," she scoffed. "But I will bestow a gift to your child, as all the other fairies have done." She then looked at Rozi, who was napping. "What a little sleeping beauty," she sneered. Then she waved her wand and said, "This is my gift to you: yes, you will be sweet, kind, brave, and true, but one day you'll prick your finger on a spindle and sleep for eternity and the world will be lost to you." Then lightning flashed and thunder boomed and Grunilla was gone.

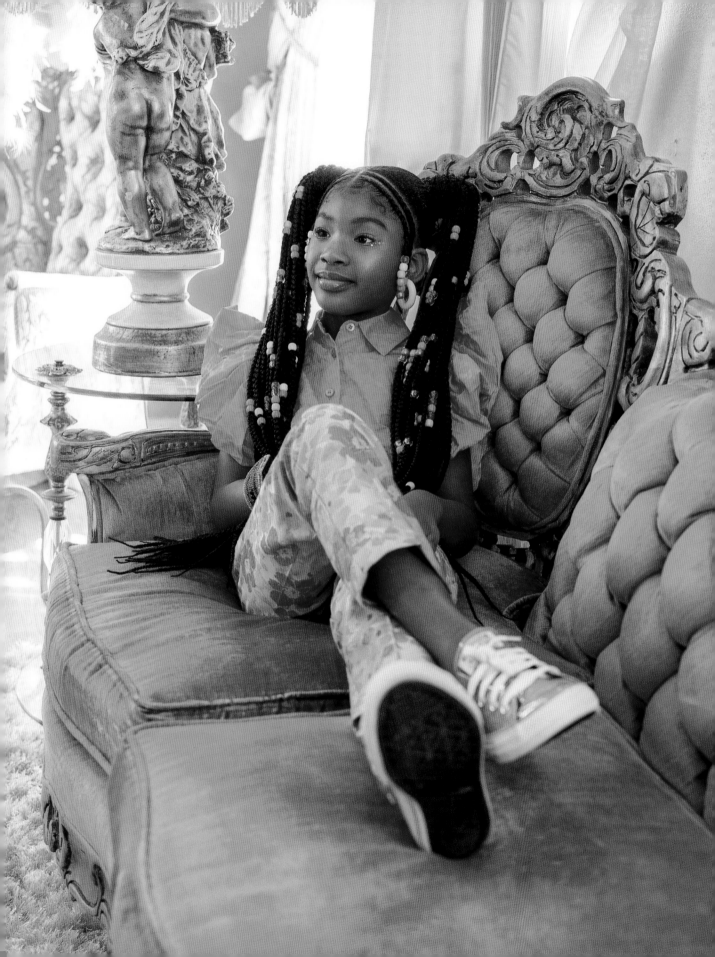

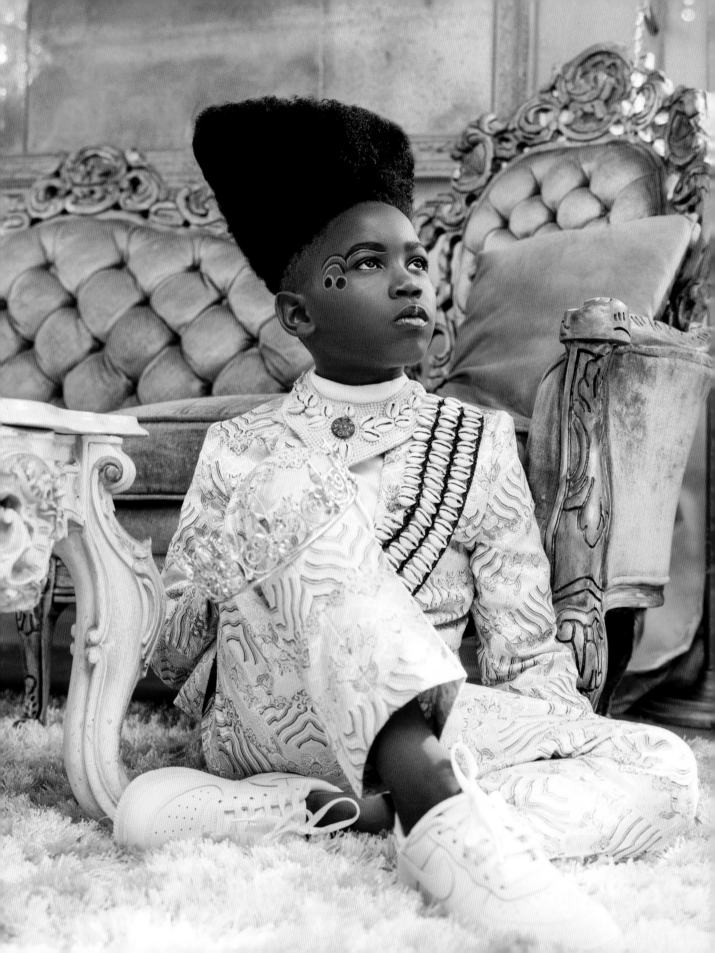

The queen cried out in despair and all the guests were in an uproar. Then a small voice said, "I have not yet given my gift."

It was the twelfth fairy.

"I cannot undo Grunilla's dark prophecy, but Rozi will not sleep for eternity, only until a prince's kiss breaks the spell, then all in the kingdom will be well."

Still dismayed, the king demanded that all the spindles in the kingdom be destroyed and so it was done.

The years went by and Rozi grew into a graceful, kind, and brave girl. She was constantly exploring the castle and its hidden places. She knew all the secret passages and loved to surprise the king and queen by appearing where she should not be.

When she was not roaming the castle, she was reading about adventures and wishing to go on one or two. But her parents were very strict and she had rarely been out of the castle on her own. Instead, she delighted in her glorious pink bedroom, with matching bed linens and curtains. And instead of going on adventures as she longed to do, she covered her walls with glorious images that took her far from the castle grounds and out into the world. She even had her own pink kitchen, where her meals were specially prepared. This was to hide her from Grunilla should she reappear. But Rozi had never been told about the danger and was unafraid.

One day as Rozi was exploring the castle she saw a doorway she didn't recall ever seeing before. She skipped up the stairs and found an old lady with a curious contraption.

"Hello, Grandmother," Rozi said. "Whatever are you doing?"

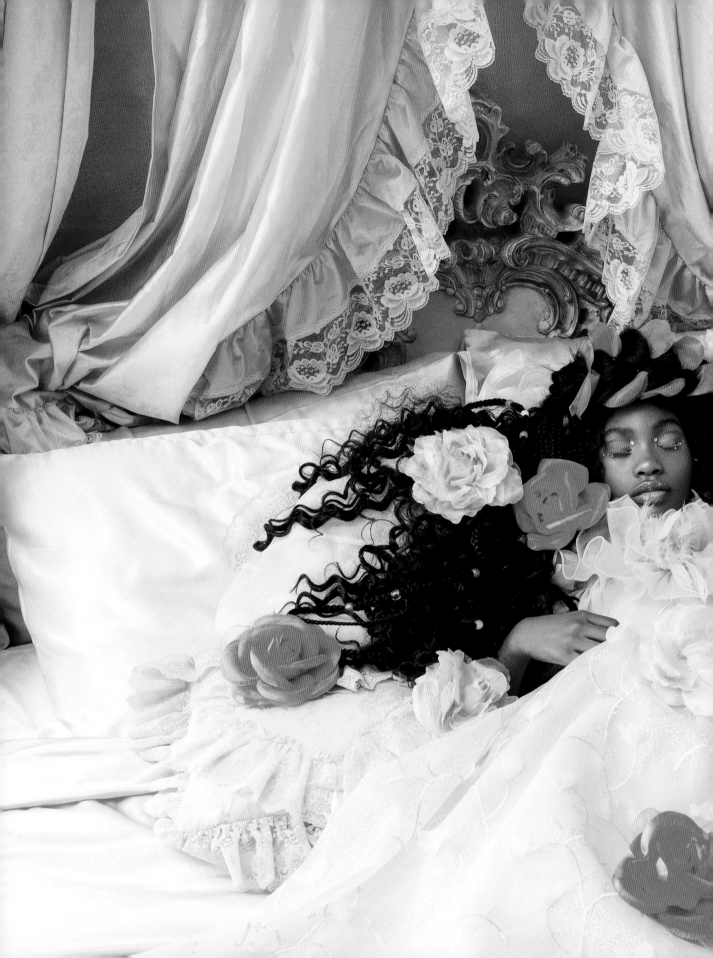

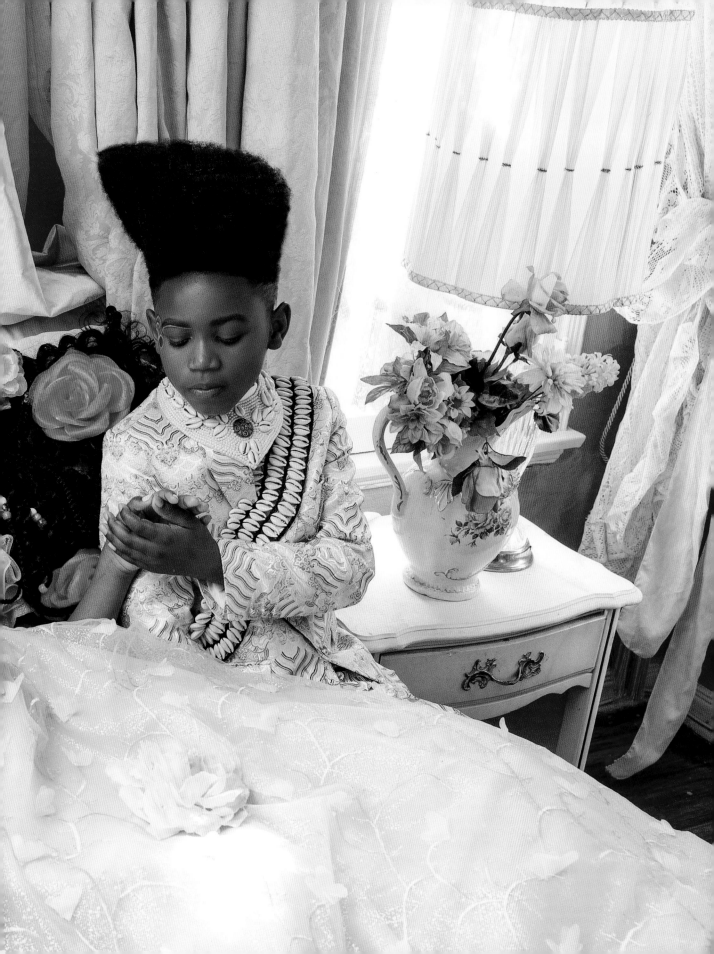

"Spinning on a spindle, child," said Grunilla.

"Look how prettily it spins." Rozi was mesmerized.

"Have a seat, dear, it awaits you."

As soon as she sat and touched the wheel the needle pricked her finger and Rozi fell into a deep sleep.

When the king and queen found her they could not wake her. Grief-stricken, they dressed Rozi in her favorite pink gown and she slept and slept.

After that day a tale was told of Rozi, an enchanted sleeping beauty that only true love's kiss could rouse. The tale also foretold that if it was not a true love's kiss that whomever bestowed it would also fall into a deep slumber. Although many princes heard this tragic tale, only one heeded the call. Prince Damon didn't know much about true love's kiss, but he was brave and wanted to help if he could.

After many days and nights, he came upon the castle, but he was entangled by a thorny bush. He valiantly fought his way through to the gate, but now it was shrouded in mist. Undeterred, Damon scaled the wall. When he came to chambers filled with pink pageantry he knew he'd found Princess Rozi. He tiptoed into her chamber where she lay sleeping. Unsure of how to proceed, he looked at the pictures on the walls and the books on her shelves and he felt a connection to her. He then sat on the bed and his hand found hers on the coverlet. Sometimes when he was sad, his mother would make him feel better by kissing his forehead. This was what he now did. And as he gently brushed his lips across Rozi's brow, her body warmed, the color returned to her cheeks, and her eyes opened.

"Hello," she said. "Who are you?"

"I'm Prince Damon."

"I was just speaking to an old woman with a wonderful spinning wheel."

"That was the evil fairy Grunilla who placed a spell on you. You touched the spindle and fell into a deep sleep and only true love's kiss could wake you."

"You don't say," she said, sitting up. "Are you my true love?"

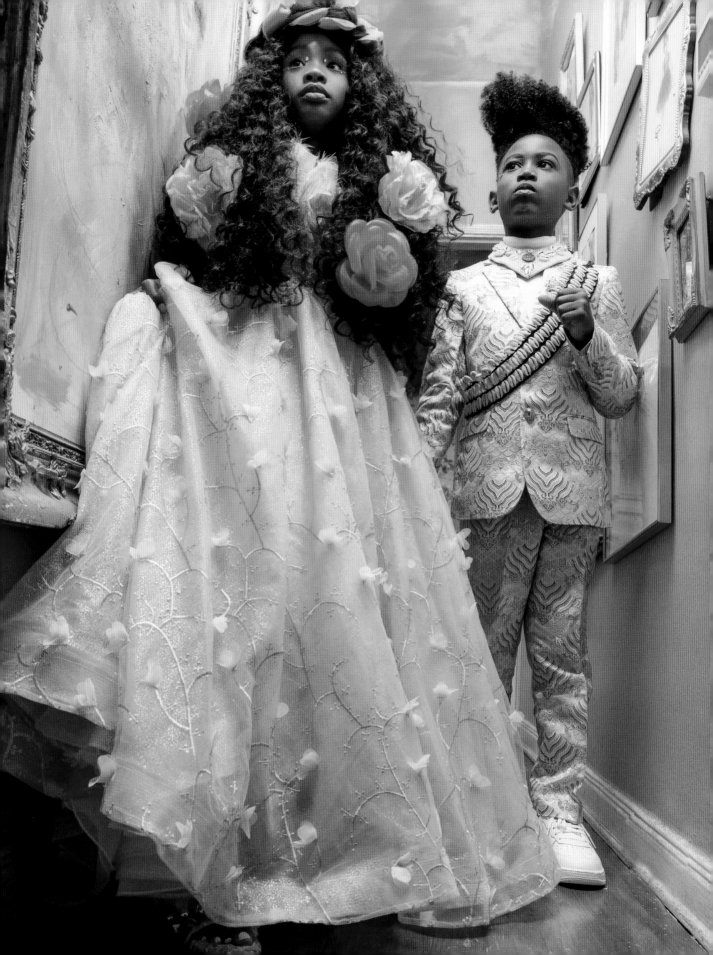

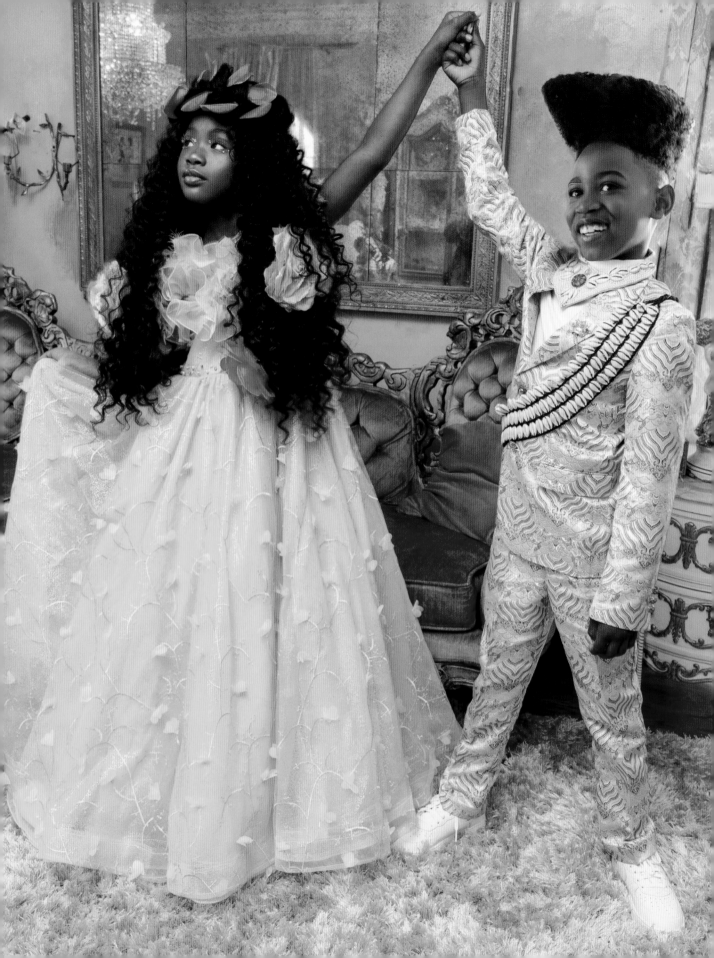

I don't know, but you seem nice. I like your books and your paintings. And I think we could be friends."

At that moment there was a flash behind the door. Grunilla, angered that her spell was broken, had returned to wreak havoc.

"We must escape," said Damon, "but how?"

"I know the castle like the back of my hand. There is a dumbwaiter behind this tapestry that descends to the main hall."

When the door burst open they were already making their descent. They gave each other courage as they lowered themselves with the pulley and rope. Then without a moment to spare they sprang out into the hall where the king waited with his guards and the twelve fairies who had returned to the castle. When Grunilla appeared they banished her back to her realm, for the prophecy was broken.

Prince Damon and Princess Rozi became the best of friends. Yes, he had saved her, but she had saved him right back. Years later, after going on many adventures together, they wed and still remained the best of friends.

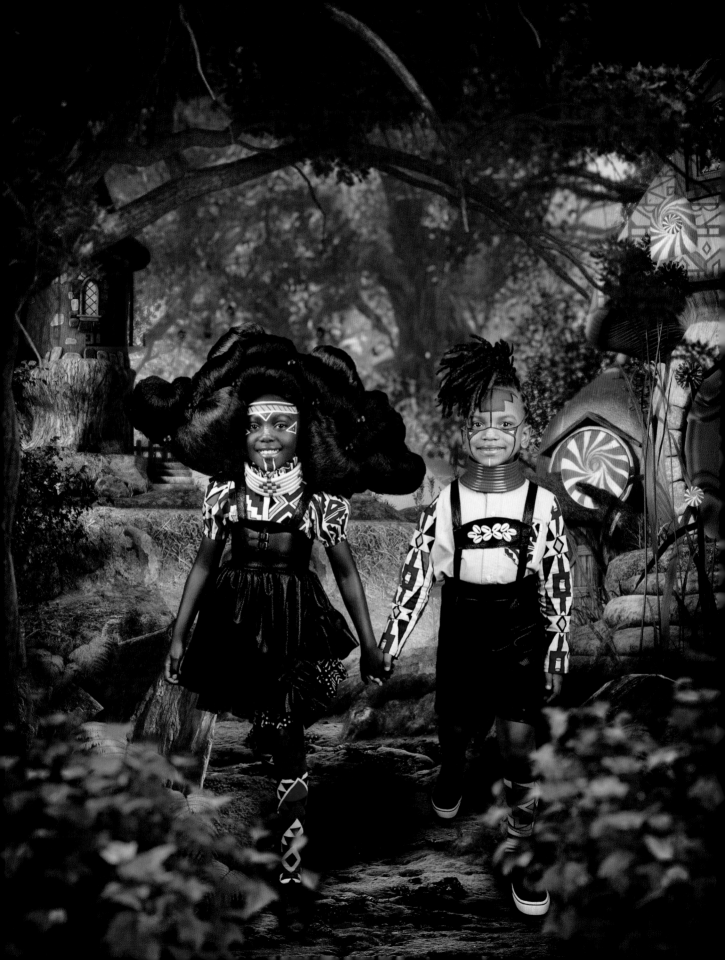

J ust outside of a large rambling woodland lived a woodcutter who had two children, a boy named Hansel and a girl named Gretel. He had lost his beloved wife many years ago and remarried. The woodcutter had fallen on hard times and had no money for food. Worried, he told this to his new wife.

"We will starve," she said. "What are we to do?"

"We will make the best of it and ration what we have," he answered.

"There are four mouths to feed, we barely have enough for two," said his wife.

"We will make do," he replied.

After he went to bed his wife came up with a plan. She'd never really liked the children because she was jealous of how much their father loved them. So, she decided to take them deep into the woods and leave them there. She was sure they'd meet an untimely end, and there would be two fewer mouths to feed. Then she'd have all her husband's attention.

The next morning while the woodcutter went to look for work, she called the children and told them they were going to search for berries in the woods.

Now she had never taken them anywhere before, so Hansel didn't trust her. The wood-cutter had raised crafty children. Before they left, Hansel hid peppermints in his pocket. As they walked deeper and deeper into the woods he made a trail with them so they'd be able to find their way home.

"Wait for me here while I look for berries, children. Don't come until I call you," the evil stepmother said, then she left them to their fate.

Hours passed as the children waited and waited. As they huddled together day turned into evening, then evening turned into night.

"I'm frightened, Hansel."

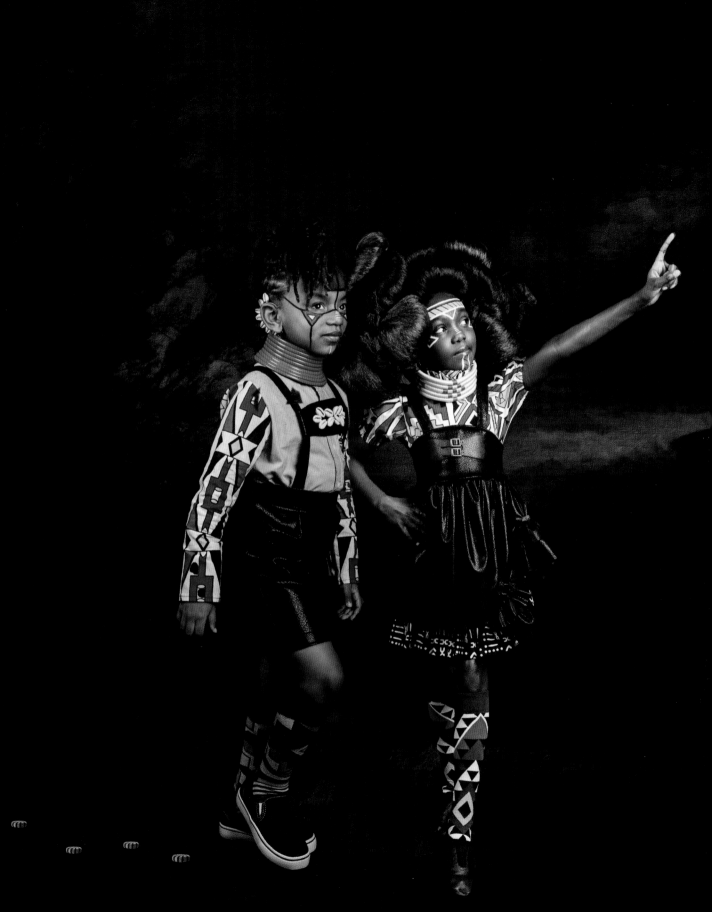

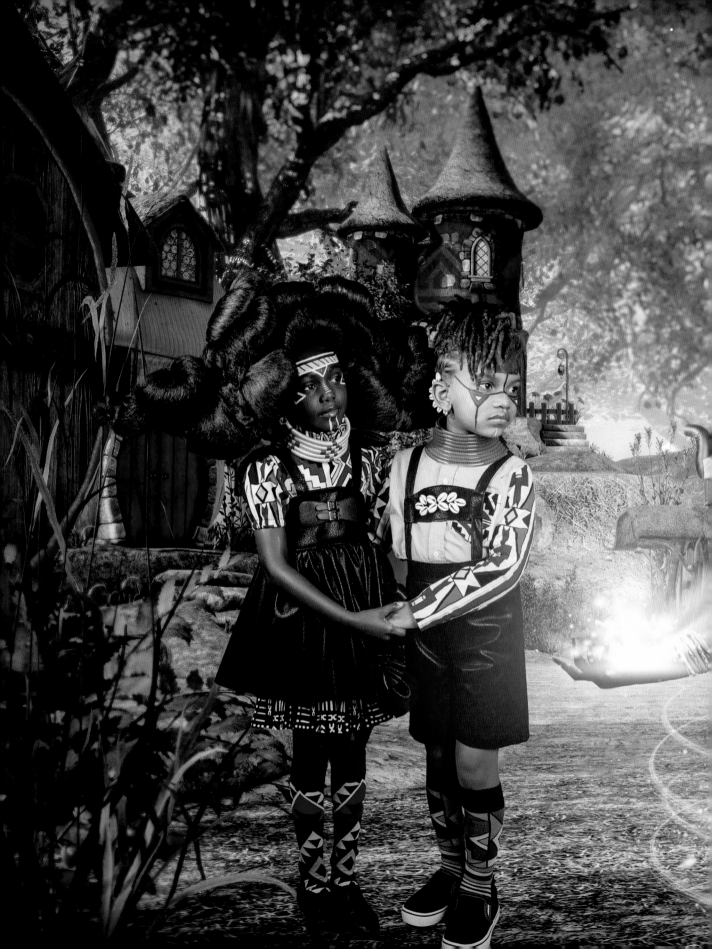

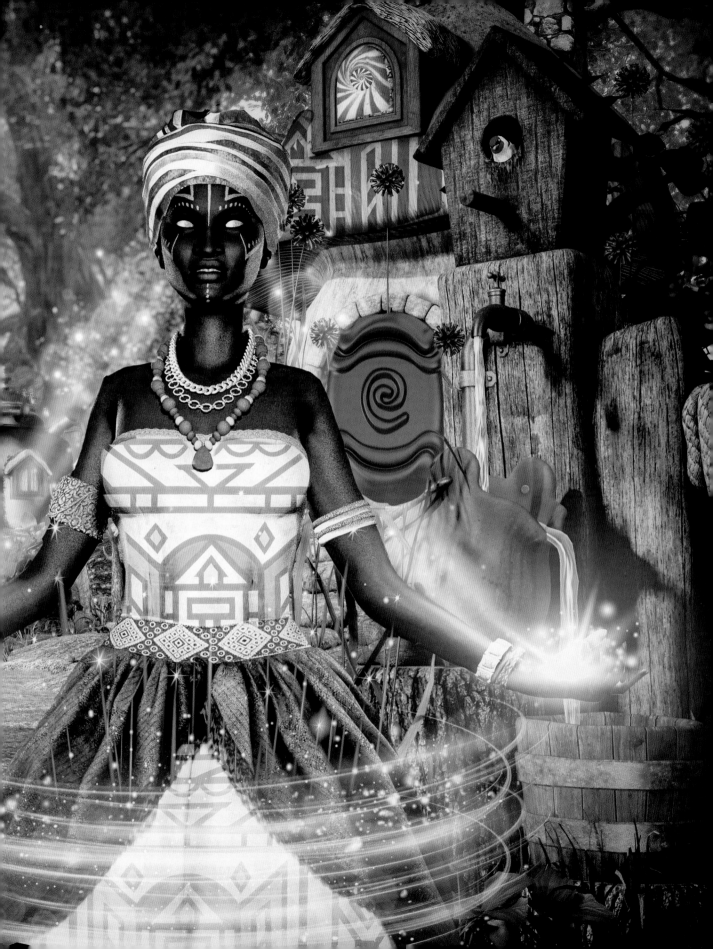

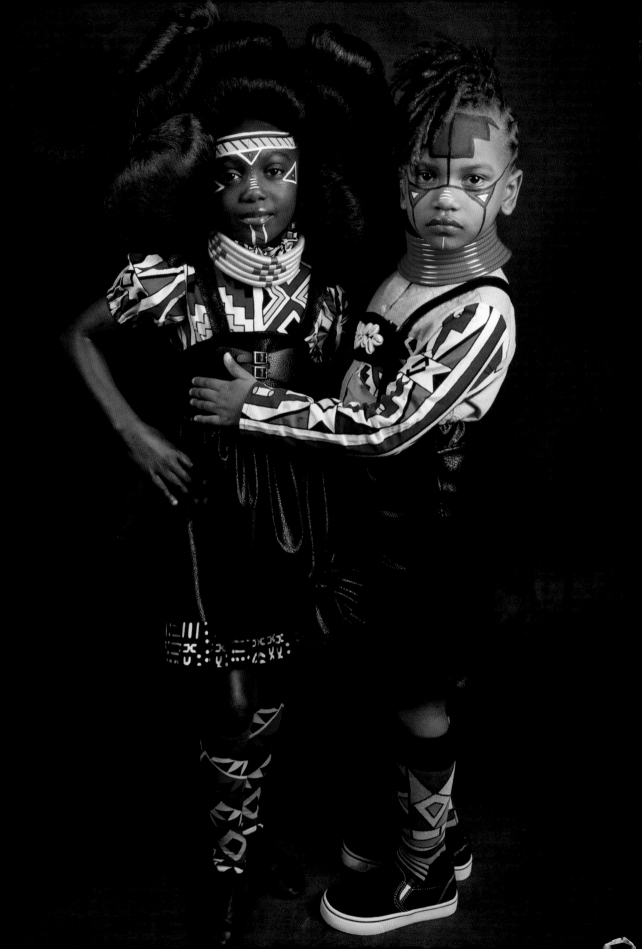

"Don't despair, sister," he said. "I left peppermints as a path to guide us home."

They searched and searched, but couldn't find the peppermints as it was now quite dark. They were terribly hungry and tired as they wandered deeper into the woods. Eventually they came upon a little house. They hurried closer and were surprised to see that the walls were made of gingerbread, and the windows were made of sugar. They were too hungry to be cautious and ran over to the house and in no time at all they were nibbling at the gingerbread. They soon heard a cry.

"Who goes there? Is that a mouse nibbling at my house?" A moment later the door opened and an old woman hobbled out. "Oh, hello, dears. Are you hungry? Come inside and I'll give you a delicious meal."

Hansel and Gretel were starving and exhausted and thankful to hear kind words. Without a second thought they went inside and found a table set with yummy food. They sat down and started eating. After a few moments they were so full they fell fast asleep.

"I have you now," cackled the old woman. For she was really a witch who preyed upon lost children.

As they slept the witch heated her oven. In the morning she woke Gretel. "Hello, child," she said. "Would you climb into my oven to see if it's hot enough? I want to make fresh bread for your breakfast."

Now Gretel was young, but she wasn't foolish. She knew there was no reason for her to climb into the oven to test if it was hot. She could feel the heat from where she sat. Having eaten and slept, she was now refreshed and alert. She saw that Hansel was fast asleep as though under a spell. She then knew why the old woman lived in a gingerbread house. It

Hansel woke up and hearing his sister's words he sprang out of his chair and together they pushed the old witch into the oven. Then they shut the door and fastened the bolt. The witch screamed horribly but she'd gotten her just deserts.

Looking around the witch's house Hansel spied a bag filled with gold coins and he grabbed it, then he and Gretel ran outside and into the woods. After a while they came upon the peppermints Hansel had dropped during their walk. It was now morning and easier to see them. They followed the trail and soon spied their father, who was looking for them. He'd been terribly worried when his wife came home and told him she'd lost them in the woods.

"Father! Father!" they yelled, running to him.

Children, I was so worried! Your mother told me you were lost in the woods."

"No, Father, she left us there and we spent the night at a witch's house and she tried to push Gretel into the oven. But we pushed her in instead." Hansel then held up the bag of gold coins. "Look, Father, we can now buy whatever we need."

But the evil stepmother didn't see one gold coin because their father put her out of the house and told her never to return. And they all lived happily ever after without her.

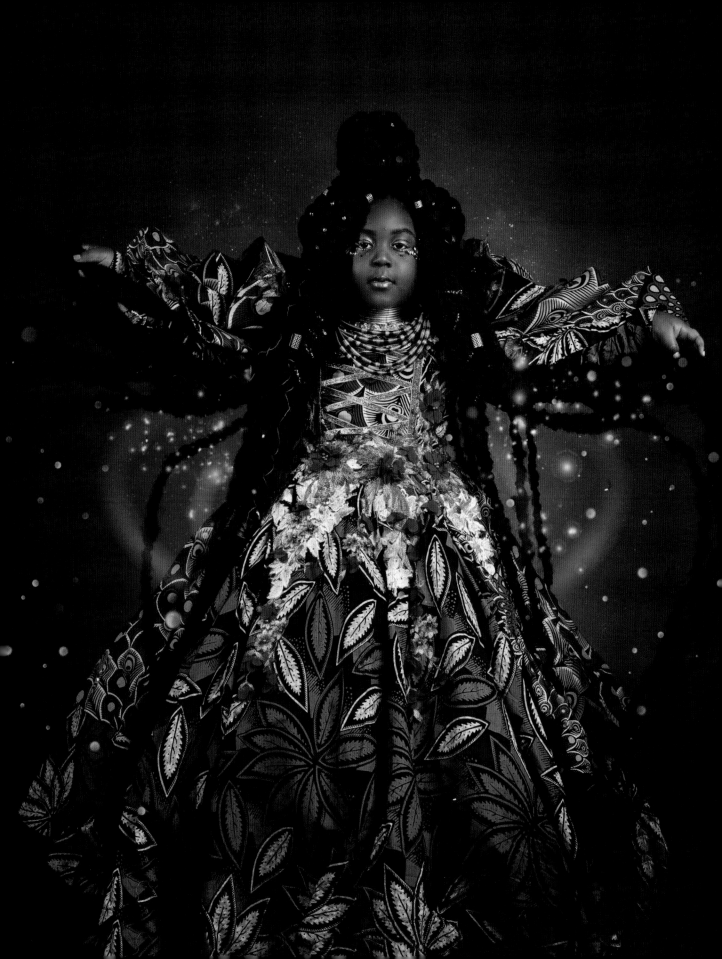

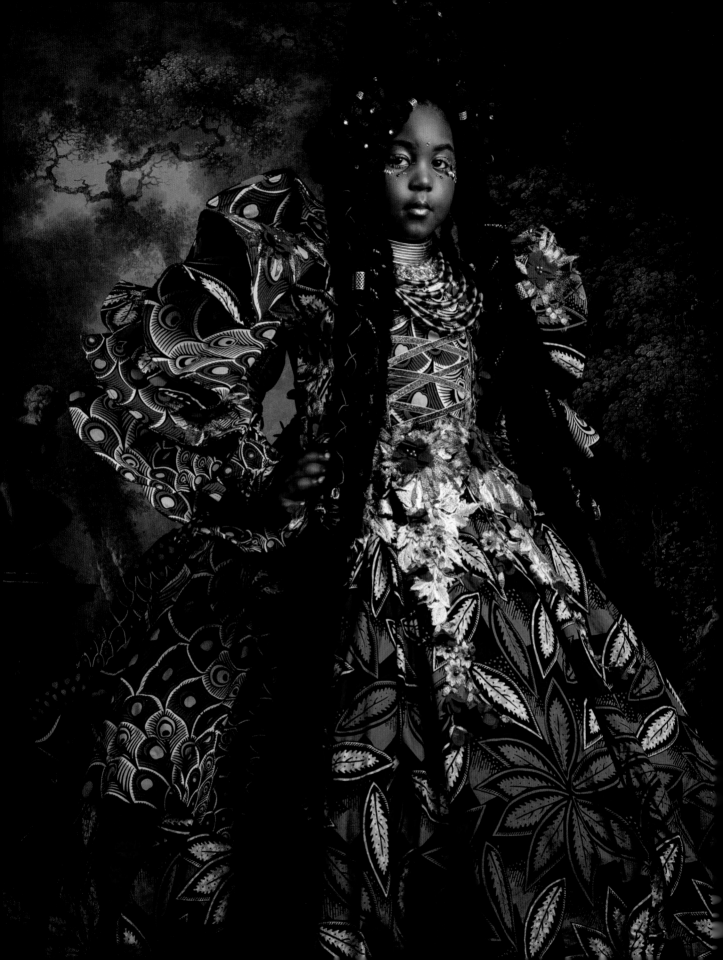

Once upon a time, in a small wooded glen, there lived a couple who wished for a child. They had so much love inside of them that it turned into magic that made their garden grow. It was filled with the most beautiful flowers and herbs. The wife especially loved the rapunzel flower and sang to it every day. Not far from their home lived a sorceress who possessed great power and longed for even more. She scowled when she saw their abundant garden and when the rapunzel blossomed under the wife's gentle care, envy grew in her heart. Shortly after, the loving couple had a beautiful little girl. They named her Rapunzel after their beloved plant.

Rapunzel became the most beautiful child under the sun with gorgeous, long, enchanted locs. Her magical hair helped her dress, tied her shoes, kept her warm on chilly nights, and even reached for things up high, like the freshly baked cookies her mother tried in vain to hide. Rapunzel thought her hair made her special. It was her pride and joy and each night she and her mother would adorn her locs with cowrie shells, beads, and bows. "You are the one who is magical, my lovely girl," her mother and father would tell her every night before putting her to bed.

On the morning of her twelfth birthday, Rapunzel sprang out of her bed, filled with excitement. Her locs helped her slip into a beautiful dress of purple and gold before she went into the forest to pick berries for the most delicious cake that her father was going to make for her special day. Her hair was picking a particularly high bunch of berries when the evil sorceress came walking into the clearing.

Not knowing who she was, Rapunzel politely smiled and said, "Good morning."

The sorceress stared in envy at the sight of Rapunzel's glorious hair, clearly a source of great magic, and knew that she had to have it for herself.

"Good morning. You're Rapunzel, aren't you?"

"I am," she replied. "How do you know my name?"

No one else has hair that reaches up to the sky like yours, Rapunzel," she answered. "Everyone in the land knows about your enchanted locs."

"Has my father sent you to fetch me?"

"Yes, dear, he has," she said after a moment's pause. "Your father has a surprise for you and I'm here to take you to it."

"A birthday surprise?" Rapunzel asked, as her hair danced with joy.

"Yes, a surprise it is indeed. Would you like to see it?"

"Very much so," Rapunzel said.

"Then come with me. It's not too far."

All thoughts of berry gathering were gone as she followed the old woman deep into the woods. After walking for a long time they came upon a tall tower covered in vines.

"Is my surprise inside?" Rapunzel asked.

"It is," the old woman said, leading her to the door, which was made of thick, weathered metal. She pushed it open, and when Rapunzel looked inside there was only a staircase that spiraled up into the darkness.

She looked at the witch in confusion and said, "I don't understand."

"You will!" the witch shouted and shoved Rapunzel into the darkness and slammed the door behind her. "I want the magic of your enchanted locs, Rapunzel, and now you will be imprisoned in my tower. It takes magic from people like you and gives it to me."

Rapunzel kicked and screamed as she was lifted up into the air higher and higher until she was at the top of the tower inside a small room. Then the door slammed shut. Rapunzel was deposited on the cold, damp floor with a thud and it hurt. She wondered why her hair hadn't cushioned her fall.

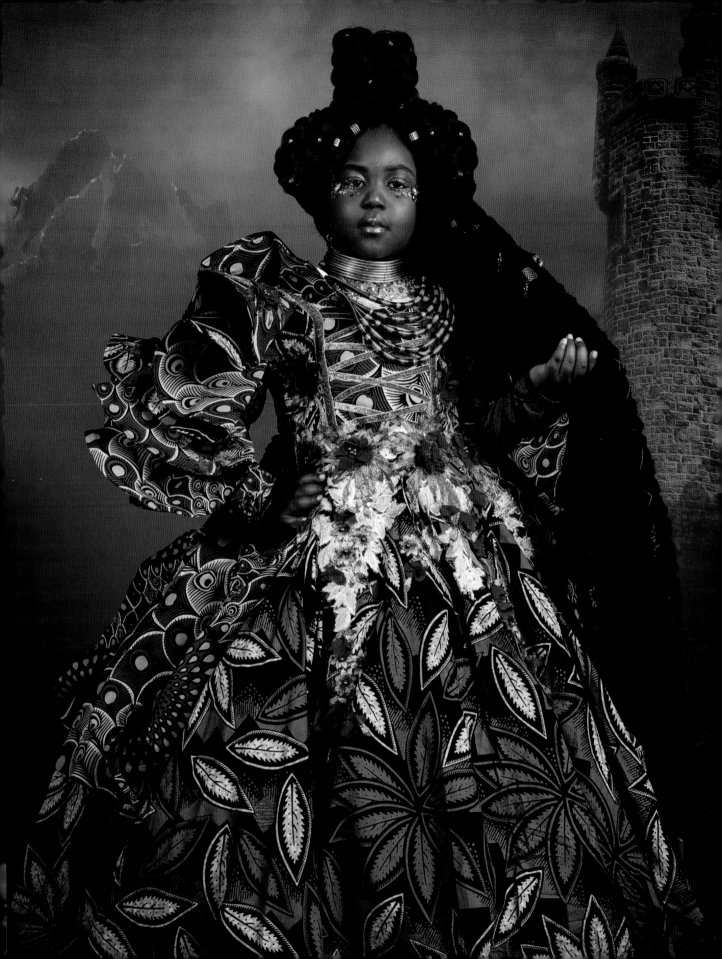

"Enchanted locs, open the door," she said, but nothing happened. "Enchanted locs, open the door!" she repeated. But again nothing happened. Her hair simply sat unmoving on her head. Rapunzel reached up and touched it; it was still thick and long but it didn't wrap around her hands or gently caress her cheeks. That was when she realized the old woman was a witch and had stolen her magic.

"Oh no, what am I to do?" Rapunzel cried. "I don't have my enchanted hair to help me." For a long time she cried, feeling helpless and alone. Then she remembered what her parents told her every night. *You are the one who is magical.*

Rapunzel saw a window and ran to it. She was many stories high above the ground but not far off in the distance she saw the cottage where she lived. Oh, how she wished for her enchanted hair, with it she could easily escape. But alas, she no longer had her magic.

The walls of the tower were covered in vines. If she could climb down she'd be able to escape. She'd never had to do anything on her own, she'd depended on the magic of her hair for as long as she'd known. But alas, that was no more. She decided then and there that she would try her best to do it on her own.

Rapunzel pushed back her sleeves, hitched up her dress, and then carefully climbed out onto the windowsill. She grabbed a vine, then slowly stepped off the sill and grabbed another vine. She was now outside and she dared not look down. Moving from one vine to the next, she slowly, oh so slowly, lowered herself step by step.

When she was almost all the way down, she jumped and landed safely on the ground. She stood there amazed at herself, but there was no time to waste. She had to get away lest the witch return. Rapunzel ran as fast as she could through the woods. The branches grabbed at her dress, and she stumbled on rocks, but she kept going until she was finally home. She flung open the door and found her parents anxiously awaiting her. She threw herself into her mother's arms and sobbed.

"Rapunzel, darling, what has happened?"

"Oh, Mother, a witch stole the magic from my hair and locked me in a tower in the woods."

"And how did you get away if not with your magic?"

"I did it on my own. I climbed down the tower on the vines and ran all the way home."

"You are a brave and resourceful girl," her father said. "Your enchanted hair was wonderful indeed, but its magic was not something you did ever truly need. It was a part of you, that is true, but not all that you are, Rapunzel, not by far. You didn't need your hair to save you, daughter, you did that all by yourself."

"Perhaps your special birthday gift is to realize that even without your enchanted hair, you are still quite magical," her mother said, hugging her tightly. "The magic that was in your hair is and will always be in you, my dear."

Rapunzel knew that what they spoke was true. All her life she'd thought the magic was in her enchanted hair, but it was always in her, and no witch or spell could ever take that away. And it was truly the best birthday gift of all!

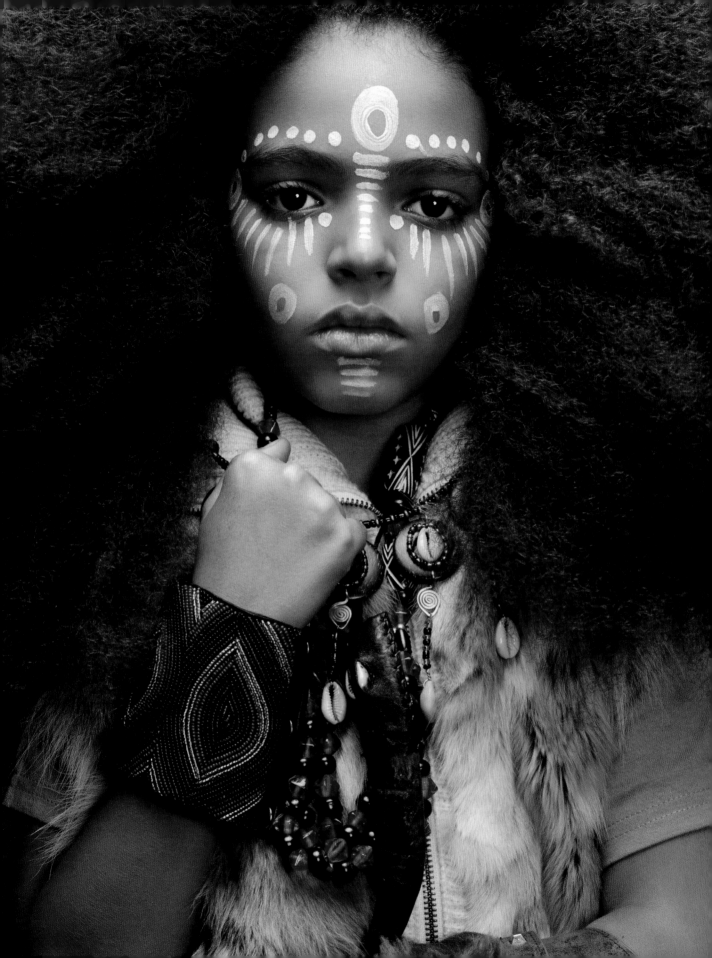

OUR STORIES RETOLD

AFRICAN AND AFRICAN AMERICAN FOLKTALES

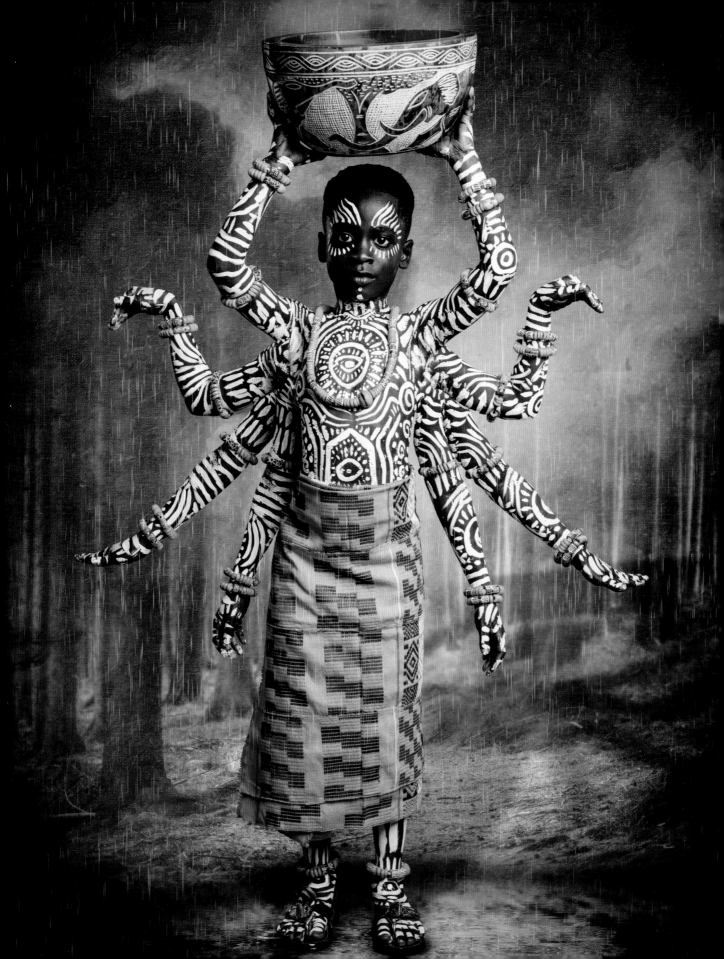

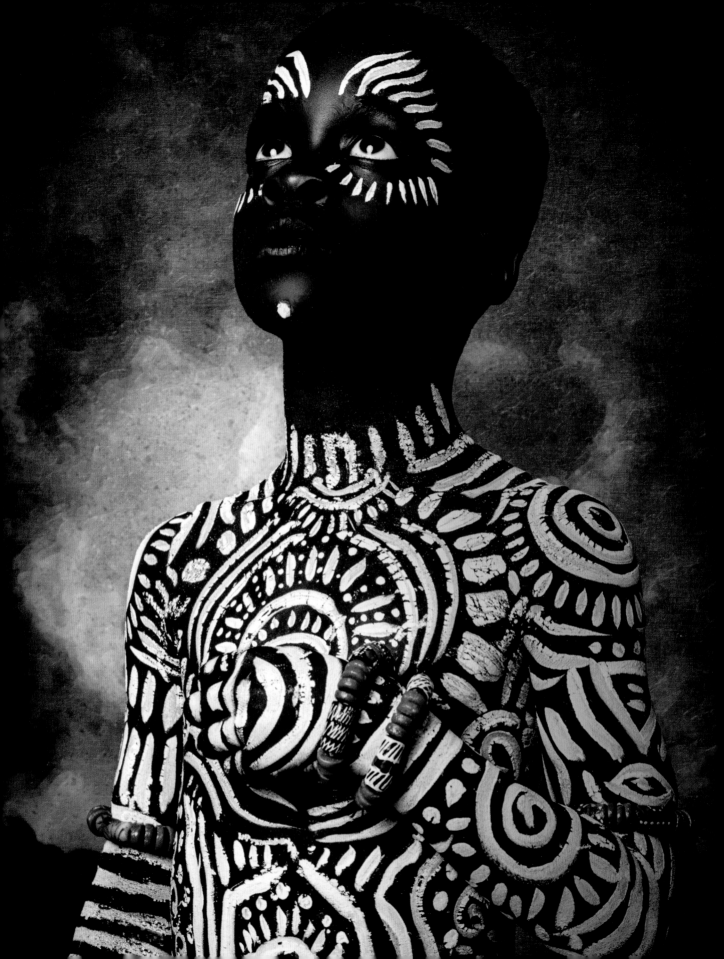

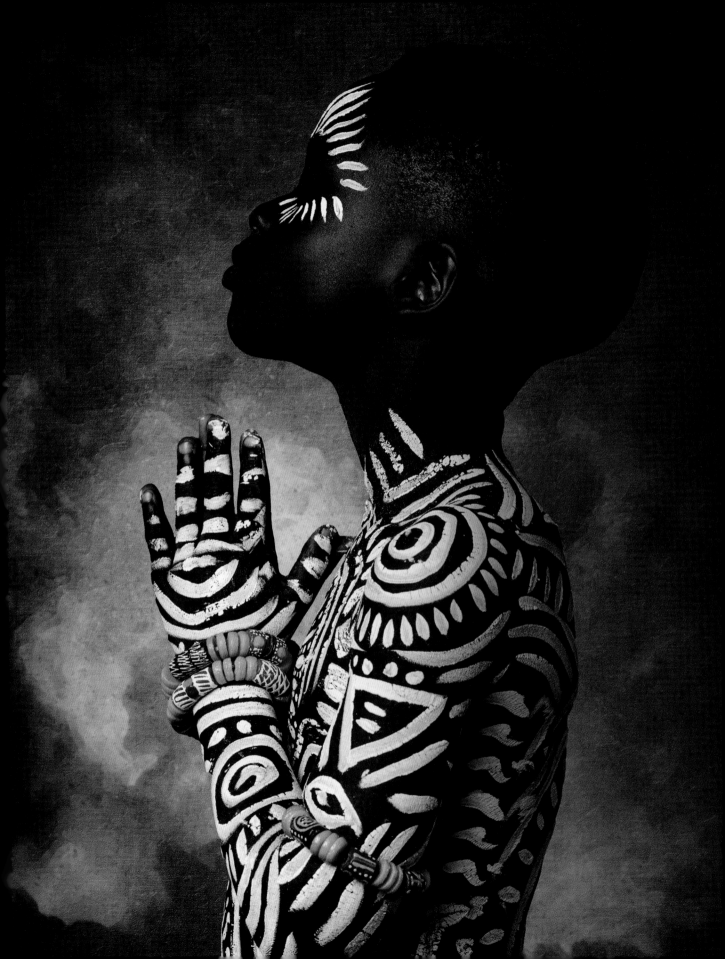

Long ago in Western Africa, before stories were given to the people, they belonged to Nyame, who ruled the sky. Because of this the people had no stories to share, to learn from, or to pass down. Bored, they busied themselves with war and fighting. Anansi, the great trickster, was tired of so much strife so he decided to claim the stories to give to the people to educate and occupy them.

Anansi could shape-shift into anything he wished. Sometimes, to trick people, he'd change into a boy, though he would most often take the shape of a spider. In the Akan language "anansi" is the word for spider, one of the smallest but most cunning, patient, and resourceful creatures, qualities the spider deity delighted in.

Anansi changed into a spider, spun his web, and ascended up to see Nyame in his sky palace.

"Oh, great and powerful Nyame, I have come to ask for the stories to give to the people. They fight and make war instead of telling the stories of how they came to be. Will you let me have the stories to share with them?"

Nyame didn't want to give up the stories for he enjoyed them for himself, but there was no good reason to deny Anansi. So he said, "I will give you the stories but you must complete three trials. Bring me Onini, the terrifying python; Mmoboro, the dreadful hornet; and Osebo, the fearsome leopard." Nyame finished, satisfied that Anansi would withdraw his request, for these he believed were impossible tasks.

"I will do as you ask," Anansi said simply.

Anansi thought and thought and when night turned into day he shape-shifted into a boy.

Although Anansi could change into anything he wanted, he always had distinct white markings on his face and body that, if you looked closely, formed a spider. Today was no different. As a boy, his skin was ringed and marked in Adinkra symbols that formed a spider. Anansi then set off to Onini's lair, waving a branch from a palm tree and talking to himself.

As Anansi drew near, Onini, the terrifying python, sidled up to him. "What are you talking about?" he hissed, thinking the boy looked like a tasty treat.

"My mother said that you are smaller than this branch. But I disagree."

Onini puffed up with pride. "I am Onini, the terrifying python. Of course I am longer than that puny branch. Lay it on the ground and I will prove it."

Anansi did as he requested and when Onini slithered up and lay next to the branch, he changed back into a spider, spun a web around Onini, and secured him to the branch. "I have tricked you!" he cried. Then he carried him up to Nyame.

"The first trial is completed," Nyame said.

Anansi descended back down to Earth to catch Mmoboro, the dreadful hornet.

He shape-shifted into a boy, filled a gourd with water, then went to Mmoboro's nest. He poured some of the water in the gourd over his head. Then he dumped the rest of the water on the hornet's nest. Mmoboro came out buzzing angrily and saw Anansi holding a banana leaf over his head.

"There is a heavy storm, and your nest will be drenched," Anansi said. "Would you like to take shelter in my gourd until the rain stops?"

"Thank you, boy," said Mmoboro, hurrying into the gourd.

"I have tricked you!" Anansi cried, capping the gourd.

He then shifted into his spider form and ascended up to the sky palace and presented Mmoboro to Nyame.

"The second trial is completed," Nyame said.

Anansi descended back to Earth and dug a pit outside of the fearsome leopard Osebo's lair. He lined the bottom with a fisherman's net, lay brushwood across the opening, and covered the wood with sticks, leaves, and dirt.

Anansi then changed into a boy, stood behind the pit, and sobbed. "Help me, I am lost. Can anyone help me?"

Hearing his cries, Osebo slunk out of his den and spied what he thought was a delicious meal. "Hello, boy, what is my lucky day is your unlucky day." He then sprang at him and fell right into the pit.

"I have tricked you!" Anansi cried. He then secured the net, changed back into a spider, and ascended by his silken threads up to the sky palace.

"The third trial is completed," Nyame said. "From this day on, all the stories belong to Anansi the great trickster, and you may do with them as you wish."

Anansi took the stories and shared them with the people, who told them to their children, and to their children's children, and so on and so on. And to this day across Western Africa they are known as spider stories. They represent what the trickster deity embodied: that if you're clever you don't need to be strong. If you're wise you don't need to be big. And if you can be patient and think your way out of a problem, you'll never have to run, hide, or fight.

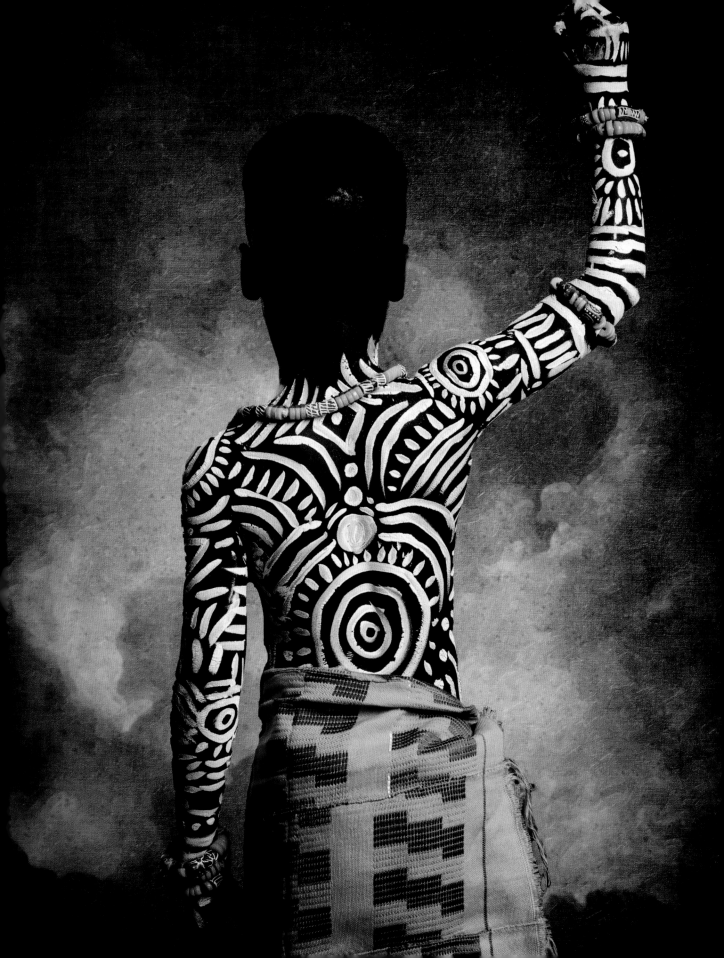

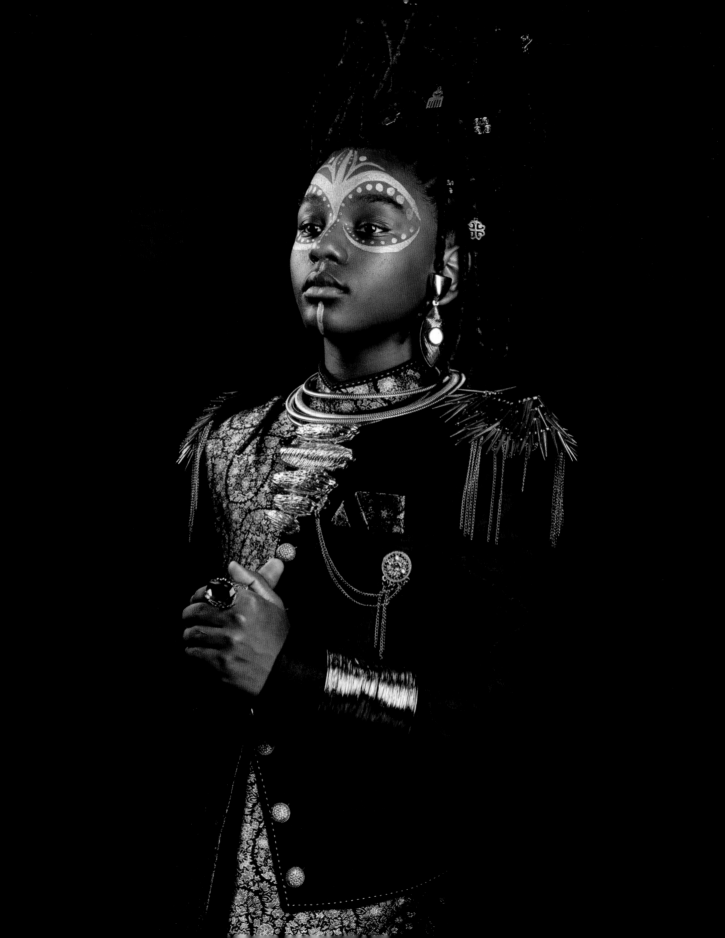

THE RING

OF THE KING

T here once was a king with a magical ring that protected him from any man who would do him harm. The ring was exquisitely made of silver and gold and topped with an emerald. It was his most prized possession and he was never without it because it made him feel quite bold.

Zafusa was a poor servant boy who worked in the castle. One day he was sent out for firewood. He carried only a small ax and shield, and a goatskin with water. As he gathered wood he heard what sounded like mewling. He cautiously followed the sound until he came to a clearing where he saw a tiger cub at the base of a great tree. He froze, then looked around for other tigers, but this cub was all alone.

A moment later, he heard rustling in the brush and saw a hyena slinking toward the cub. Zafusa yelled, then ran over, brandishing his ax at the hyena. He then grabbed the cub and scurried up the tree, settling on a branch out of reach. As he waited another hyena appeared, then another and another, until they surrounded the tree. Hyenas aren't very good at climbing, but the sun was setting and the jungle was no place to be alone at night. And certainly not up a tree surrounded by a pack of hyenas.

As they prowled below him, Zafusa heard a noise in the distance. Looking out over the jungle he spied a tiger approaching. As it got closer, he could tell from the size that it was a tigress. She sniffed the air and slunk closer to the tree. She was looking for her cub. When she entered the clearing and saw the hyenas she growled ferociously. Hyenas are powerful animals but there were not enough of them to take down an angry tigress protecting her cub. When she charged the beasts they sped off. The cat then circled the tree, sniffing, and when she looked up she saw Zafusa holding her cub. Hyenas may not be able to climb trees, but tigers certainly can.

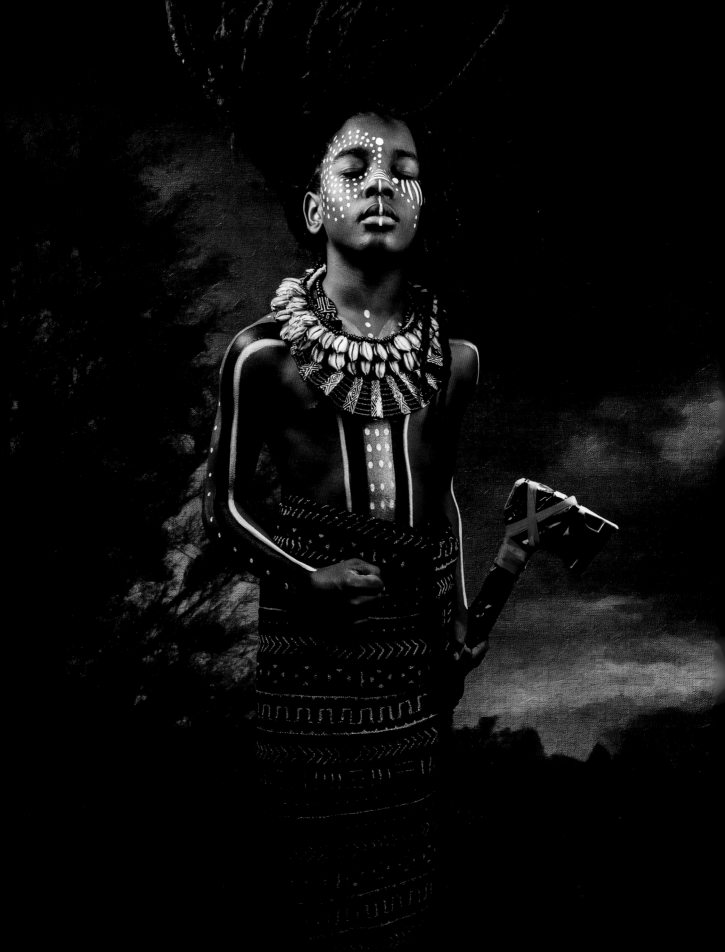

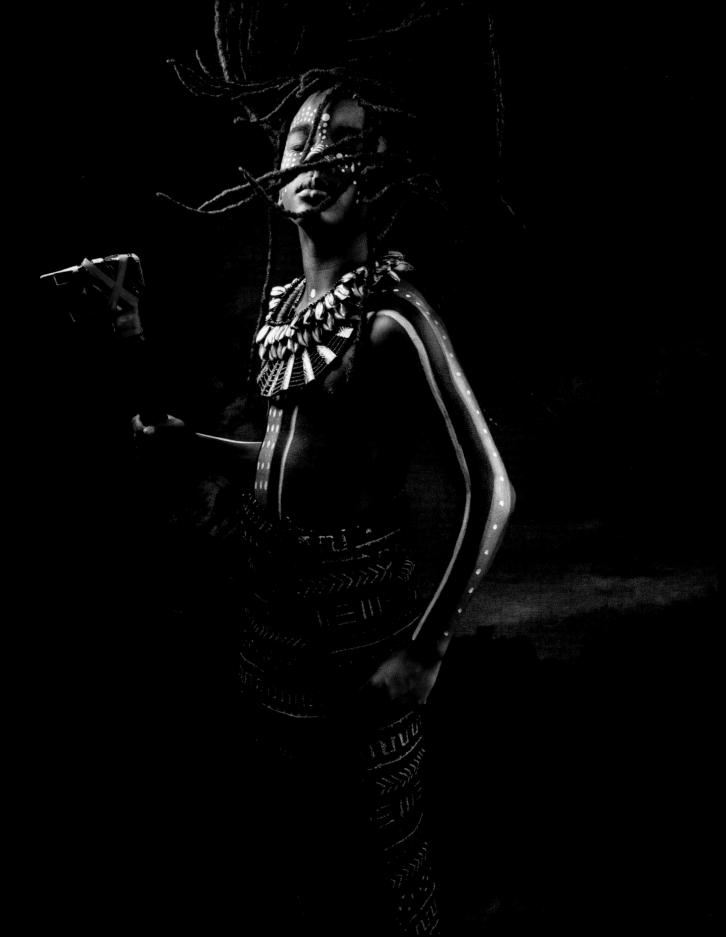

She was large for a female and had a long slash across her nose. When she placed her huge paws on the tree and started to climb, Zafusa thought fast, for he had little time. He gently lowered the cub and let it drop to a branch, then it tumbled down to the ground. The tigress jumped down and sniffed the cub, as though carefully examining it. Satisfied that it was unharmed, the beast looked up at Zafusa and their eyes met. She then picked up the cub by the scruff of its neck and trotted off. Shaken, Zafusa wasted no time as he scrambled down and hurried back to the castle.

The next day the king decided to go on a hunt. He called for Zafusa to accompany him to carry back the trophy. The king, emboldened by his ring, didn't travel with an escort of guards, for he knew he was safe from any man who might try to do him harm.

Together they rode out into the jungle, the king on his mighty steed and Zafusa on a pony trailing slightly behind. After a while they came upon a rushing river. It was too deep for their horses to wade through. When they turned to find another way to cross they heard a growl and saw a tiger approaching. It had stalked them silently and was now only a few feet away. The king startled, and before he could fit an arrow into his bow the tiger raced toward him. Then with a powerful leap it pounced on the king, knocking him off his horse.

Without a moment's thought Zafusa jumped from his pony and ran toward them yelling and waving his arms. Then something incredible happened. The cat stopped. With its massive paws still on the king it turned to Zafusa and sniffed the air. As he crept closer Zafusa saw a slash across its nose. It was the tigress whose cub he had protected. She locked eyes on Zafusa, then bowed her great head, as though in acknowledgment. She then turned and dashed off into the jungle.

Stunned and nearly speechless, the king stared at Zafusa. "Why did my ring not save me?" he finally stammered. "I am protected from any man."

"The magic of your ring held no sway over her," Zafusa answered, helping the king to his feet. "The mighty tigress is not a man, she is a beast."

"But how did you command it?" the king asked, astonished.

"I protected her cub from hyenas only a day ago. She remembered my act of kindness and returned it when I protected you."

The king looked at Zafusa in awe, then whispered, "Where magic failed, kindness prevailed."

"Yes, your highness, one act of kindness can be multiplied tenfold and come back to you in unexpected ways."

"You are brave beyond your years. For risking your life to save my own I will gift you one hundred gold coins and make you part of my royal court." The king took off the magic ring and gave it to Zafusa. "You have taught me many things, young Zafusa. I now know that magic has its limits, but kindness knows no end."

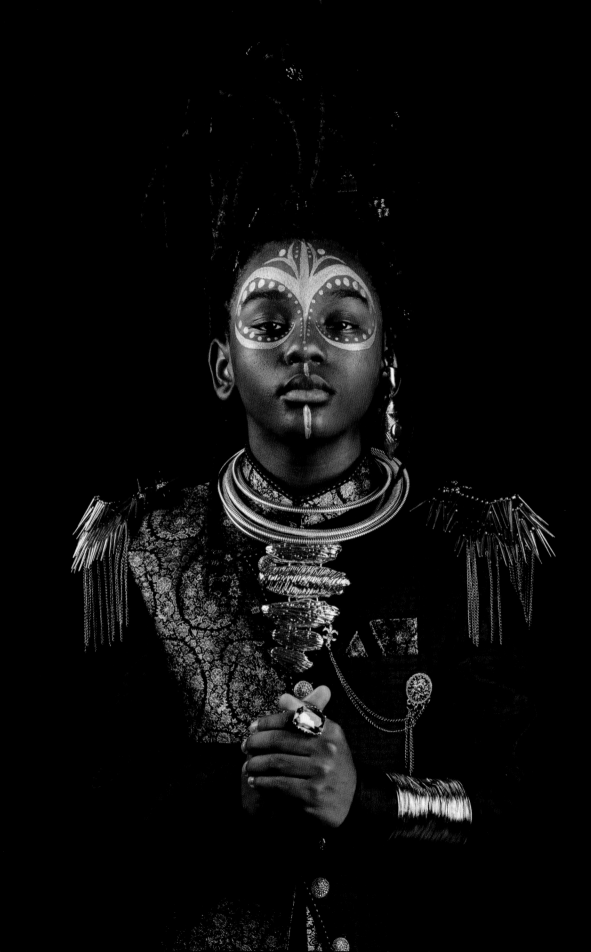

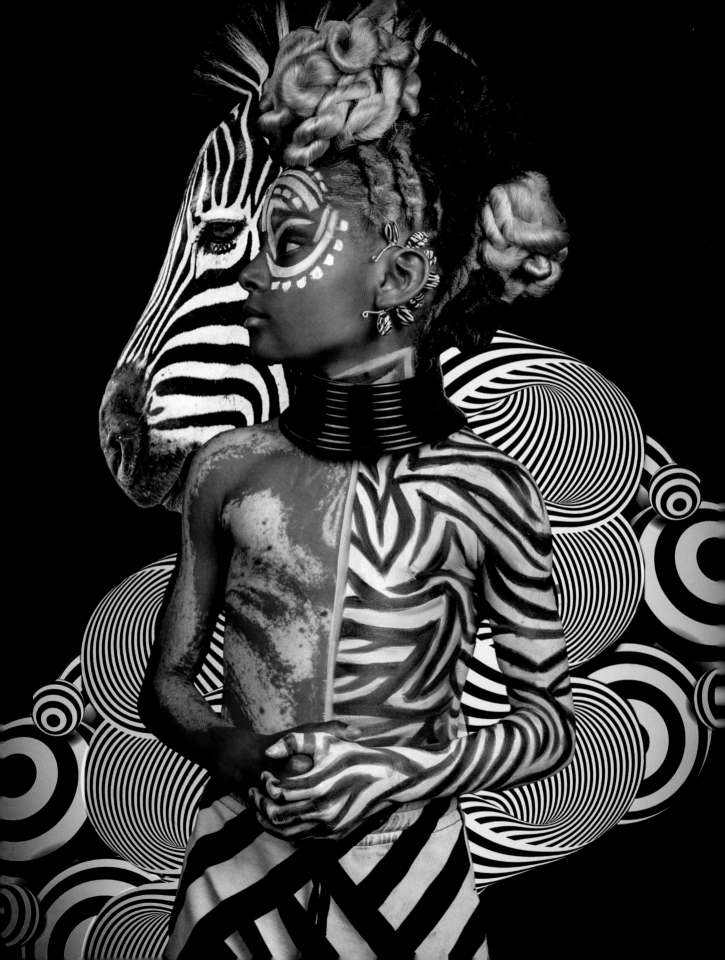

HOW THE ZEBRA GOT ITS STRIPES

A long, long time ago when animals first came to settle across Africa, it was hot and dry and there weren't many rivers, lakes, or seas. What little water there was could be found in only a few pools and ponds across the dry savannah plains. Many animals had to share the few watering holes there were, and they did, until one day an unctuous baboon got it in his head that he was the lord of one particular watering hole. He presided over it day and night, loudly proclaiming his ownership and trying to frighten away the animals who came there to drink.

One particularly hot day, a young zebra and his sister came down from the hills for a drink. This zebra was different from other zebras. At that time, zebras didn't have stripes. But he had light markings on one side of his body. As they approached the watering hole, the baboon blocked their path. Although there was plenty of water for all the animals, he did not want to share, for he was a greedy baboon.

"This is my watering hole. Go away, you are not welcome here," he said.

"This is not your watering hole, greedy baboon," the zebra replied. "You cannot own what nature has freely given. The water is for all animals, and there is plenty here to share."

The baboon would not back down and because he was bigger than the zebra he thought he had the advantage. "It is my watering hole because I say it is so. If you wish to drink you must offer something in return," he said.

The zebra and his sister were very thirsty. He thought for a moment, then said, "If I give you something, may my sister and I have a drink?"

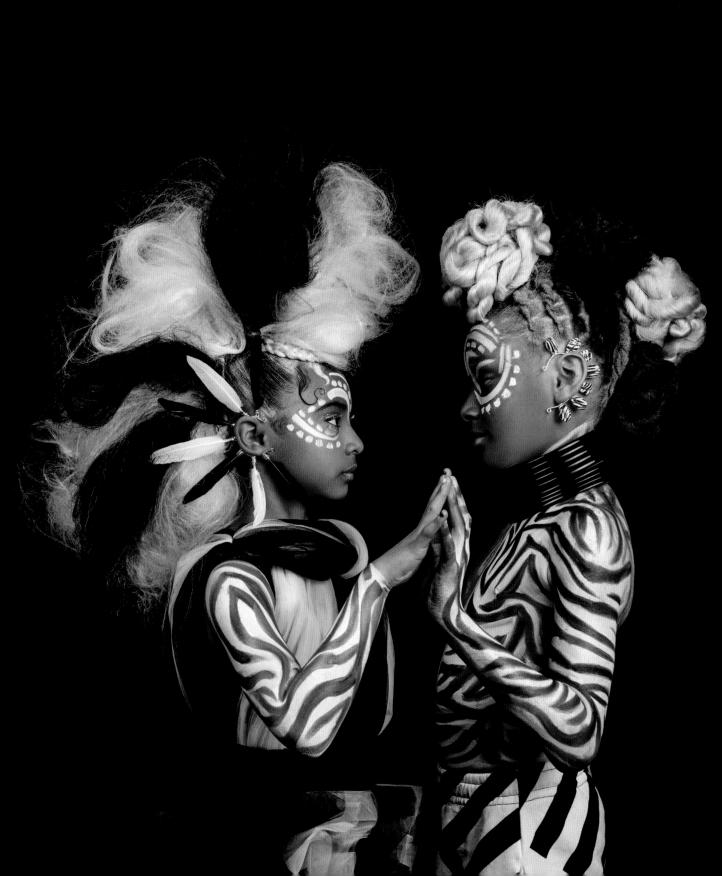

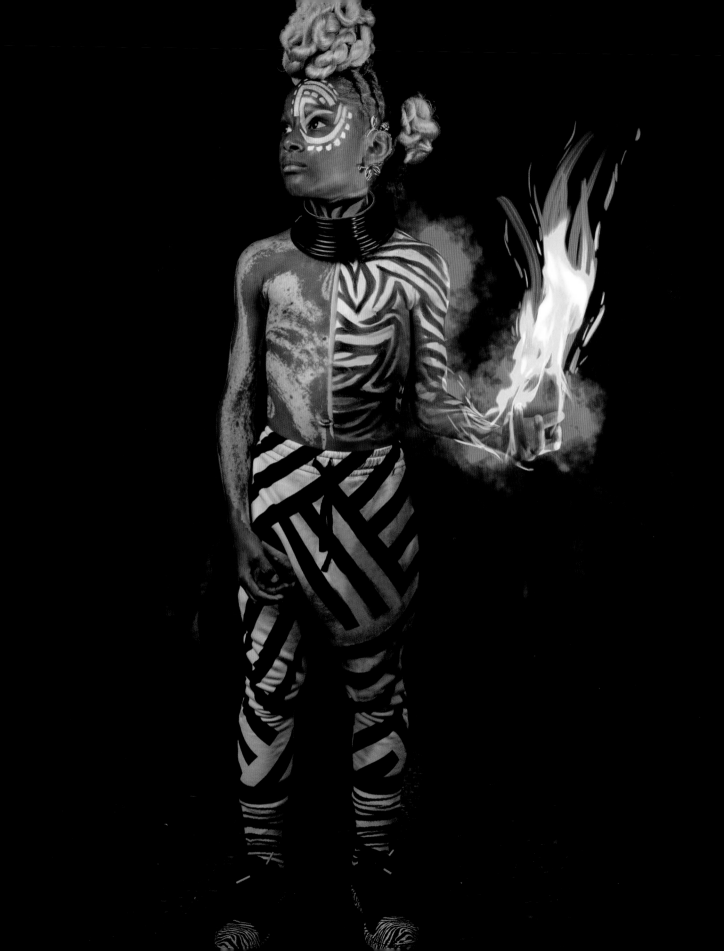

"Yes," said the baboon, "if it is something I want."

After a few moments the zebra nosed about on the ground and gathered a rock, some wood, pieces of kindling, and some dry grass. He placed the wood in a pile and placed the kindling and grasses inside the pile. He then turned to the baboon, who was watching with gleeful interest.

"I have magic that I will share with you, greedy baboon," the zebra said.

"Let's see it then," said the skeptical beast.

"If I give you this magic, do you agree to let my sister and me, and all the animals, drink from this watering hole?"

"Yes, yes, I agree," said the testy baboon, barely listening.

The zebra then raised his hoof and kicked at the stone, which threw sparks at the kindling, and it caught flame.

"Oh!" the baboon exclaimed, as he jumped back in amazement.

"This is the magic I offer to you," said the zebra.

"What is it?" asked the baboon in awe, as he crept closer.

"It's called fire and its flames makes light out of dark and heat out of cold."

"It is wondrous indeed," said the baboon, his eyes wide with greed.

He'd never seen fire before. It warmed his skin and threw a bright light. He now wanted to not only preside over the watering hole, he also wanted to be king of the flame, for it never occurred to him to share.

"I have given you this magic, and as you have agreed, now step aside and let us drink."

"No!" said the baboon as he crossed his arms and stood his ground. "You take me for a fool. Why would I give you something that is already mine?" he jeered. "The water belongs to me and I claim this fire for my own." The baboon now stood to his full height in front of the watering hole. "Begone, you two annoying zebras," he said, blocking the flame. "This lesson is all I will give you today. You are young and foolish and should not trust so freely. I am King Baboon and this watering hole and flame are mine." He then raised his arms, beat his chest, and ran at full speed toward the zebras.

The young male stood protectively in front of his sister. He then reared up and kicked the baboon back into the fire. The baboon shrieked in pain and fanned at the flames that burned his butt. Looking back, he saw he now had a perfect circle where his hair had been. Enraged, he jumped on the zebra's back, and as they fought the zebra staggered into the flame and he was scorched, leaving burned stripes on his skin. The zebra shook the baboon off his back and kicked him up into the trees where he remained. He and his sister then drank as much water as they wished.

The wounded baboon now lived above the watering hole in the trees and would shout insults at any animal who came by, but he could not stop them from drinking. Now all baboons have a bare patch on their butts because of his selfishness and are known for their greed.

The zebra was forever marked by stripes from the flames, but these new stripes matched his original markings and it looked as if they were always meant to be. He was proud of his stripes for he had won against the greedy, selfish baboon and now all the animals could come to the watering hole and drink, as it should have always been.

And this is how the zebra got its stripes.

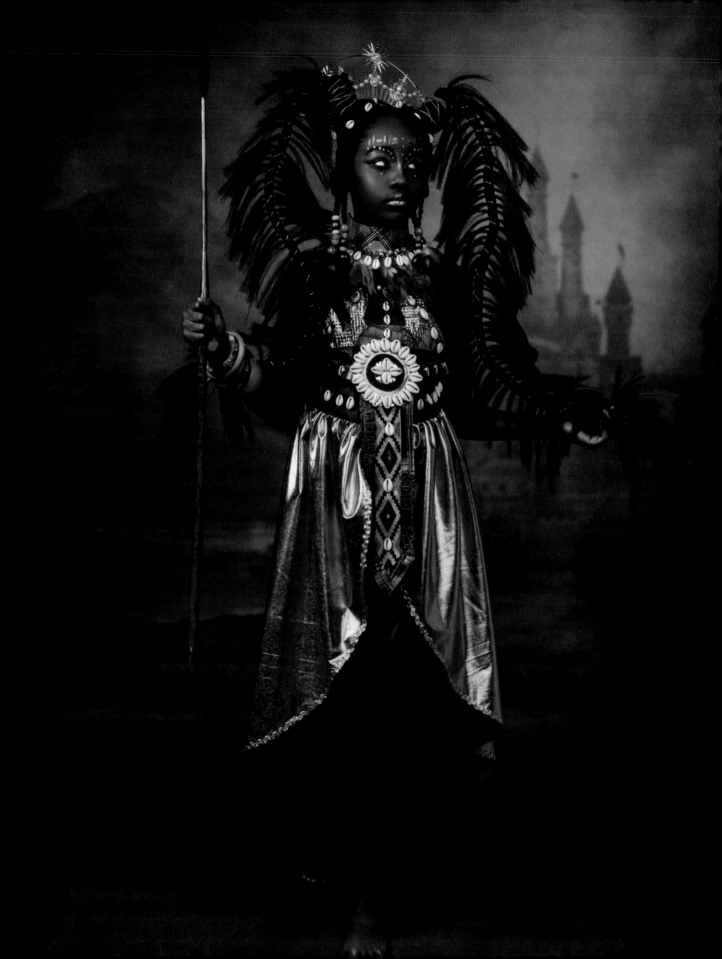

THE
LEGEND OF
PRINCESS
YENNENGA

Not all princesses want a fairy-tale life, filled with finery and jewels, their days without strife. Princess Yennenga was not content to be unassuming and demure, she wanted to walk a different path than what was laid out for her. She was tall, slim, and naturally athletic, and she longed to be more like her three brothers who lived without a care. They wrestled and ran free and wild, unencumbered by the rules and customs that she had to abide.

The only daughter of the king and queen, she was loved dearly, but she was coddled and fussed over as though she were made of glass. But oh, how she longed to roll in the grass, to jump in the river, to hike up her skirt, and walk barefoot in the dirt. But these were not things that princesses could do. They were prim and proper and bashful and shy. But Yennenga was none of these things, though she had tried.

While her younger brothers spent their days on long walks, or on the lawn wrestling and playing, she was confined to the palace. She could not join them on their adventures and be outside all day long. There could be no running, certainly no jumping, and definitely no long walks in the hot sun, for she would get dirty and sweaty and her hair would come undone. But to Yennenga that was all part of the fun. She wanted to scream like a banshee, climb trees like a monkey, and swim like a fish in the sea. She wanted to test her skills and compete against the boys, who were not half as skilled as she. But this was not to be, for she was told that girls are sweet little ladies, and only boys are bold.

So, she sat in the palace in her flowing golden gown with her tiara like a sunburst on her head. She smiled sweetly at all who came to pay their respects, but barely listened to a word that they said. For deep down inside she dreamt of adventure and fun. And why not, she could do everything her brothers could do, and then some. She was curious and clever and she knew the land like the back of her hand.

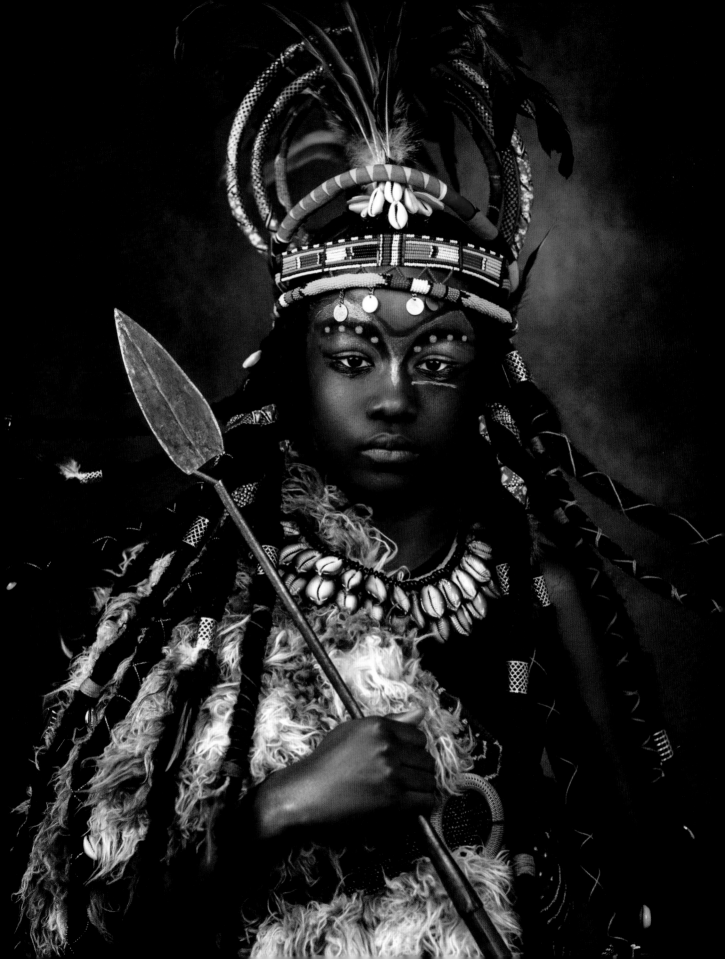

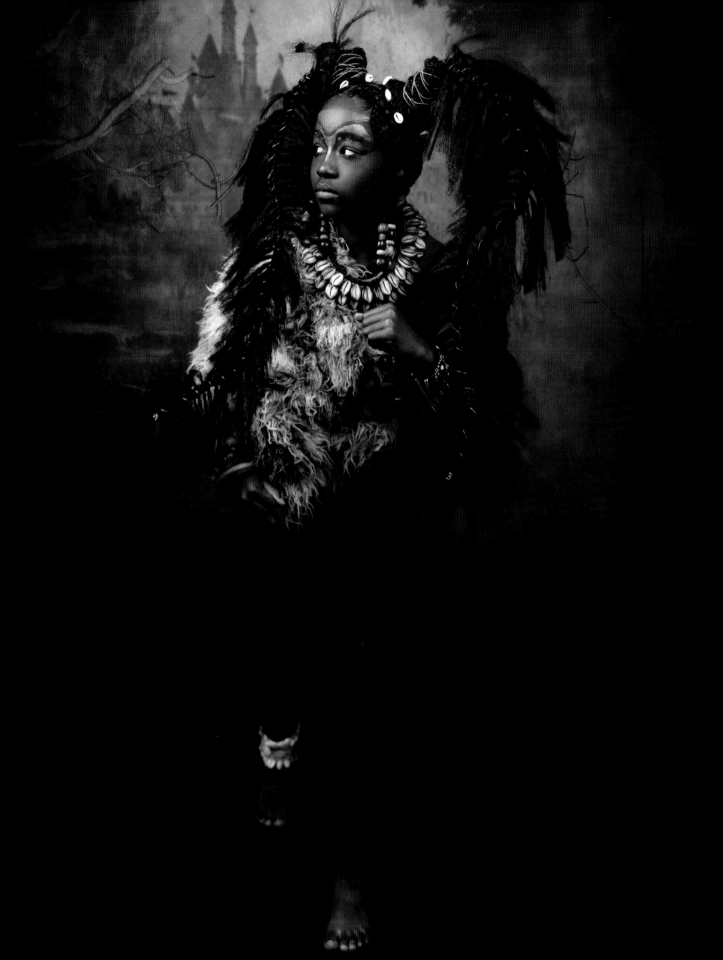

Although she was good at all the things a princess should do, she knew she could be so much more. Yes, her beauty was rare, but she had other gifts just as important to share. She was fleet of foot, smart as a fox, and her riding skills were beyond compare. She was skilled with a spear, and she knew by heart many of the stars in the sky. She could do anything a boy could do; at least they should let her try.

When she was told that girls are fragile and not strong Yennenga did not listen, and one day she proved them wrong. On that day there was a great competition on the palace lawn. Young men had come from far and wide, and only the best had been chosen, for the reward was to lead the king's army and to fight at his side.

When the horn sounded they lined up to test their mastery of the spear. They had to hit the bullseye with one throw, and it was easily one hundred feet away. One by one their spears flew, but only ten warriors had an aim that was true, and all were well known except for one who was tall and slim. His headdress was adorned with colorful plumes, and his face was painted in various hues. He wore a collar of beads in a glorious array and his magnificent presence was felt by all that day.

These warriors would advance and test their endurance in a race. They got on their mark and when the horn sounded they sprinted down the track. They were well matched and ran apace. No winner was yet decided in this competitive race. But the mystery warrior had fallen far behind. His heavy headdress was weighing him down and it seemed he was out of the race.

They pounded around the track, closing on the finish line. Then to their surprise, the mystery warrior appeared and he was quickly coming from behind. Who was this great warrior? The crowd murmured in wonder, straining their eyes to see. When he flung off his headdress, a gasp rose from the crowd, for it was not a man; he was a she. It was Princess Yennenga, her hair flying in the wind as she ran past. She wore a smile as bright as the sun, and she was gaining fast. The king and queen saw for the first time their daughter in all her glory, and she was a sight to behold. Yes, she was beautiful and charming, but she was also skilled and bold.

As they made the final turn Yennenga was almost neck and neck with the other runners, but the finish line was not far ahead. It was too close, she wouldn't win but she had surely done her best. Then something wondrous happened that spurred her on to victory instead. The crowd rose to their feet and started chanting her name. All the girls were singing and yelling because they wanted to do the same. Yennenga didn't give up, instead she gave it her all and she crossed the finish line, just in time, to win it all.

After the race was won, Yennenga claimed her reward. She became a mighty warrior princess, whose great army protected the kingdom. From that day on not only boys and men could do as they please, girls also got to choose what life to lead. They became scientists, and clerics, doctors, and royal guards, for Yennenga had broken the mold. And many followed Princess Yennenga into battle, and about them many great stories were told

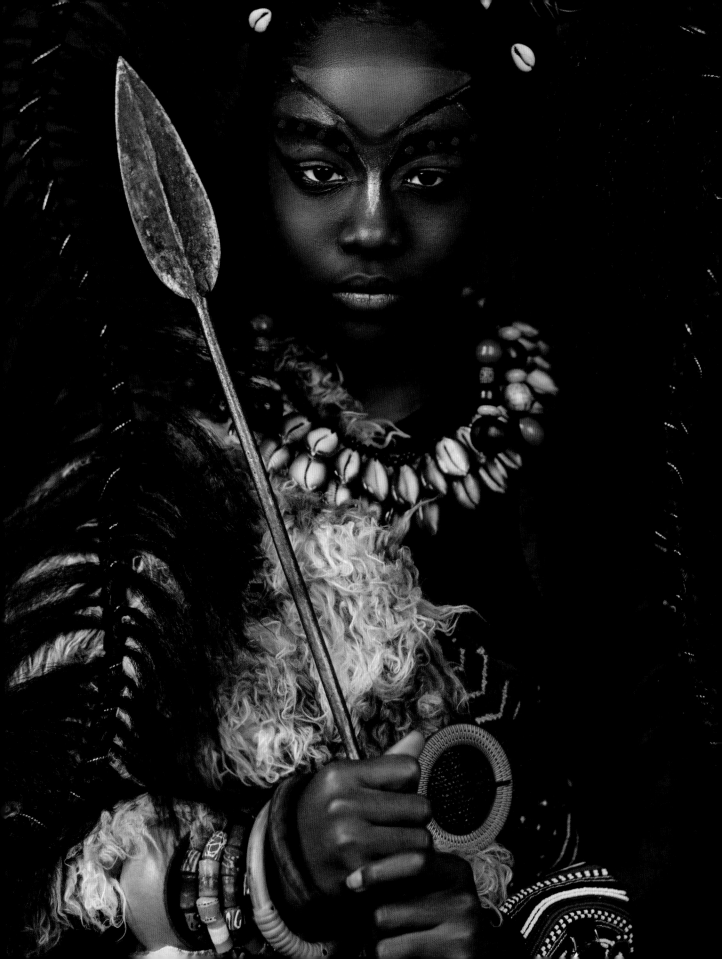

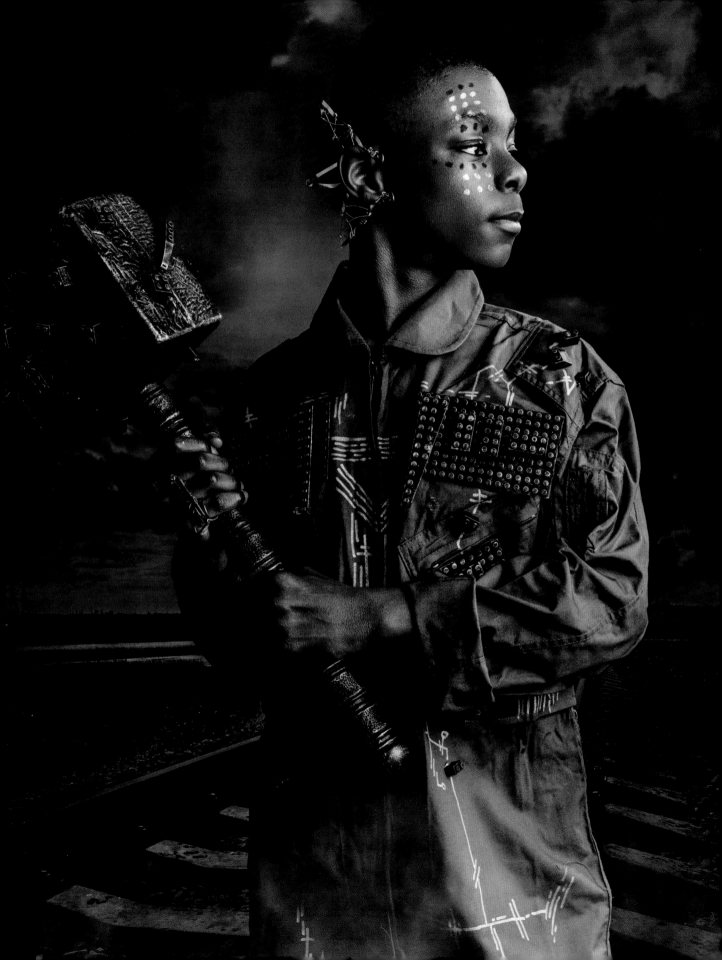

Now way, way back when the country was still figuring itself out, there lived a man named John Henry. He wasn't a regular man, he was a steel-drivin' man. But we'll get to that a little later.

His story starts when he was just a wee baby boy who came into the world to Mama and Papa Henry, sharecroppers in Virginia in the mid-1800s. They sure did love their baby boy and they showed him off to any and everyone. And a good-looking lad he was, big for his age and strong too. Within the first few months he could walk and talk. Mama and Papa Henry knew he wasn't a regular boy, they knew he was something special.

John Henry's family had to work hard to make ends meet. They toiled in the tobacco fields from sunup to sundown. And sometimes Papa Henry worked on the railroad. He'd hammer steel drills into mountains to make holes for explosives to blast openings in the rock for train tunnels.

One evening, after a long day's work, Papa Henry sat his son on his lap. John Henry looked down and saw his father's ten-pound hammer. A curious boy, he picked it up. Now this was no simple feat for a child, but John Henry was no regular child. He lifted it up as easy as could be. The long wooden handle with the large piece of steel at the end looked oddly fitting in his small hands. At that moment, Papa Henry knew it was his son's destiny to work on the railroad. "A steel-driving man you will be," he proclaimed. Then he looked down at the boy and thought, *I hope it won't be the death of you or me.*

As the years went by the demand for steel drivers grew. Now, barely in his twenties, John Henry was six feet tall, well over two hundred pounds, and stronger than any man around. Fulfilling his father's prophecy, he became a steel driver, working on the rails from sunup to sundown.

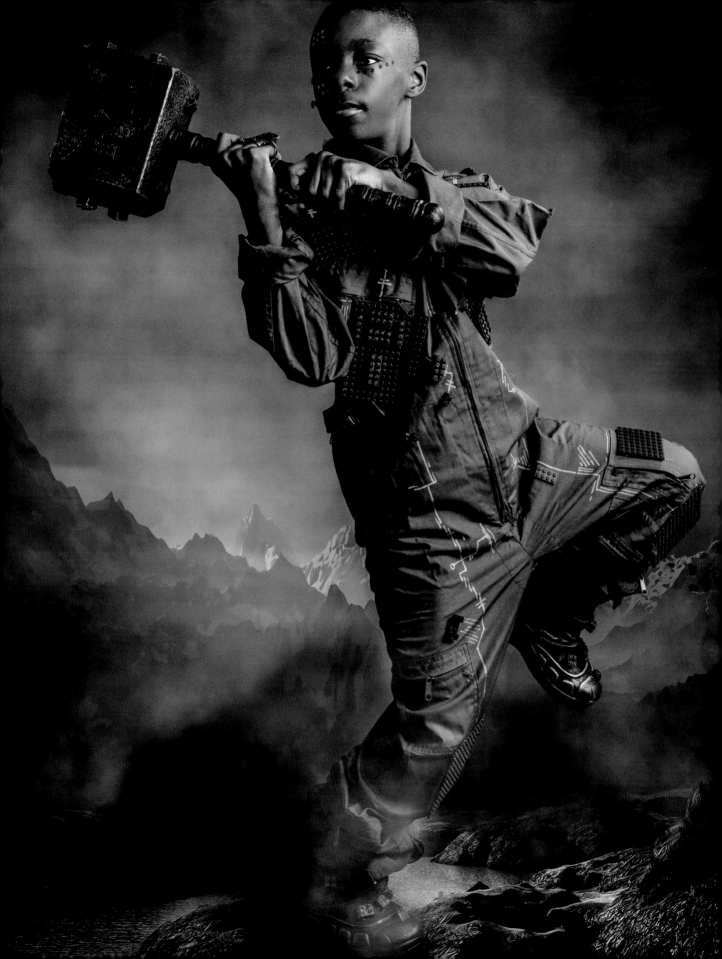

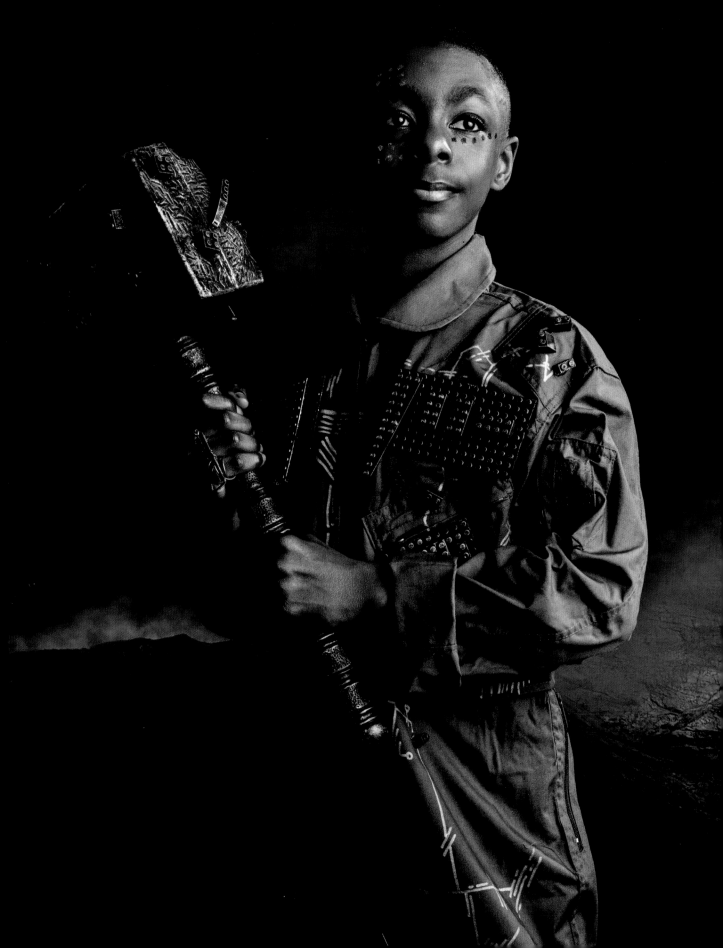

A diligent and tireless worker, he wielded a massive twelve-pound hammer. With it he drilled ten to twenty feet in a single day, easily the fastest of any man on the rails.

All day long, John Henry and the other workers labored, shoulder to shoulder, hammering their way through the rugged mountainside. While watching his men work, John Henry's captain decided that a steam engine would more quickly drill through the thick rock. The next day he bought a steam drill and stood in front of his workers. "This engine can drill faster than anything I've seen," he declared. "I dare any man to step forward and beat my machine."

The new steam drill posed a great threat to the men; the job blasting rock was their livelihood. They had families to feed, and communities to build. John Henry couldn't let a machine outdo his team.

"I may be only a common man," John Henry said, rising to the challenge. "But before I let that steam drill beat me, I'll die with my hammer in my hand."

He turned to the other workers and promised he'd do the best he could. He swore to make the mountain fall or he'd die right where he stood. John Henry then faced off against that mighty steam engine as it drilled holes in the rock, belching up great clouds of black smoke as it did. He hammered and hammered through the massive mountain's tunnel, cleaving rocks with each mighty blow. He would not let that steam drill defeat him and his men. They had families to feed, and homes to heat. They went head to head for hours in a mighty race between man and machine, the likes of which had never before been seen.

John Henry steadily hammered along with the steam drill, refusing to be outdone. Beads of sweat slid down his forehead and coated his massive arms, as the sun rose higher and higher in the sky. The men chanted a song, in rhythm to the beat of John Henry's hammer. Then one by one, inspired and heartened, they joined him. Lifting hammer to chisel on the mountainside, they worked together as one, in community and harmony until the sun crested high in the sky and then slowly, slowly began to set.

John Henry proved that a machine could not beat a team of men working together, in unity. The coordination of the workers bested that steam machine until it shuddered and ceased to move. And still John Henry swung his hammer. While his men chanted and pounded on the rails, John Henry hammered until finally he swung no more. He collapsed to the ground still clutching his hammer. The men gathered 'round, lifted him up on their shoulders, and solemnly carried him down the mountain. When he was laid to rest, John Henry became forever a part of that mountain where he'd proven that in a race between man and machine, there was no contest.

No one ever forgot that day and John Henry's sacrifice. The workers kept their jobs and filled their homes with food and warmth, and every night at dinner they'd tell the tale of how John Henry bested that steam engine. Their families grew big and strong and their children traveled far and wide. And wherever they went, they sang the ballad of John Henry, a man who became a hero and then a legend. He was a man among men, the greatest of the greats—he was John Henry, a steel-drivin' man. A hero who looked just like you and me.

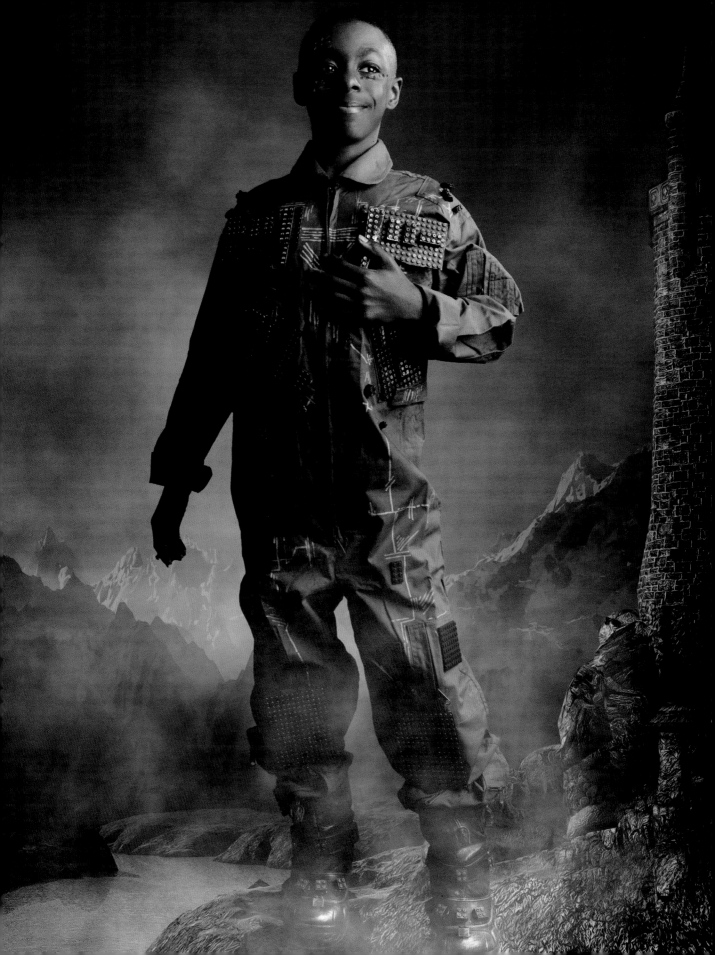

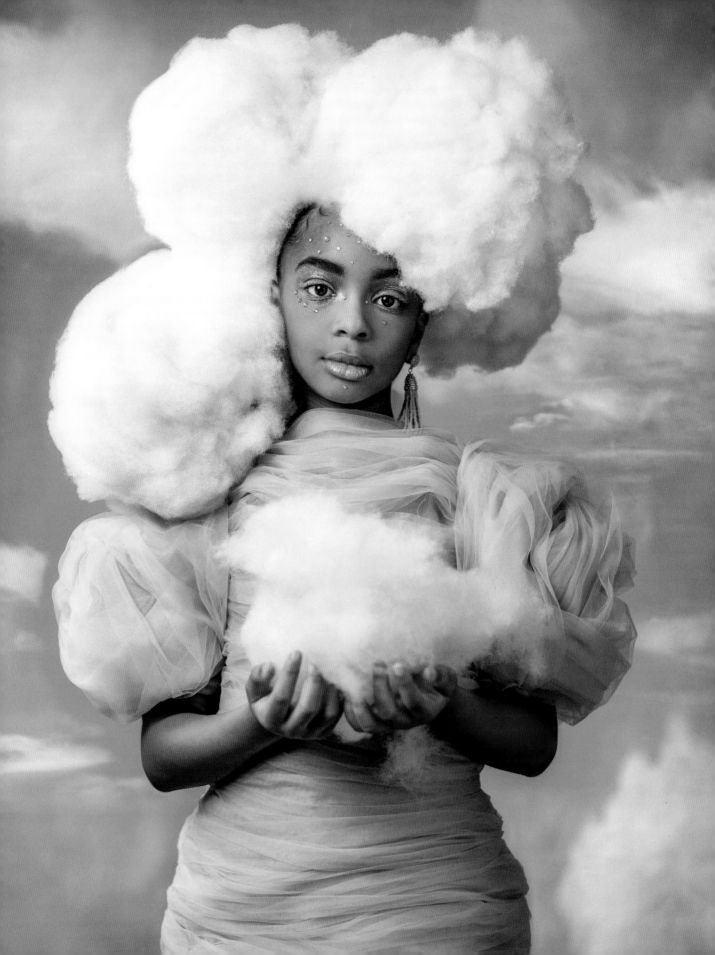

In the heavens way up high in a palace made of clouds and sky, there lived a princess, clad in a magnificent headpiece and gown, with diamonds like raindrops trailing down. She and her cloud sisters sent the rain to fill the rivers and the seas, and made sure that it wasn't too hot or too cold where it should not be.

She often gazed upon the land, enthralled by the goings-on of man. She didn't understand them, you see. They had everything they needed but always wanted more. More crops, more grain, more ox to till the land. Yet they were never thankful for what they had on hand. One day the princess decided to take a closer look, so she stepped from her heavenly perch and fell to Earth.

Far below the cloud palace there lived a lowly farmer with a small patch of land. On it he grew corn, pumpkins, and wheat. He had a chicken that laid eggs, and a cow for fresh milk. It was just him so he didn't need much. He was content with what he had, for it was enough.

Sometimes he grew lonely when it was dark and cold at night. He wanted someone to sit with in front of the fire, share a meal and stories, and laugh with delight. But alas, he had never wed. He had so little to offer that the maidens always chose someone else instead.

After a stormy night the farmer went to check on his crops and saw that several branches had been felled. As he walked closer, he noticed a bird trapped under a limb. Its feathers were a glorious hue, the likes of which he had never seen before.

"What a sight you are to behold. Don't be afraid. I know how it feels to be hungry and cold," said the farmer. "You must be from a king's menagerie. Don't worry, I'll take care of you so you can find your way home." He then lifted the heavy branch and gently freed the wounded bird.

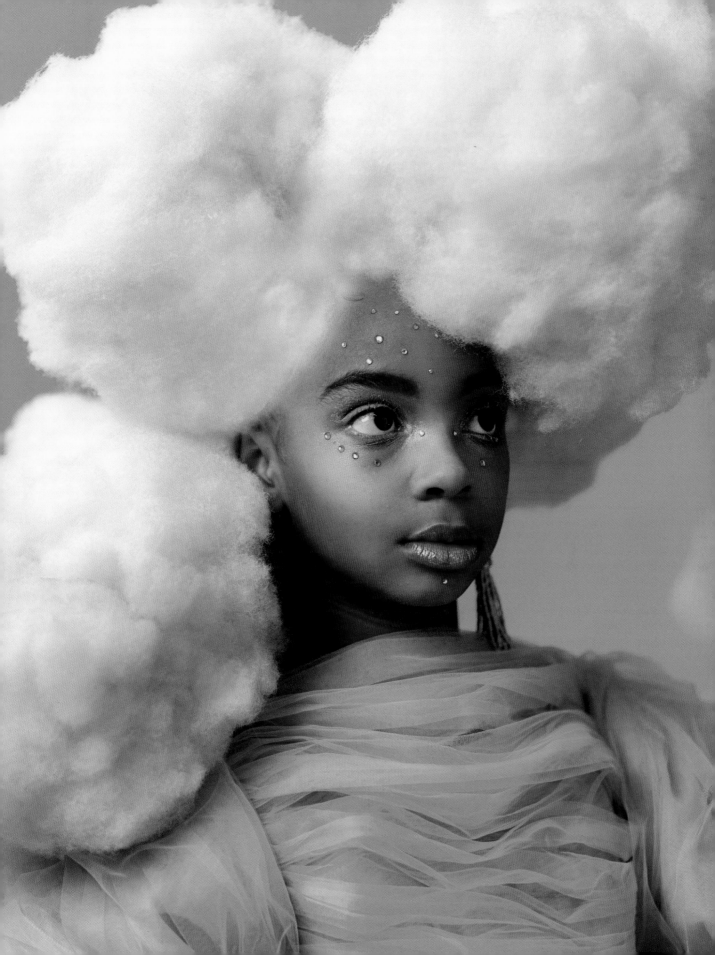

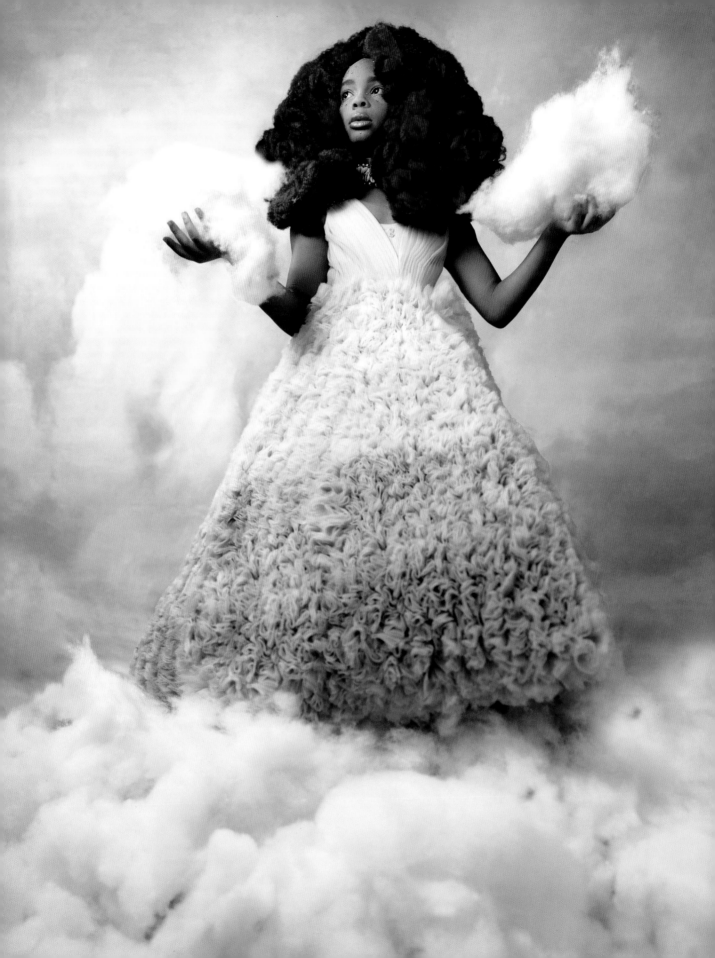

For several days and nights the farmer cared for the bird and nursed it back to health. While he ate bread and soup, he gave the bird corn kernels and pumpkin seeds. They would sit in front of his little fire and he would talk and sing to it, and at times it sang back.

One day as he picked up the bird, he accidentally plucked a feather from its wing and it transformed into a fair maiden in a magnificent gown as billowy as the clouds and as blue as the sky.

The farmer stepped back in surprise. Hardly believing his eyes, he said, "Oh my, are you bewitched?"

"No, dear farmer. I'm the cloud princess," she said. "I send the rain to water the fields you plant in a row, and I coax the sun from behind the clouds so your crops can grow."

"But how did you come to be the bird who sang with me?" the farmer asked.

"I would gaze down upon the land and wonder how it felt to have a friend, but you have shown me so much more." She placed her hand on his and the farmer felt a rush of love. "Man can be so selfish and cruel but not all; there are a few whose generosity and kindness are quite rare. And that, my dear farmer, is you."

To have this fine maiden look upon him with such warmth filled his heart, and he wished it would never end. He knew though that it would, for she belonged in the heavens, but he was glad to have made such a friend.

"Because of your kindness I will grant you one wish," she said. "When I was hurt you healed me and when I was tired you gave me a place to rest, and for this you deserve nothing less."

"You'll grant me a wish?" repeated the farmer in disbelief.

"Yes. So, think carefully what you wish for with all your heart. Then take this feather and close your eyes and when you open them it will be yours."

The farmer thought but for a moment. He then took the feather, closed his eyes, and made a wish. He opened them and looked down at himself, but he was just the same. His hands, his face, his clothes, his simple home, nothing had changed! He turned to the princess in despair. "Dear lady, my wish was not granted."

"Oh, no? Tell me, what did you wish for?" she asked.

"I want to be worthy of your love, princess," he answered, eyes downcast. "I wished to be handsome and brave, royal and regal. I wished to be a prince, so I would be worthy of you, and you would love me the way I love you." He looked up at her sadly. "But nothing has changed. I am still the same."

The princess smiled. "You are kind and gentle, you are loyal and true. You give more than you take and you help those in need. Your wish has been granted indeed." The princess took his hands in hers. "You made me strong when I was weak. You made me warm when I was cold. You fed and nurtured me, wanting nothing in return. I could love you no more than I already do, you see. You've always been a prince to me."

Now through her eyes the lowly farmer saw himself as he'd always been, a prince among men, stalwart and true. And she loved him just as he was; his wish had indeed come true.

And they lived together in his small home filled with love, as happy as can be. And they wished for nothing more, for they had all that they could need.

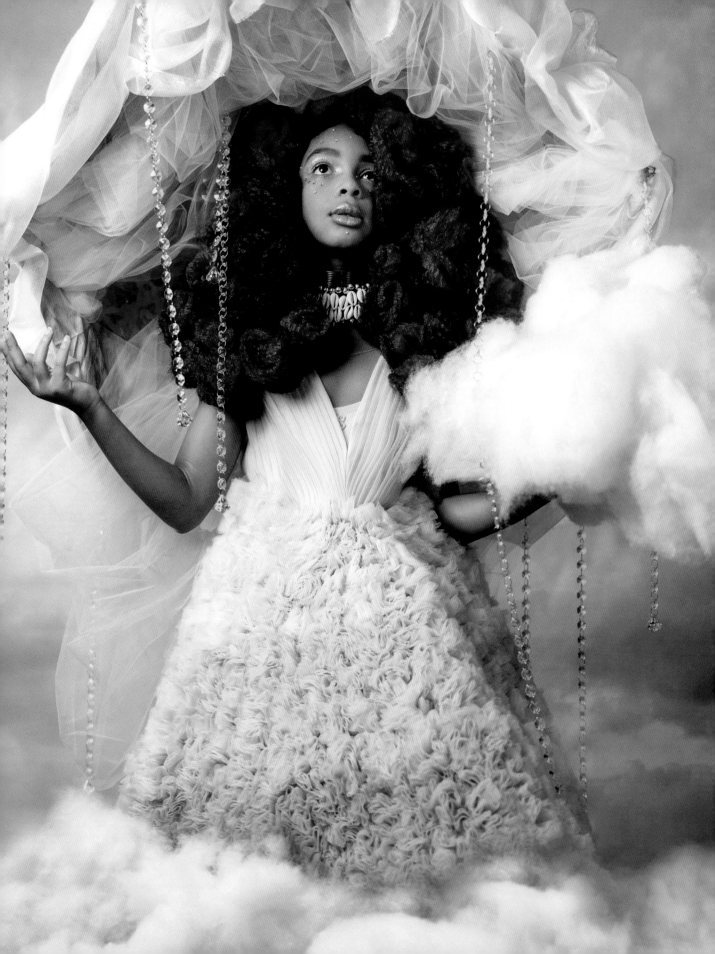

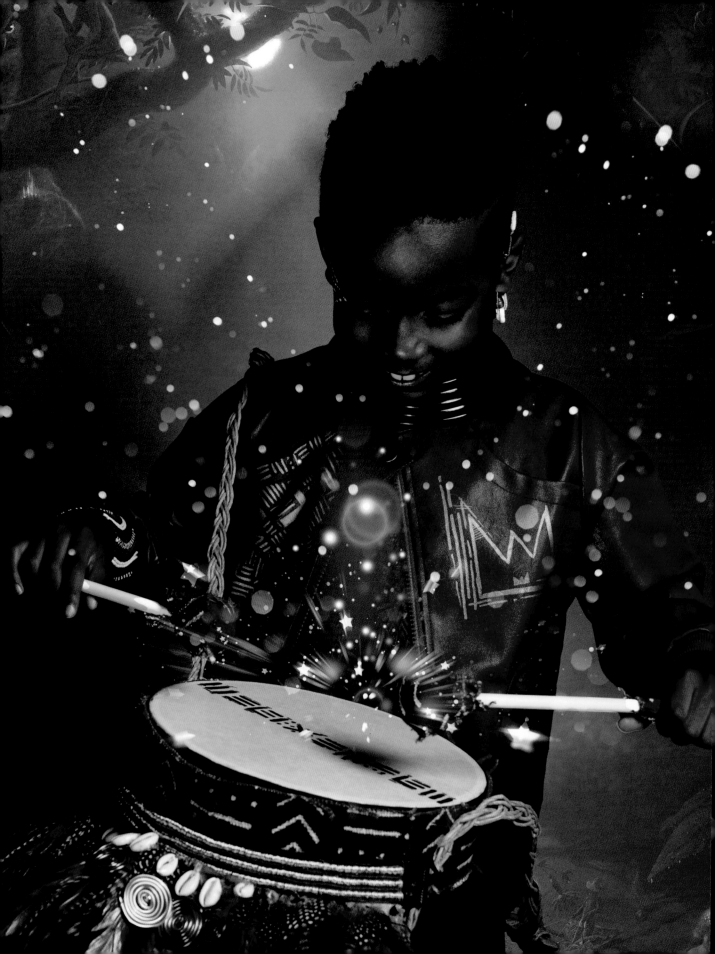

THE KING'S
MAGIC DRUM

There once was a king with a magic drum. When you played the drum, it gave you whatever you wished. But the drum could only be given, not taken from its owner. And until it was returned to its rightful owner the person who had taken it would have bad luck whenever they made a wish.

Efram was a good king, kind and fair. He was a peaceful man and whenever there was a threat of war he would beat his drum and a magnificent feast would appear. He would then invite his enemies together in the great banquet hall and they would enjoy a wonderful meal. Afterward they'd talk instead of fighting because their bellies were full. They always came to an agreement and left with plenty of food for their villages. In this way King Efram avoided wars and his people lived happily in his kingdom for many years.

The king had a son, only one, named Torto. He doted on him from the day he was born. Torto never knew lack, strife, or scarcity. He never had to work and anything he wanted was given to him. Because of this he was quite spoiled and since he could have anything he wanted, nothing was ever good enough.

One day Torto snuck into his father's chambers. As he watched, the king beat his drum and a great feast appeared. King Efram then beat the drum again and a golden goblet of wine and a velvet cloak appeared. The king took a sip of wine, slipped on his cloak, slid the drum under his bed, and left the room.

Torto was envious. He wanted the magic drum for himself, and since he'd never been denied anything he didn't see why he shouldn't have it. And today was his birthday, and his father hadn't given him any gifts—not one! Torto decided to take the drum. He wanted it, so he decided to take it. Of course, Torto could have simply asked his father for the drum. King Efram wouldn't have denied it to him, but Torto was spoiled and envious and it would be his undoing.

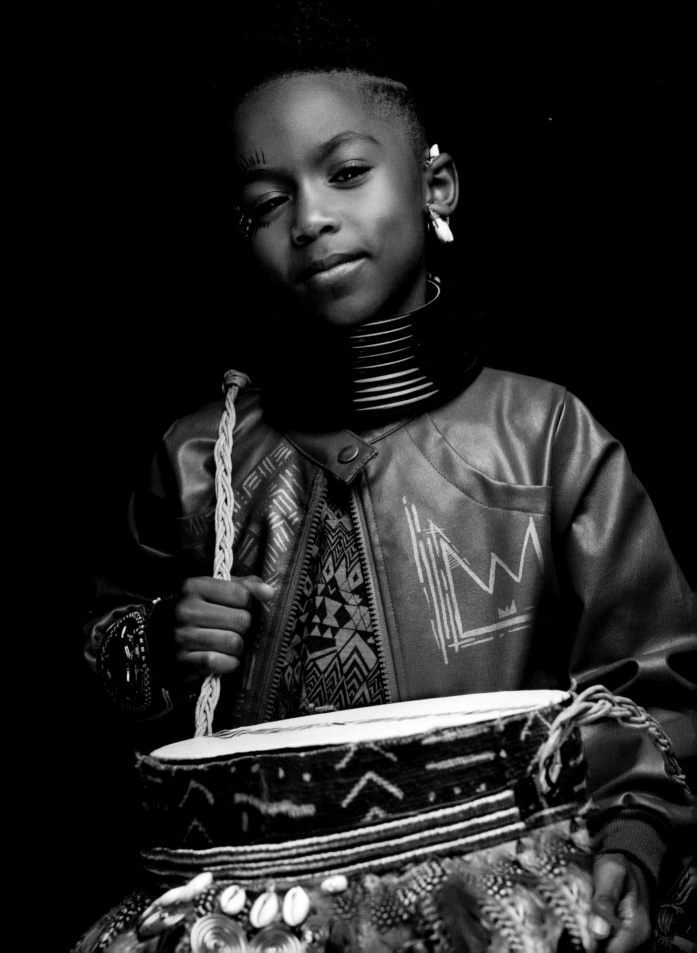

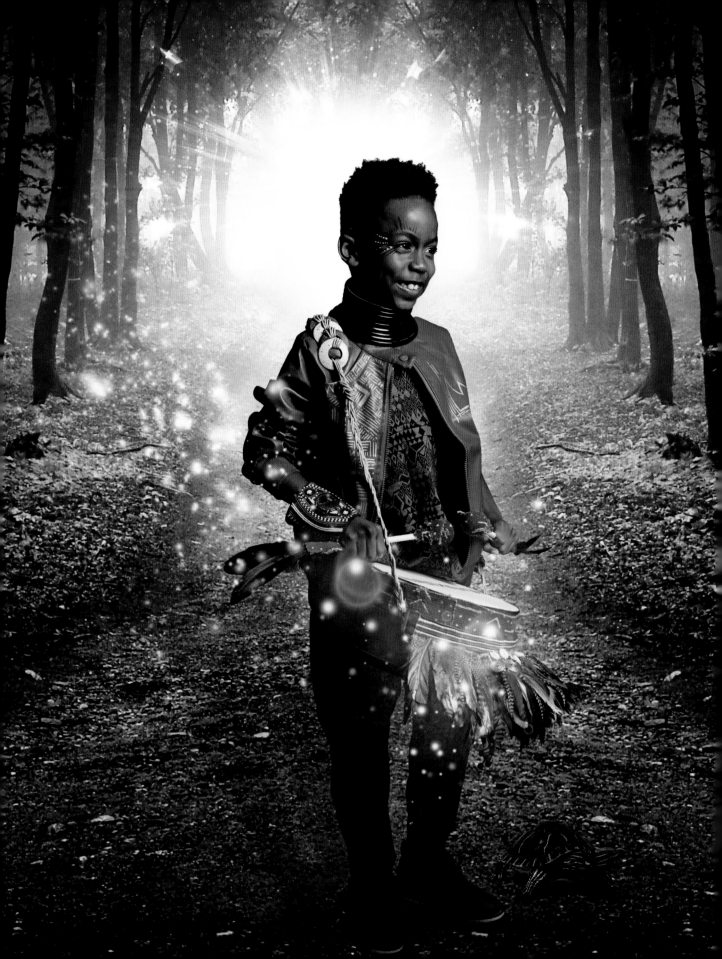

Torto grabbed the drum and hurried out of the castle and into the woods where no one would hear him. He stood in front of the river and as he beat the drum he said, "I'm a drummer boy, I'm a drummer boy." And in the blink of an eye, Torto became a little drummer boy.

This isn't so hard at all, Torto thought. *My father isn't so special, I can make magic just like him.* He marched around happily beating his drum. But he kept getting younger and younger until he was almost a child again. While he could still speak he said, "Oh no, I don't want to be a baby, make me older." And in the blink of an eye, Torto began to age. He got older and older until he was older than his father.

When he saw his hands getting wrinkly, Torto ran to the river and looked at his reflection. "I'm an old man. This cannot be. I don't want to be old." At that moment Torto saw a tortoise in the river. "Make me a tortoise, make me a tortoise!" he shouted, beating the drum. And once again, Torto changed and this time he became a tortoise. But alas, he could not beat the drum to make another wish. He could only crawl slowly around the drum. Not long after he heard footsteps approaching. It was his father out for his daily walk, with one of his guards. As he approached the river, where he liked to sit and reflect, he saw his drum. *What is my magic drum doing here?* he wondered. He then saw a tortoise beside the drum.

"Oh, what a fine-looking tortoise," he said to his guard. "I bet Torto would like to have it as a pet. It's his birthday today. I was going to give him the drum but he might like them both." Because King Efram was a generous and giving man, he'd also planned to make a splendid feast for Torto that evening for his birthday.

King Efram scooped up his drum and the tortoise and headed back to the castle. He hurried to Torto's room to give him his gifts but he wasn't there. *That's strange,* the king thought. He placed the tortoise on the bed and beat his drum. As he did the tortoise turned back into Torto, for the magic drum was now with its rightful owner.

"Torto, did you take my magic drum and make a wish?" the king asked.

"Yes, Father, I did," he answered. "I wanted it and today is my birthday and you hadn't given me any gifts so I took it. I wanted it for myself and why shouldn't I have it?" He pouted.

"Son, if you'd asked I would have happily given it to you," the king replied. "The magic drum was going to be your birthday gift, but your envy and greed have shown me that you're not yet ready for something as powerful and special as this." King Efram then walked to the door. "If you are to be king you must lead by example, and envy and greed are not traits to sow among your people. You have a lot to learn, son. Today there will be no gifts or celebration. Instead, you will think about how to be a better man or you will never be king, for that is also a very powerful and special gift." And with that King Efram left Torto alone.

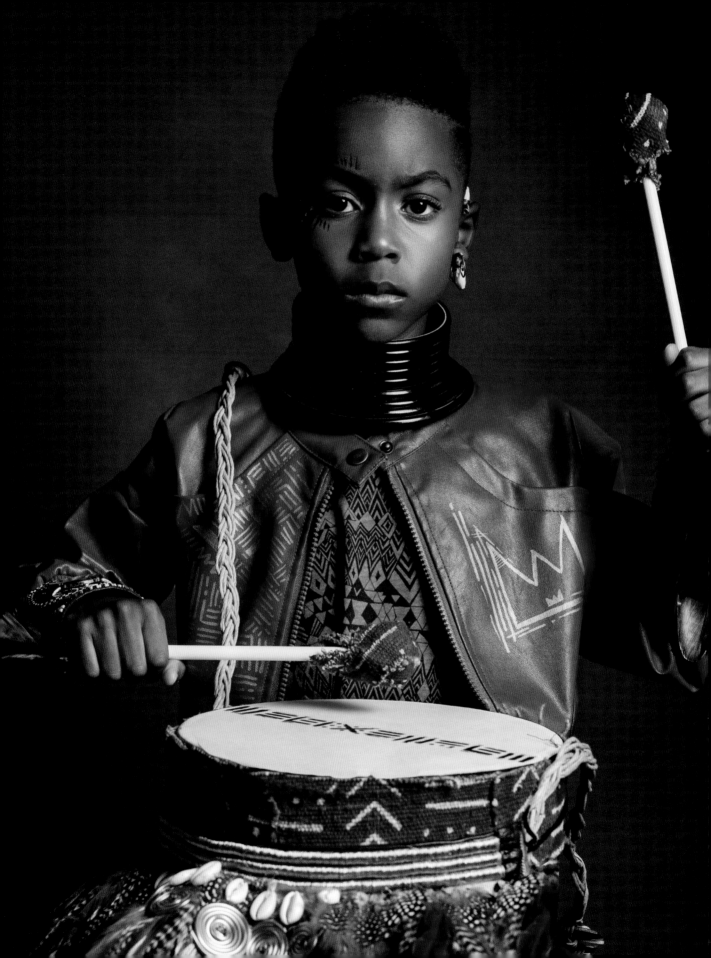

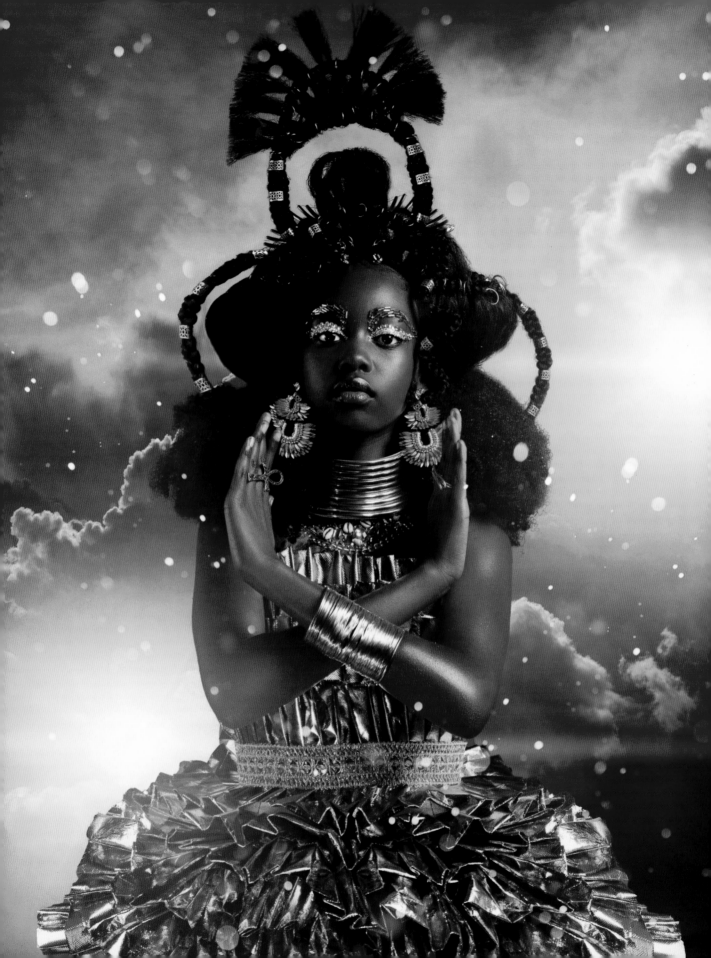

Orphaned at a young age, Aku had known hardship all her life. For years her people had been devastated by war. Having escaped, they traveled for many miles and settled in a peaceful part of the land, but they still struggled to survive. Water was not plentiful and their crops did not grow because the sun stayed hidden behind the clouds. It was as if the sun god, saddened by the strife he saw on Earth, had retreated to his kingdom in the heavens.

The terrible war her people had fled filled them with grief. They had suffered greatly, lost loved ones, their homes, and many of the memories of their land. They had hoped to make new memories here, but the sun had not shone for almost a year, and without it their crops could not grow. They missed its bright rays and warmth almost as much as they missed their homeland. Despite the struggles Aku had faced she refused to be diminished by them. She would start the day with a smile and although she had little, she offered whatever she could to those in need. She had the same beautiful ebony skin and dark eyes of her people, but her optimism in the face of adversity stood her apart and made her a beacon.

Her radiance was so bright that even the great sun god noticed. He wondered what shone so brightly as to draw even his eye. Curious, he went down to the village. He covered his glittering golden robes with a simple tunic and hood. He then hobbled down the road in the guise of an old man. Stopping in the small square, he sat and observed those gathered there. Not long after he saw a young girl, tall and thin, with eyes aglow. Wherever she went a brilliance seemed to follow. Though her sandals were worn and her clothes threadbare she had a magnificence that made you stop and stare. He watched her greet each villager with a smile and kind words of inspiration. It was clear that she was the light during these dark days that gave them hope for a brighter future.

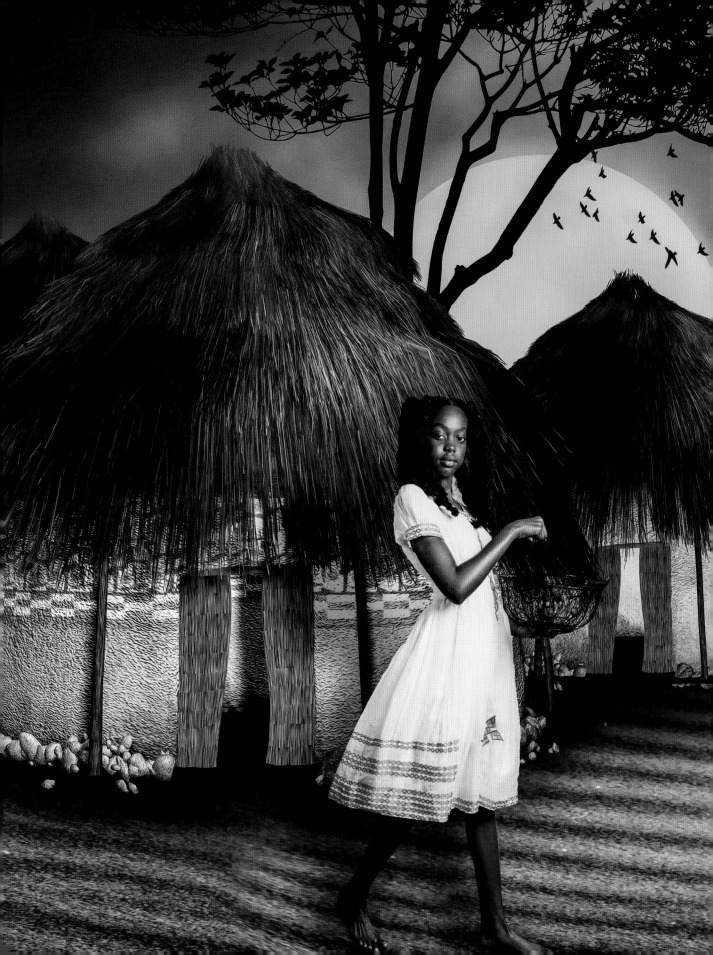

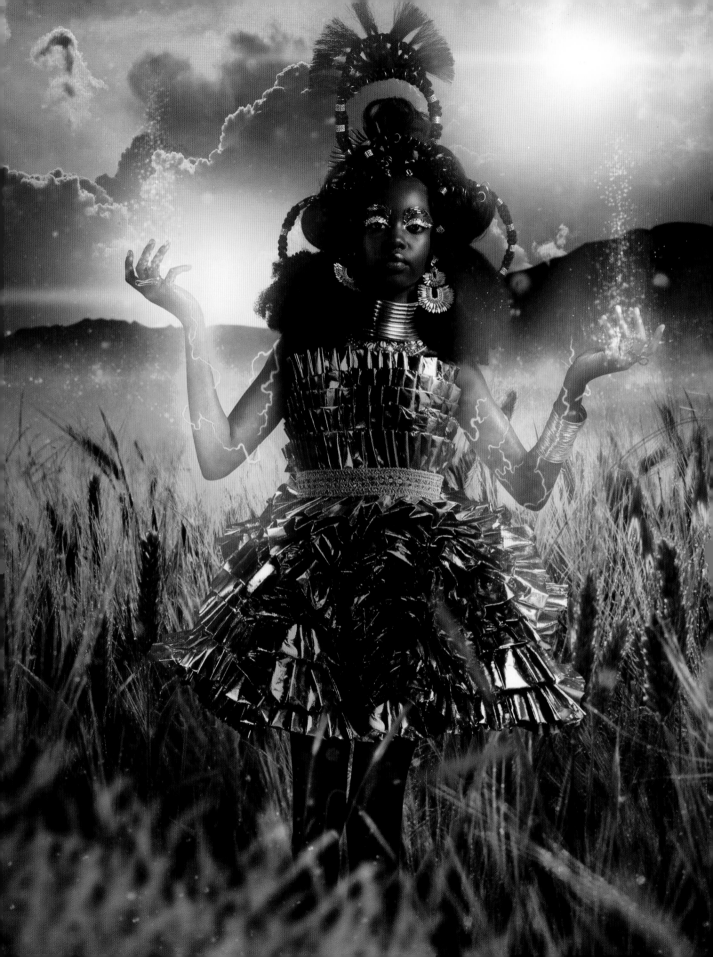

The sun god was mesmerized by her glow. She reignited in him the spark for humanity that he had lost long ago. That was when she saw him sitting alone. She hurried over. "You must be thirsty, traveler. Take some water, and a bit of bread. Do you need anything, perhaps a place to rest your weary head?"

"Thank you," said the sun god, taking a sip of water. "You have so little, why would you share it with a stranger?"

"There are no strangers among us, sir. We are all one," she said, opening her arms wide. "Indeed, I do not have much, and great sorrow I have known. But when I lost my family the villagers raised me as their own."

"What is your name, child?"

"Aku," she answered. "Have you come from afar?"

"Very far indeed." He laughed. He then stood up to his full height, and when he threw off his tunic, his golden glow dazzled everyone in sight. The villagers stared in awe and gathered round. For they knew who it was. He said, "Listen, villagers, for I now decree: You have struggled for so long and now this gift I give to thee. I will send the clouds to make rain and fill your rivers. I will make sure the sun shines so your crops will grow." As he spoke the clouds drew back from the sun and it shone brightly on the village

"Great sun god," said Aku. "Thank you for making the sun shine once again."

He turned to Aku. "Strength like yours is quite rare. You never gave up even in the face of overwhelming despair. You refused to be defined by your past struggles. Instead you reminded your people of their resilience and fortitude. You gave them hope and your light of optimism gave me a reason to look again to man for promise and inspiration." He then gently touched her hand. "It was your brilliance that drew my eye and guided me. It was not I who made the sun shine, Aku, it was you." He waved his hand. "Your light warmed me and now those in need will be warmed by you." Aku was then engulfed in a golden glow and when she emerged she was transformed. Her dress now glittered like the rays of the sun and on her head she wore a crown of sunlight. "From this day on, you are Aku the Sun Maker. You will shine down from the heavens and show that no one is ever too young or too humble to create a spark. And, that the smallest glimmer of hope can banish the darkness in our heart."

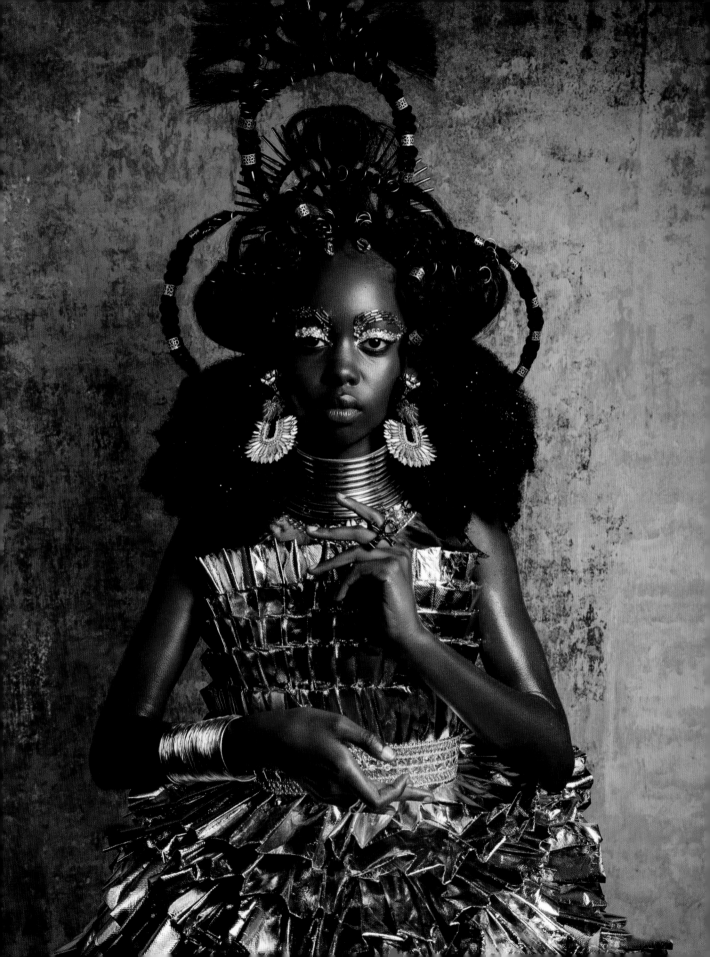

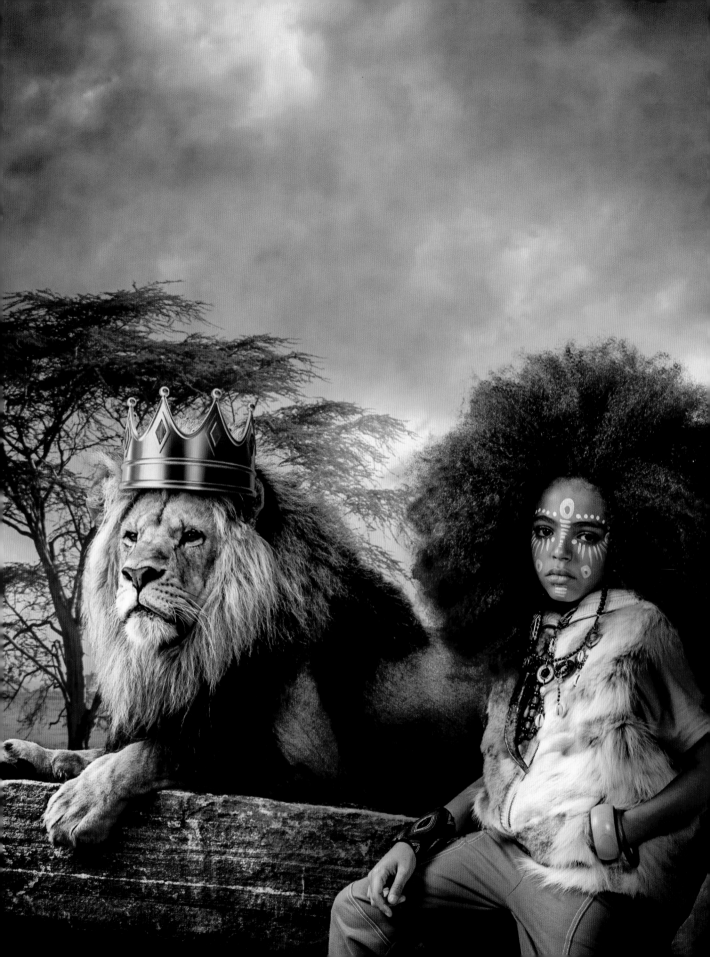

The lion is the king of the jungle and he takes great pride in how he governs the animals in his kingdom. One day he stood on a massive rock and surveyed the vast fields, forests, deserts, and plains and all the animals who lived there and he decided that he would bestow on each creature a gift to show how special it was. This gift would not only protect them, but would also contribute to the greater good of the animal kingdom.

The king then let out a mighty roar and sent a message to all the creatures far and wide that they were to come to the clearing in the middle of the jungle where he sat on his great throne, for he had an important announcement.

King Lion then sat regally and watched as the animals arrived and crowded around. He looked at each carefully as he decided what would be their perfect gift. *What can I give to the beasts in my domain that would help them?* he wondered. As he did, he considered the creatures themselves.

The monkeys lived high in the trees, and the fish swam in the oceans, lakes, and streams. The bats slept all day and woke at night, while the owl gave sage counsel and advice. The coyote and fox must outsmart the great cats that would make of them a tasty snack. The snake has to slither from rock to rock all day, while the spider weaves enticing webs to lure and trap its prey. He smiled at the ferocious bear sweetly holding its little cub tight. And the graceful gazelle and the peaceful lamb were such a lovely sight. The glorious flash of the lean and agile cheetah entering the clearing jolted all the other animals to attention. As King Lion delighted in the brilliant plumage of the birds sitting on the branches overhead, he decided on a way to make us look up and notice them, so they could grace our day. He then saw two doves sitting wing to wing and his heart was moved by their loving embrace. The lowly caterpillar seemed quite ordinary, so for it, he had something very special to show that even the smallest of us can be quite extraordinary.

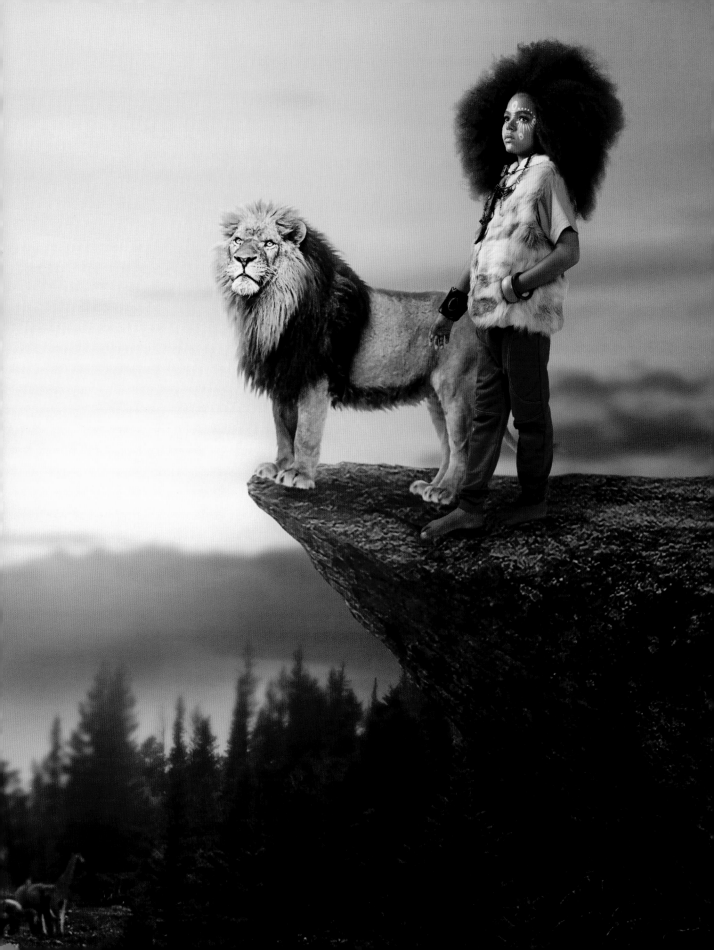

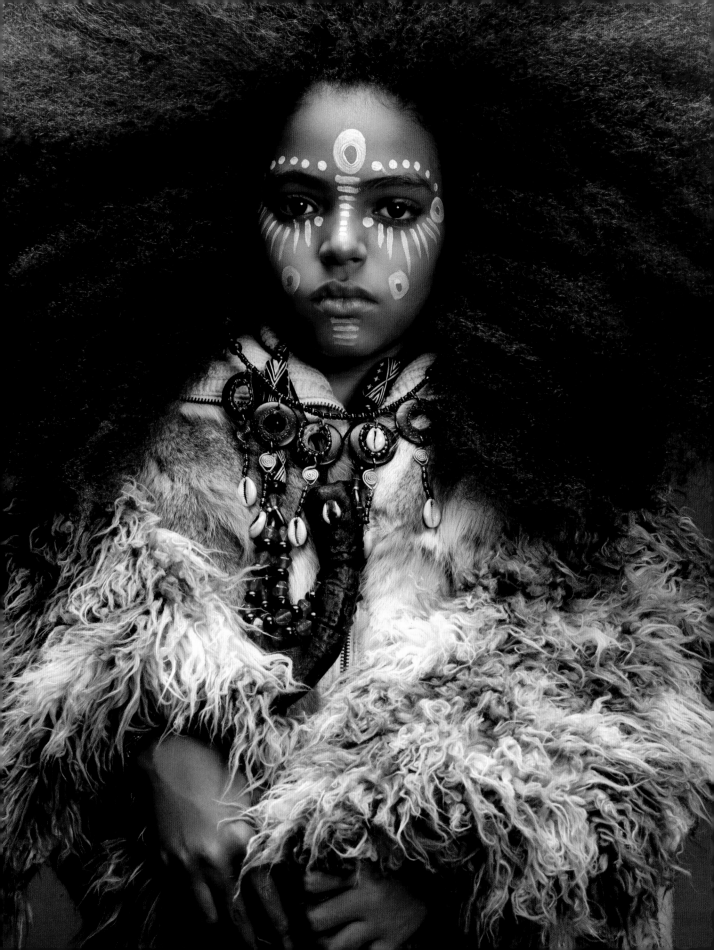

After a few moments King Lion roared and all the creatures came to attention.

"Now listen closely, for I will grant you each a gift. It will not only help you but also our family, which is the animal kingdom."

King Lion then granted his gifts. He made the monkeys agile, to swing in the trees, and the fish swift swimmers in the rivers and seas. For their nightly pursuits, he gave bats and owls the ability to see in the dark. He made the coyote cunning, and the fox clever to outsmart those who would do them harm. The lovely gazelle delights us with its grace, while the sweet lamb calms and comforts with one embrace. The big bear he made strong and fierce but also gently protective of its cubs. He made the cheetah fast as lightning, but also a very good climber to keep the other animals on their toes. He made the slithering snake silent and watchful, and the spider spinning its web he made industrious and patient. When the caterpillar becomes a magnificent butterfly it shows us that we are more than we may seem and that we can always change and grow. He made the peaceful dove the emblem of love, to comfort us during the darkest of times. He then gave the birds the gift of song, which they sing to us all day long.

And this is how King Lion's gifts came to be. Not only for the animals, but also for you and me. For we all have something very special and rare, something wonderful that we should always share. From the biggest to the smallest, from the oldest to the youngest; you may be fast or strong, or sing like the birds in the trees, or you may be smart or graceful, caring or brave, patient or wise, or loyal and kind in word and deed.

These gifts can help each other and our family, which is the human race. And now I pose this question to you and please be true: With your great gift what will you do to make the world a better place?

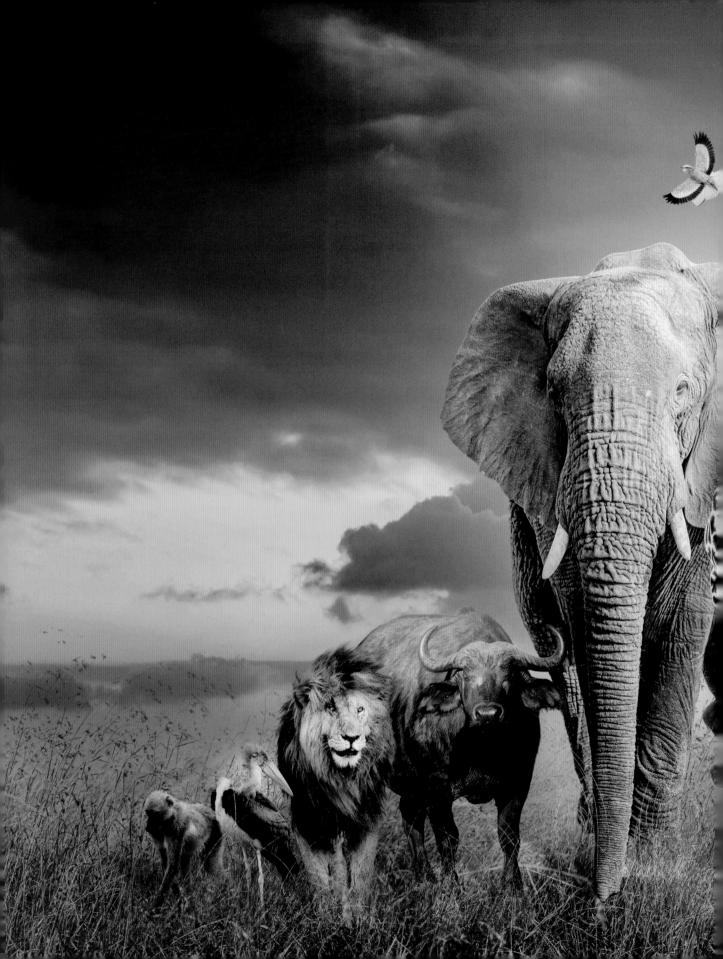

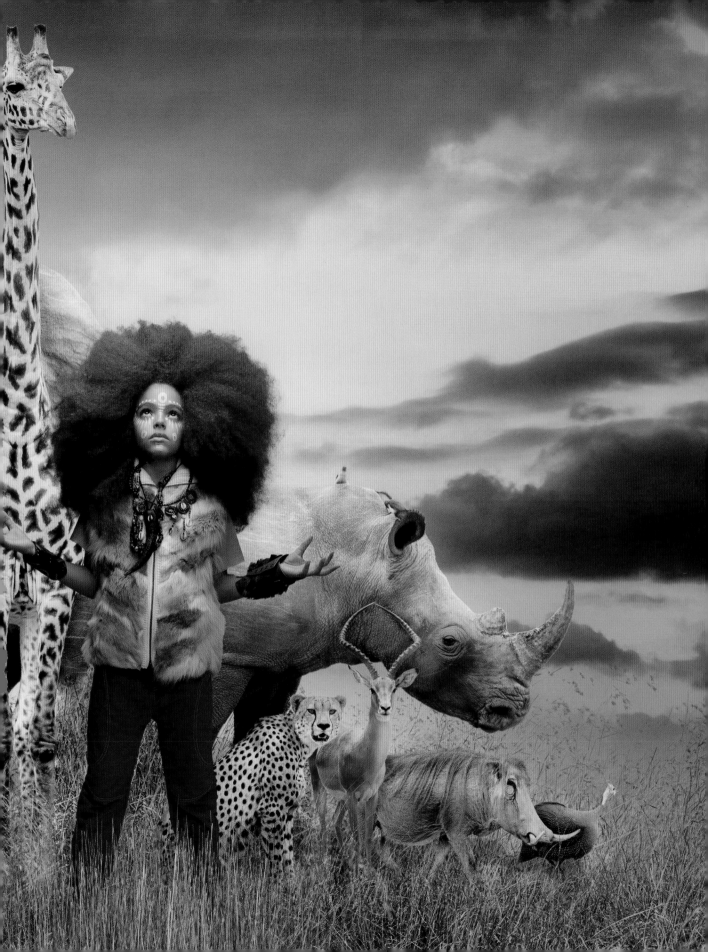

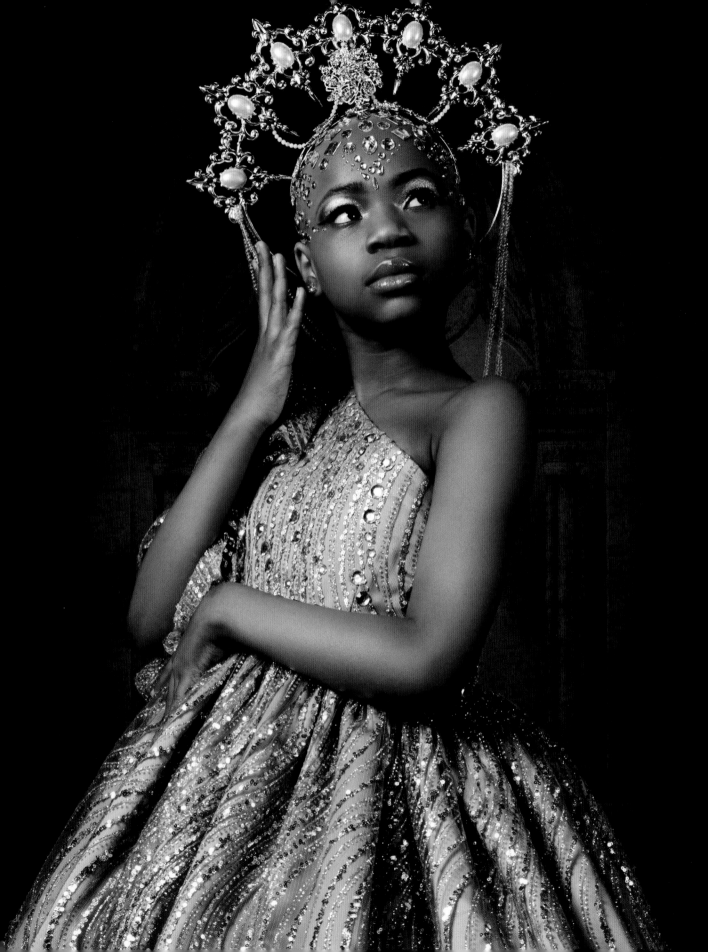

NEW CLASSICS

OUR STORIES

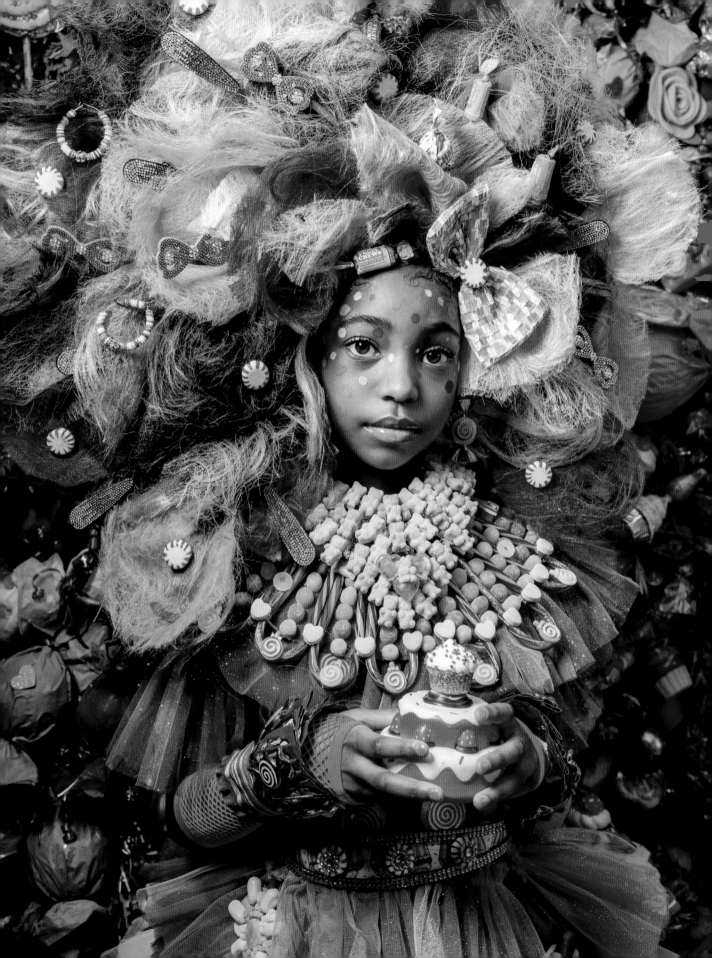

Candice Kane was an only child who lived in a big house in the center of town. Her mom and dad had a hard time saying no to her, and because of it she was a little bit spoiled. She usually got her way and did what she wanted. But she was a sweet girl, with an even sweeter tooth, and never went too far for she loved her parents dearly.

Candice loved candy. That's why everyone called her Candi. Her mom didn't know how much she loved it until the dentist told her that Candi had three new cavities! Now candy was banned until her next checkup showed she was cavity-free, but that was not for a whole year!

Candi wasn't happy about this. After all, as a kid, candy was an important part of her life. There was candy for Halloween, Christmas, and Easter, and, of course, cake and treats for your birthday. *I'll be an adult soon enough and no longer interested in candy,* was what Candi thought. *Why not enjoy it now?* But her mom had other ideas. She'd cleared out all the candy from the house. She'd even found Candi's secret stash under her bed. And she'd told her dad and all her friends not to give her any sugary treats.

That evening after dinner, there were no sweets for dessert, only fruit. Candi looked at it and sighed. She didn't want to face a whole year of this. That night as she got ready for bed she remembered there was a bag of Halloween candy that she'd gotten trick-or-treating. There was so much that she hadn't finished it. It was buried under a pile of laundry, which was why her mom hadn't found it. Candi tiptoed to the closet and found the pile of clothes. Sure enough underneath was a Halloween bag chock-full of chocolate, candy corn, and jelly beans. *Score!* Candy thought. She closed the door, sat on the floor, and opened a bag of jelly beans. She was only going to eat one bag, but before she knew it she'd eaten two bags, the chocolates, and all the candy corn. At least there'd be no evidence. She'd toss it in the trash in the morning and her mom would never know.

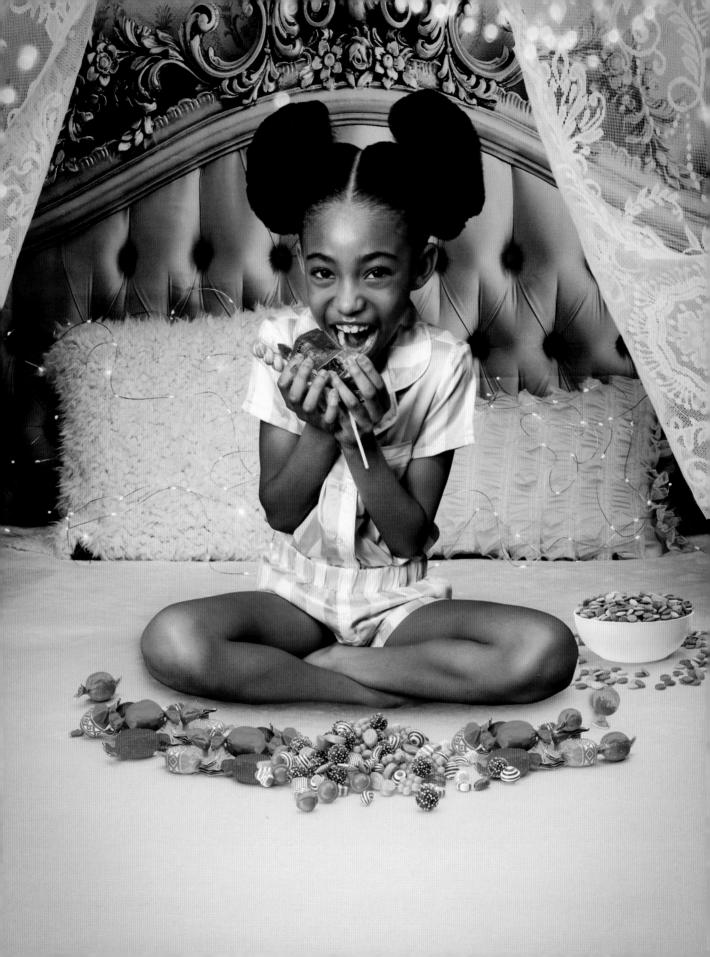

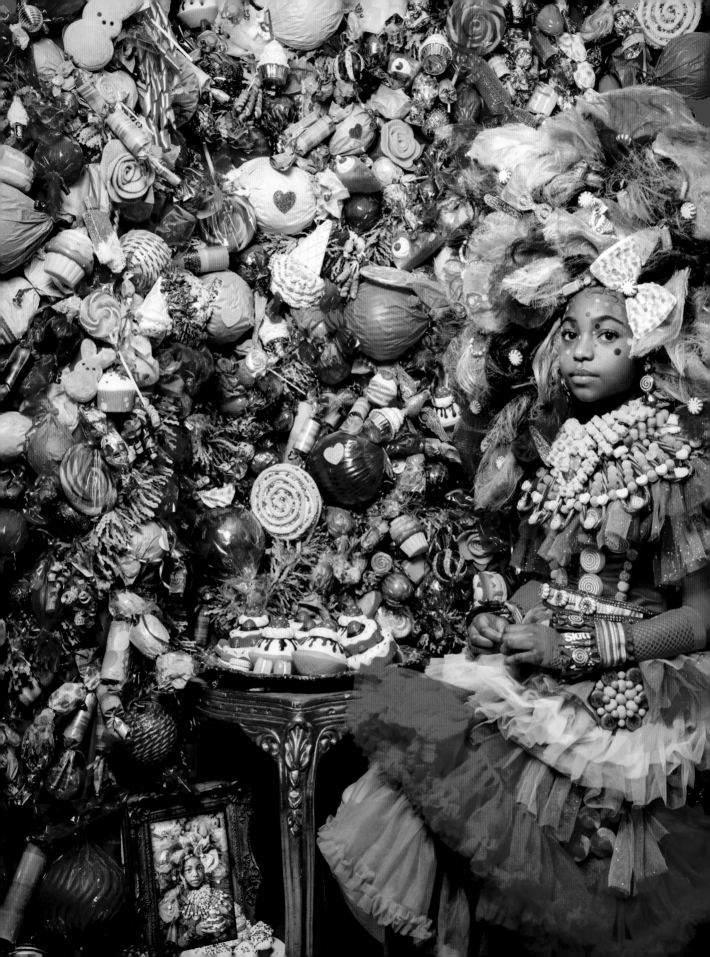

As she stuffed the empty wrappers in the bag she started to feel a little sick. She'd eaten too much too quickly and now she had a tummy ache. She decided to close her eyes for a bit until she felt better. A few minutes passed, then a few more, and when she felt better she stood up and quietly turned the doorknob, but when she opened the door she was no longer in her bedroom. She was in a town, but not her town, and it was unlike any town she'd ever seen before. It was a magical place!

Everything was brightly colored, the cars, the houses, the grass, even the trees. But when Candi stepped out of the closet and onto the street, she stopped in surprise. The street was squishy, not hard. She touched it, then licked her finger. It was made of fudge! Looking around she saw that the houses were made of cake and the trim was frosting! The hedges were cotton candy and the flowers were lollipops! Then she saw a sign that read "Welcome to Candy Land!"

"Whoopee!" Candi shouted. "This is my kinda place!" When she looked down at herself, she was no longer in her pajamas; instead she wore a beautiful dress, made entirely of candy! On her wrists were colorful jawbreakers strung on a bracelet and on her finger was a huge candy ring!

Candi danced and twirled around. She loved Candy Land! But where were the kids? She wanted to make some friends. She walked to a house that sat behind a brightly colored candy cane fence. When she tried to open the gate it cracked and broke into pieces. *Uh-oh! I hope they won't be angry. But a gate made of candy isn't very sturdy,* she thought. She stepped over the broken pieces and skipped up the glazed sugar walkway, but when she slipped and almost fell, she stopped skipping. *A glazed walkway is very silly.* She shook her head. *You could fall and hurt yourself.* But she quickly forgot about it when she reached the chocolate chip cookie door, with a big chocolate chip doorknob. Candi knocked but the cookie only crumbled and didn't make a sound.

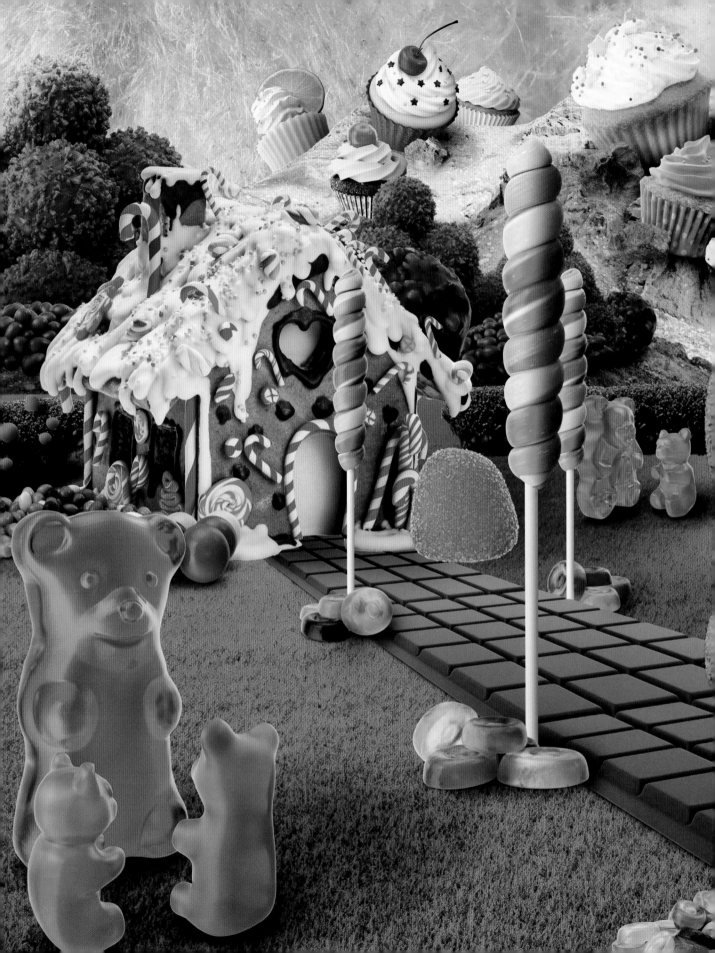

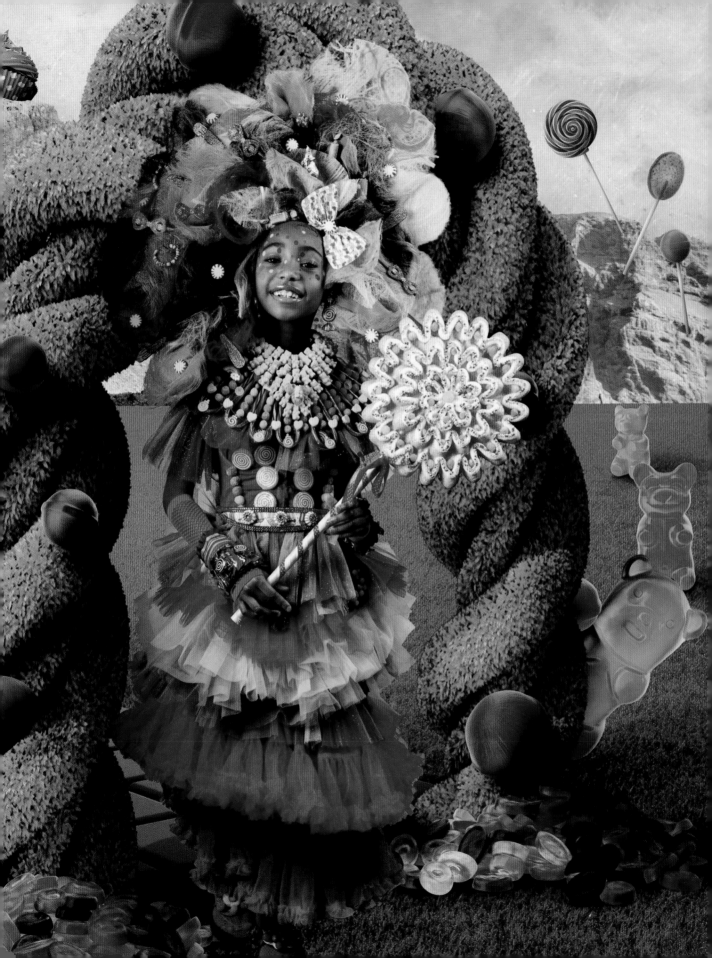

She looked through the little window in the door but couldn't see through the sugared glass.

"Hello, is anyone home?" she called out. When there was no answer she turned the doorknob but it melted, leaving chocolate in her hand.

Candi left the house and stood on the fudge street looking around. The streetlamps were candy canes with gumballs for bulbs. Although they looked quite yummy they didn't give any light. *What good is a town made of candy?* she wondered. Although everything was tasty, they weren't very handy. And for goodness' sake, if all you ate was chocolate, candy, and cake, you'd get cavities and a tummy ache. This she knew from experience. The idea of endless treats had quickly lost its appeal. Candi wanted to be back home, where things worked, even if you couldn't have sweets for every meal. She wanted a real door you could open and a place to rest her head. She wanted to slip under real covers and be in her bed. She closed her eyes and wished to be home. And if it came true she promised not to eat another sweet, for a year or two or three or four. Goodness, she'd had enough to last at least that, maybe even more.

When she opened her eyes she was delighted to see that she was in her bed in her pajamas and she was very glad indeed. She yawned and stretched for she knew it had been just a dream. But when she pulled up her covers she still wore her candy ring.

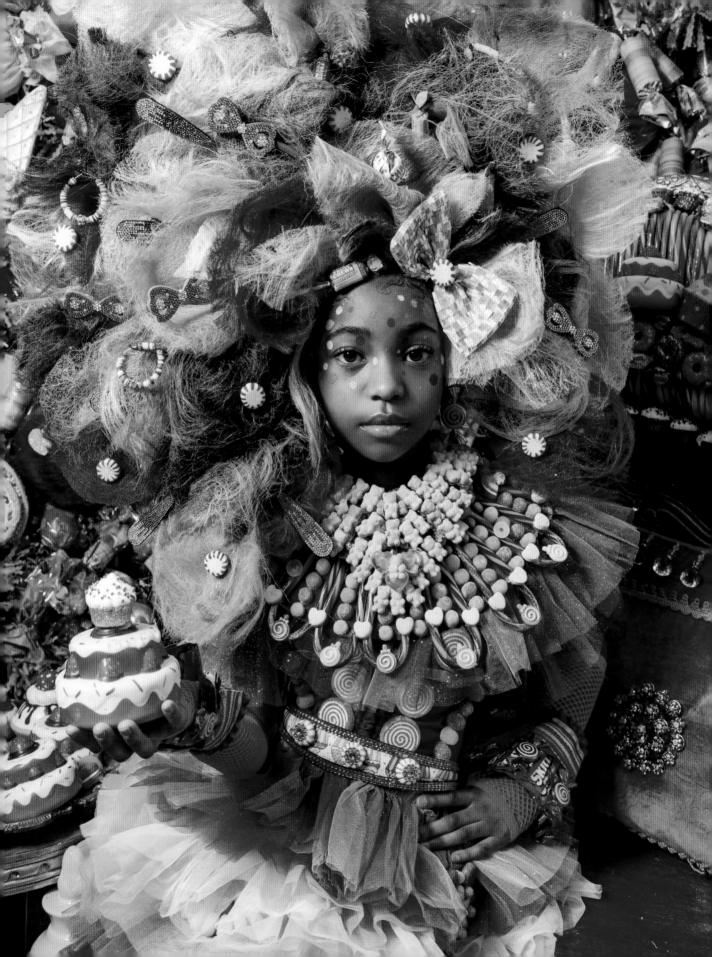

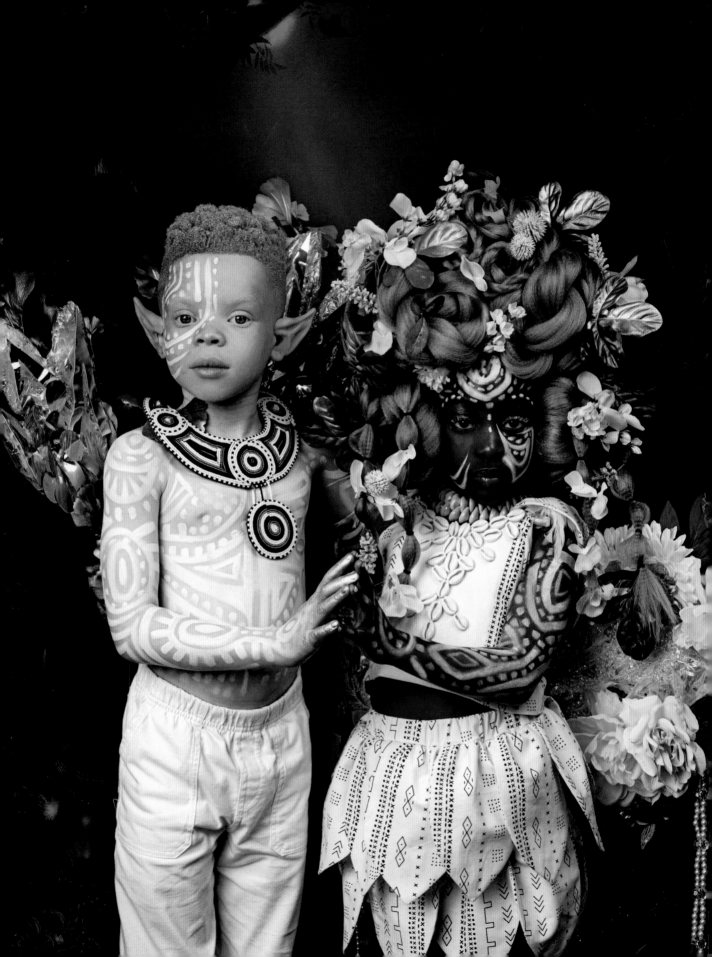

THE YUMBOES
·LITTLE FAIRY FOLK·

The Yumboes are magnificent fairy folk. They are and always have been here, but hidden in plain sight for they are quite rare. When the moon is full they will emerge and slyly make their way to the forest's edge. You might spy them as they sing, dance, and make merry. But be quick or they'll be gone, back into the woods before dawn. They have always been and will always be, but rarely seen by you and me. Unless you're careful and quiet and patient and calm, you'll never see them for they'll be gone.

Small and spritely they moved so silently that they were almost invisible, unseen, but if you looked carefully and held your breath, so as not to move a muscle, you'd see them among the bushes. The Yumboes, the little fairy folk, ferns and flowers woven in their hair, nearly hidden in the trees, wild and free, at home in nature, near woods and seas.

On Goree Island when evening descends they make their way silently down from where trails end. And if you're lucky and quiet, you'll spy them, the little fairy folk called the Yumboes. Tiny folk, only two feet high, small and spry, hidden in plain sight. Their eyes shine like stars and are filled with light, hair coated in silver and dressed in white. Their skin is marked with runes and carvings bright. Look there, in the moonlight! Four fairy folk, two dark, two light. Such lovely creatures, oh what a sight! You might spy them as they sing, dance, and make merry. But be quick or they'll be gone, back into the woods before dawn. They have always been and will always be, but rarely seen by you and me. Unless you're careful and quiet and patient and calm, you'll never see them for they'll be gone.

See the Yumboes dancing there, with ferns and flowers woven in their hair. You must look carefully for them to be seen. Between the woods and the trees and brooks and the sky, they are quite invisible, but you should try.

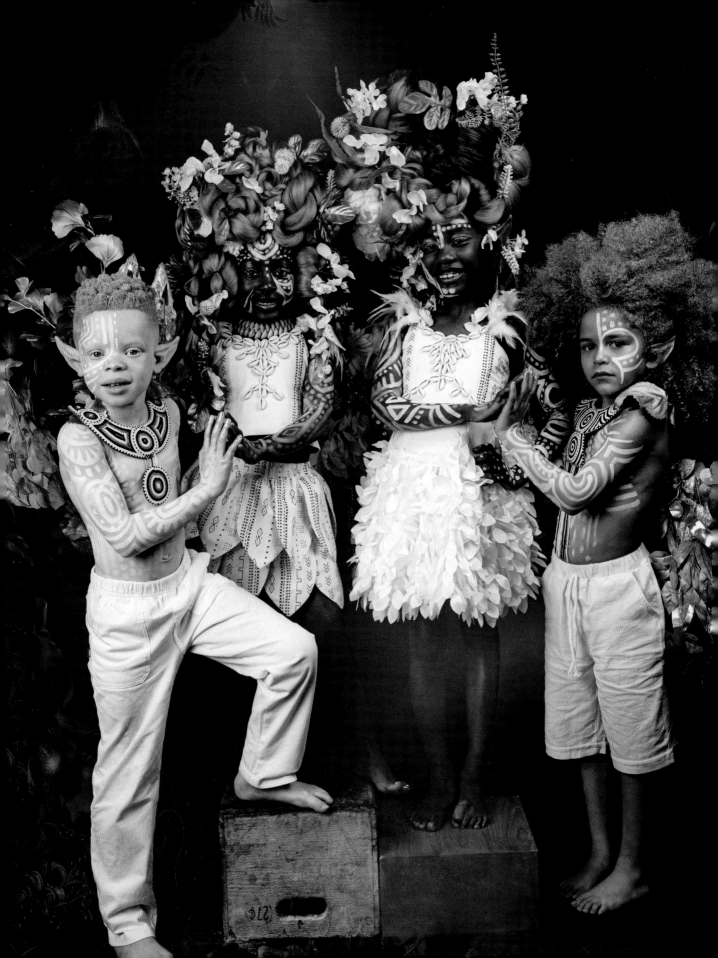

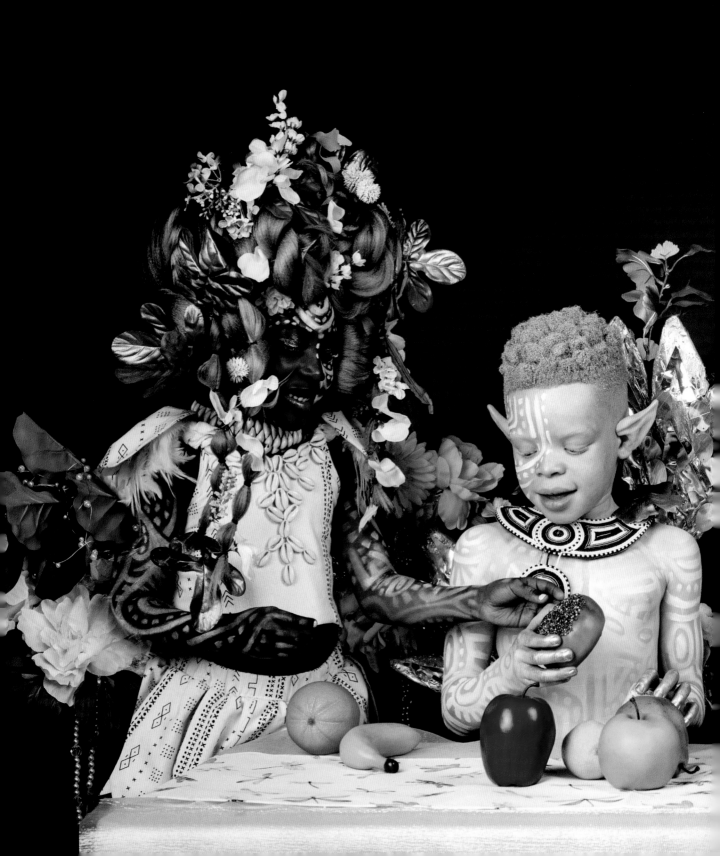

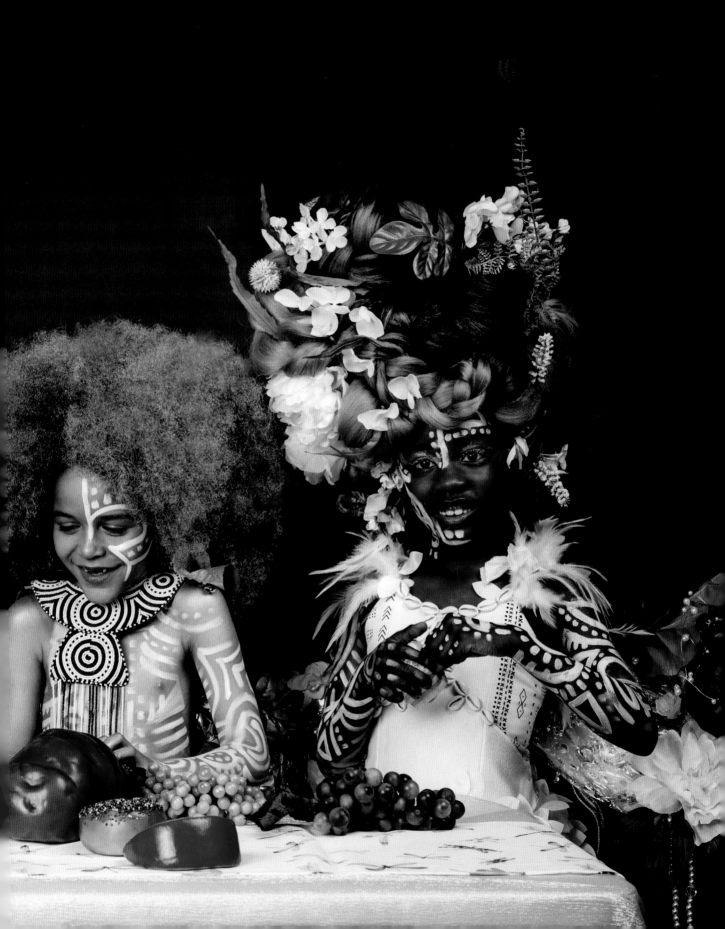

You might catch a glimpse of these fairy folk and hear their songs before they're gone. At first blush of dawn, they creep back to their hidden places, where human eyes have seen no traces. They will sleep and rest and wait until sunset. Then rise again and spin legends in the rays of the moonlight.

So, look closely and you might spy four sweet fairies, spry and wild. Behind a hedge, near a tree, lovely and graceful, wild and free. These fairy folk known across the land as the Yumboes will escort you by hand to the great beyond place, should it be your time, and if not, then they'll dance and sing with you for a while.

Their eyes shine like stars and are filled with light, hair coated in silver and dressed in white. Their skin is marked with runes and carvings bright. Look there, in the moonlight! Four fairy folk, two dark, two light. Such lovely creatures, oh what a sight! You might spy them as they sing, dance, and make merry. But be quick or they'll be gone, back into the woods before dawn. They have always been and will always be, but rarely seen by you and me. Unless you're careful and quiet and patient and calm, you'll never see them for they'll be gone.

The Yumboes, magnificent fairy folk. They are and always have been here, but hidden in plain sight for they are quite rare. When the moon is full they will emerge and slyly make their way to the forest's edge. They seek for their meal fresh bread and corn but they need your flames to keep them warm. So they'll sneak into your hut and home and spirit away a small bit of fire to cook their meal. And should you be generous they'll remember this kindness and look after your family until it's time to escort you to the great beyond place. The magical place they call home.

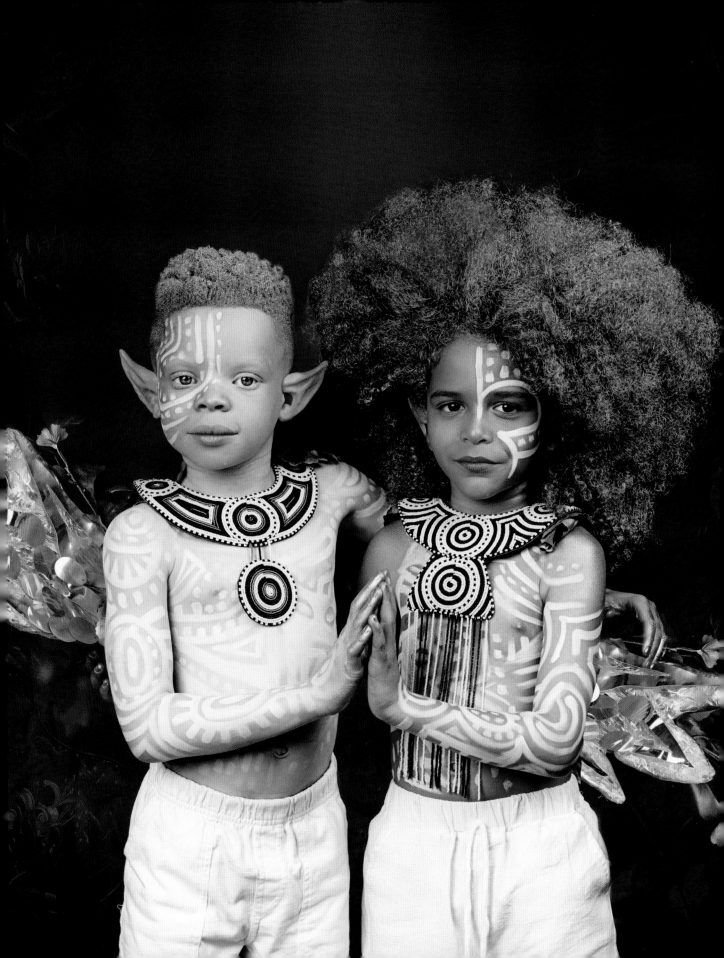

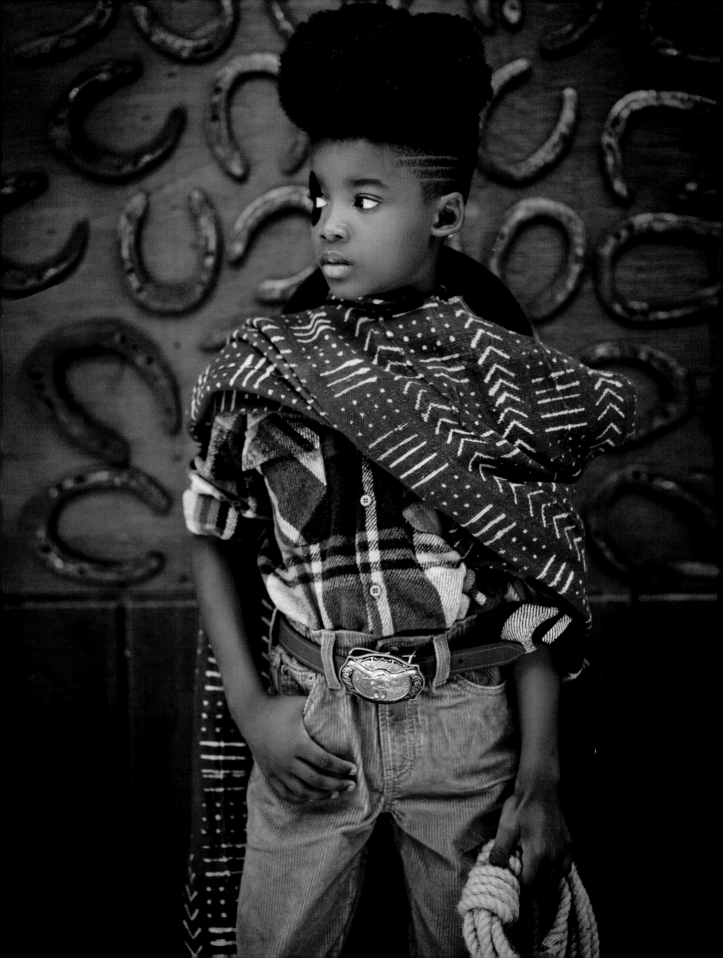

Ty and his family lived on a farm in rural Maryland. They were a rodeo family descended from five generations of cowboys. Ty's dad's dad, his dad, and his dad's dad before him were cowboys. He and his siblings were in the saddle as soon as they could sit up. Even ten-year-old Didi, the youngest, was a fine rider.

Ty was on his way to the community center in town. The Center, as it was called, was supervised and safe, and kept the kids out of trouble. Behind it were stables where the kids could ride horses in the corral. Ty always ended up there; he and his siblings loved nothing more than riding horses with the other kids in town. Ty was also a bronco buster. Or at least he wanted to be.

As he cycled up to the building he stopped short. The Center was closed. The lights were off and the doors were locked. *What's goin' on?* Ty wondered, getting off his bike. The Center was the life of his small town. It's where Ty, his brother, Cody, and their sisters Kya and Didi hung out most weekends.

Ty headed to the stables to look for Joe the caretaker. Inside he saw there was a horse in the last stall. It was snorting and pacing around.

"Who's there?"

"Hey, Joe, it's me, Ty."

"The Center's closed, Tyrone."

"Why?"

"Rent's gone up and we just ain't got it." Joe shook his head. "It's a wonder we kept it open this long." The horse snorted. "I see you've met Jet."

"She's a beauty," Ty said. Her mane and coat were shiny and brown.

"That she is. But stubborn as a mule." Joe laughed. "She don't listen, won't let you ride her, won't pull a plow. She's only good for bronco riding. She's being boarded here for the contest this weekend. Whoever can stay in the saddle for ten seconds wins ten thousand dollars in prize money and gets to keep her, if they want her."

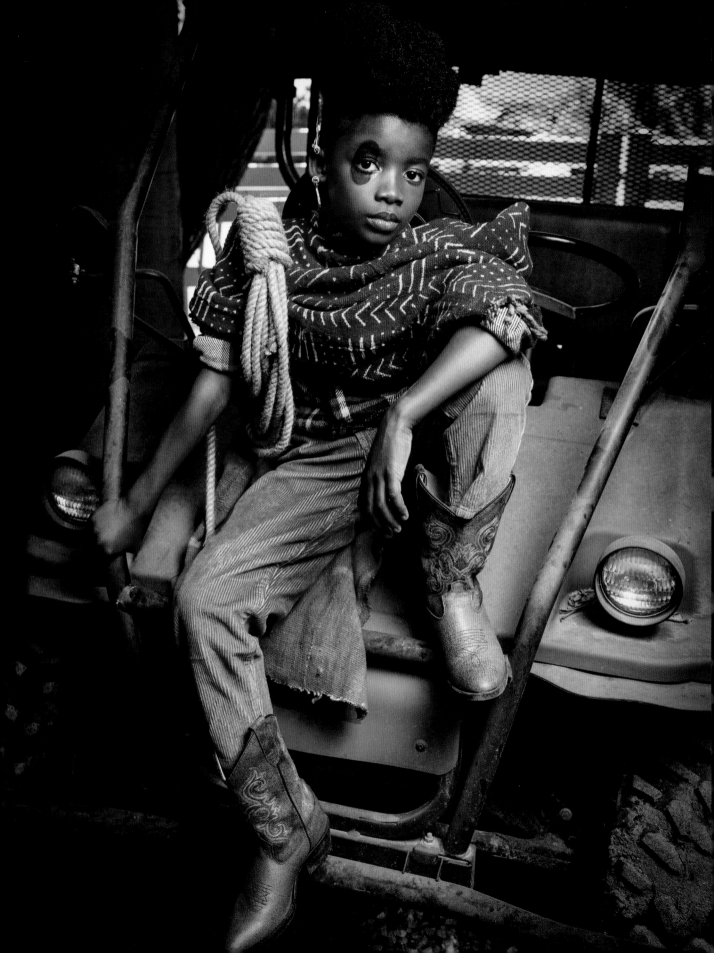

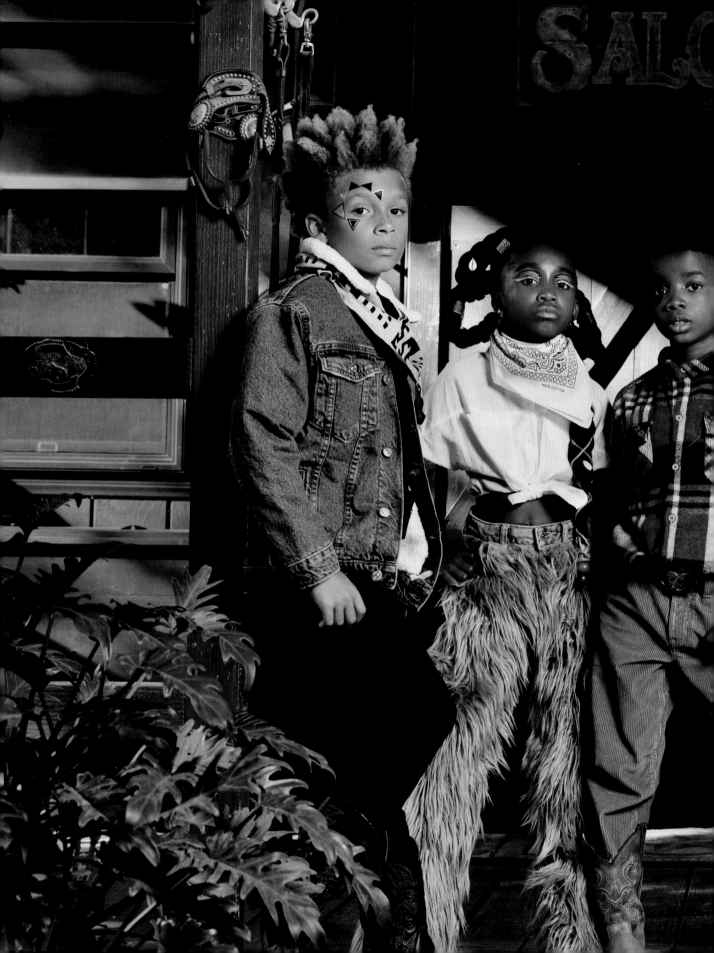

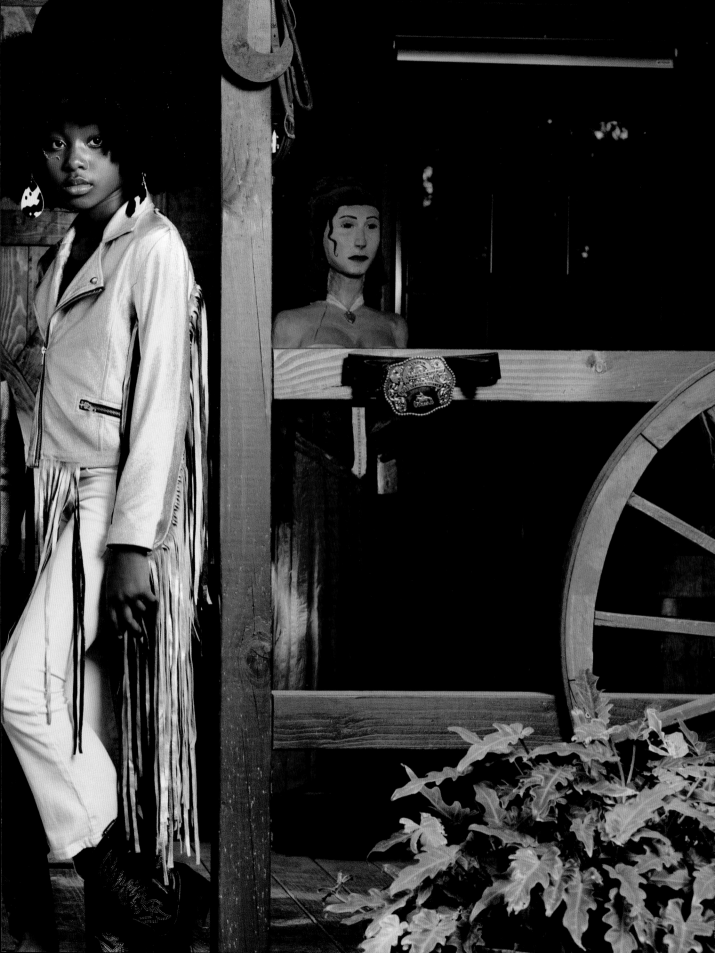

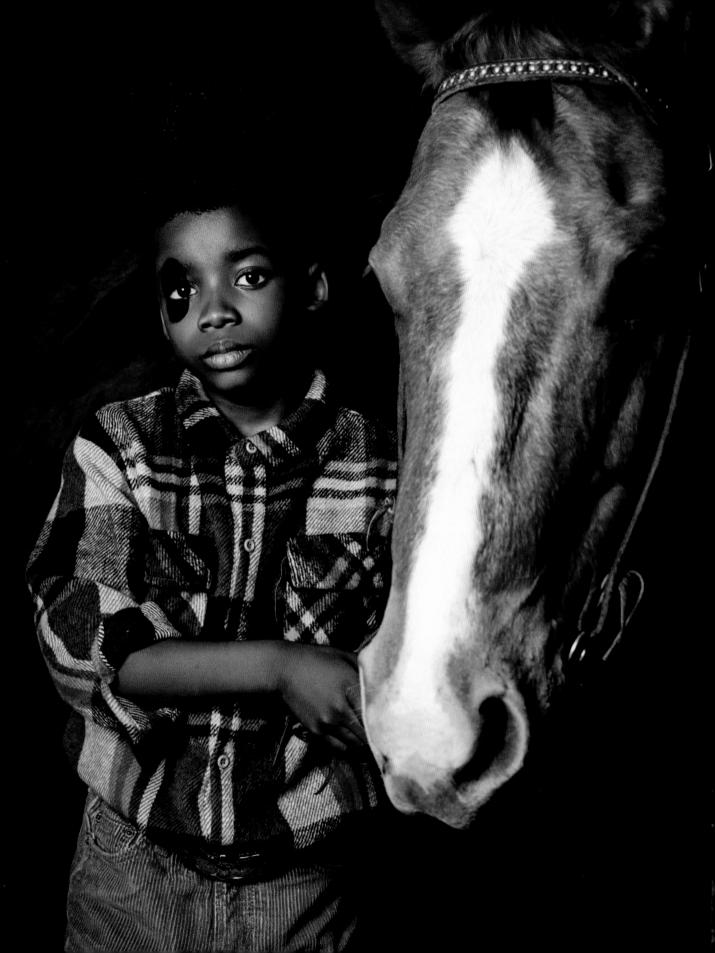

"Ten thousand dollars," Ty repeated. "That's a lot of money."

"Sure is. You plan on winning?"

"Maybe so."

"What would you do with ten thousand dollars, young man?"

"I'd give it to you to keep the Center open."

Joe smiled. "You're a good kid, Ty, and a fine horseman. But you can't ride that horse. Lotta good riders much older than you've tried. But I appreciate you, son. I do."

That night when everyone was asleep Ty bicycled into town and snuck into the stables. Ty had known horses all his life, he'd grown up with them. He and his dad were professional riders, folks called them cowboys, and they always caused a stir when they rode through town.

Ty walked quietly up to Jet holding out his hand. "Hey, girl." He had a couple of sugar cubes. He offered her one, but she backed away. "It's okay. I just wanted to say hi." He rested his elbows on the gate. The moonlight reflecting off her coat lit up the shadows. "You sure are a beauty," he whispered. "I don't make a lot of wishes but I wish you'd let me ride you, then you can come live with us and not be locked up all the time." Jet was looking right at him. "And I'd use the prize money to keep the Center open." Ty tossed the sugar cubes into the stall. "Well, that's my wish. I appreciate you listenin'. Good night, girl." He then hurried out and cycled home.

The next night he snuck out again to the stables with a handful of sugar cubes. Jet didn't take them, but she listened as she had the night before. Just talking to her made Ty feel a little better. He tossed the cubes into the stall, said good night, and left.

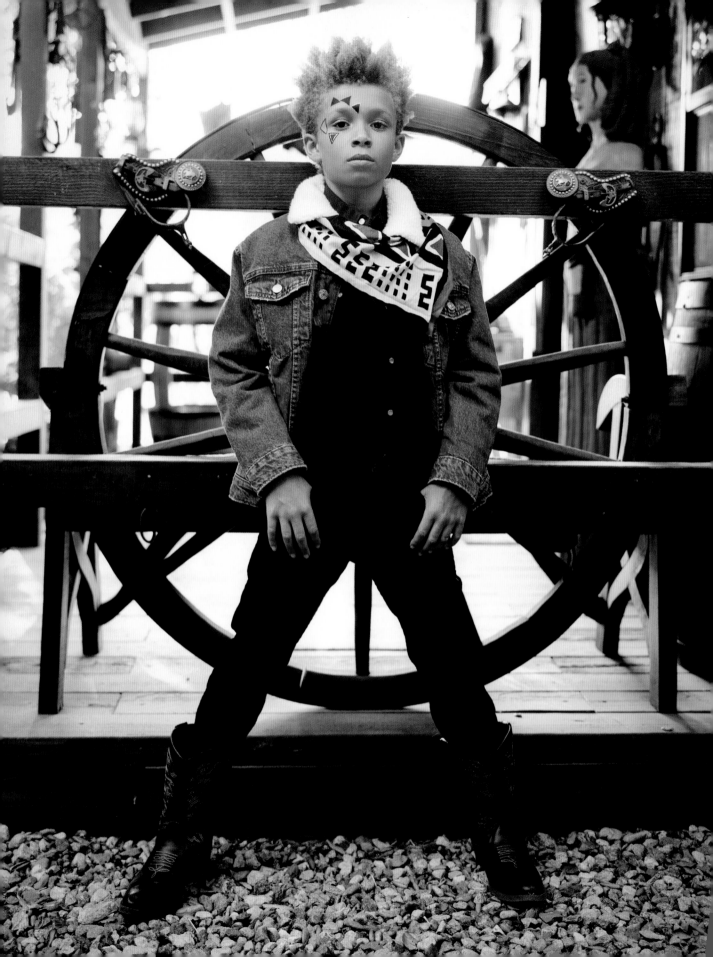

The third night was right before the contest. This time he slid open the latch and stepped inside her stall. Jet backed away but she didn't snort or rear up. Ty took a seat on a bale of hay and made the wish again. "I wish that you'd let me ride you. If I win, we can keep the Center open and you can live with us." When it was time to leave he went to toss Jet the cubes but she was only a few feet away. He held out his hand and closed his eyes, then he felt her snout in his palm as she ate them. She then backed away. Ty whispered good night, then tiptoed out of the stables.

The next morning Ty stood with his dad behind the gate, waiting for his turn to ride Jet. She'd bucked every rider and showed no sign of easing down.

"You sure you want to do this, Tyrone?" his dad asked. "She's a wild one. I don't want you to get hurt, son."

"She won't hurt me, Dad."

"And how do you know that?"

"'Cause I made a wish. I told her that if she lets me ride her, I'd give the money to the Center to keep it open and she could be my horse and not be locked up all day."

"That's a big wish, son. But I'll tell you what, you win, and we'll talk about it."

When it was time to mount up, Ty sat in Jet's saddle and, right before they opened the gate, he leaned down and whispered, "It's me, girl. How 'bout we go for a ride. Then you'll be free."

The gate swung open and Jet sped out. She bucked and reared, but Ty hung on. She raced back and forth and stopped short, but Ty hung on. She spun and spun and kicked, then she stopped. For the last few seconds as the clock ticked down, Jet let Ty take her lead, then she trotted around the corral as the crowd cheered. When the buzzer rang Ty leaned down and hugged her hard. She'd granted his wish and he would grant hers.

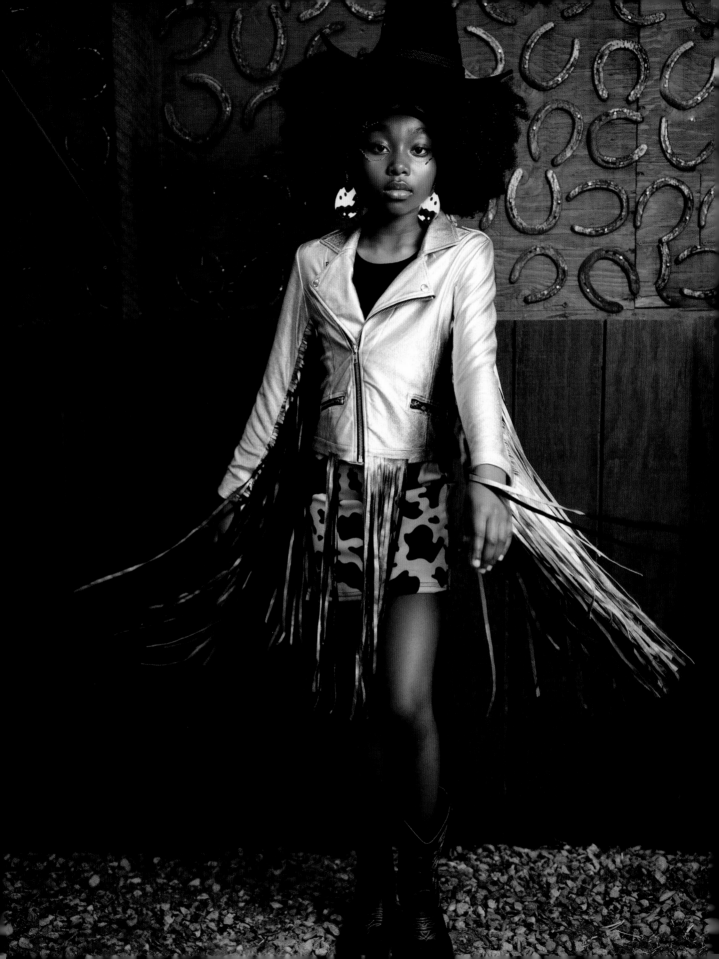

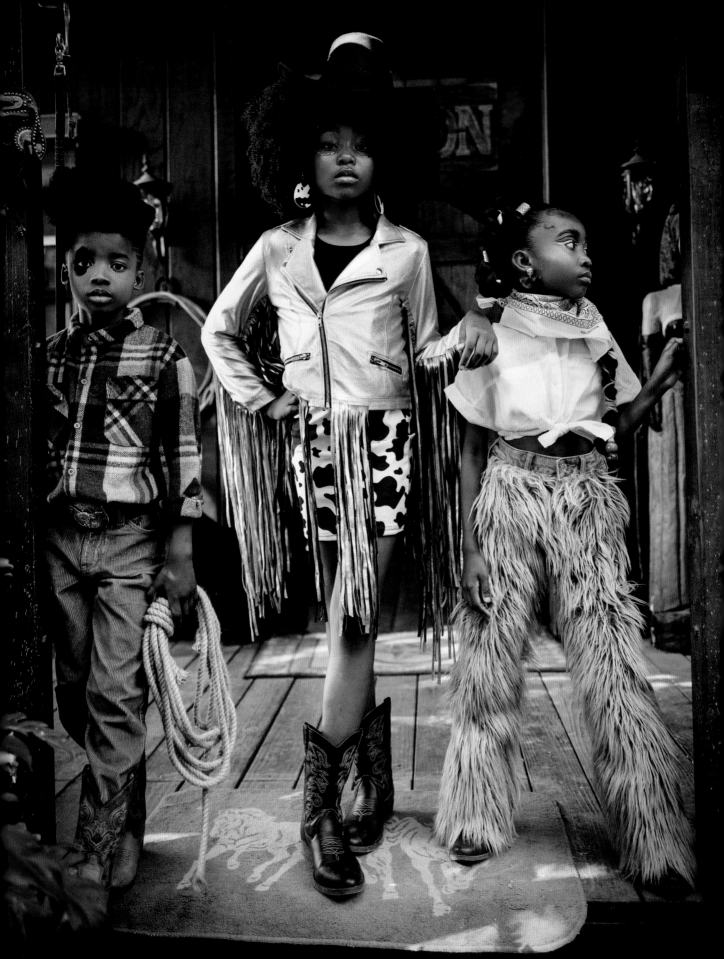

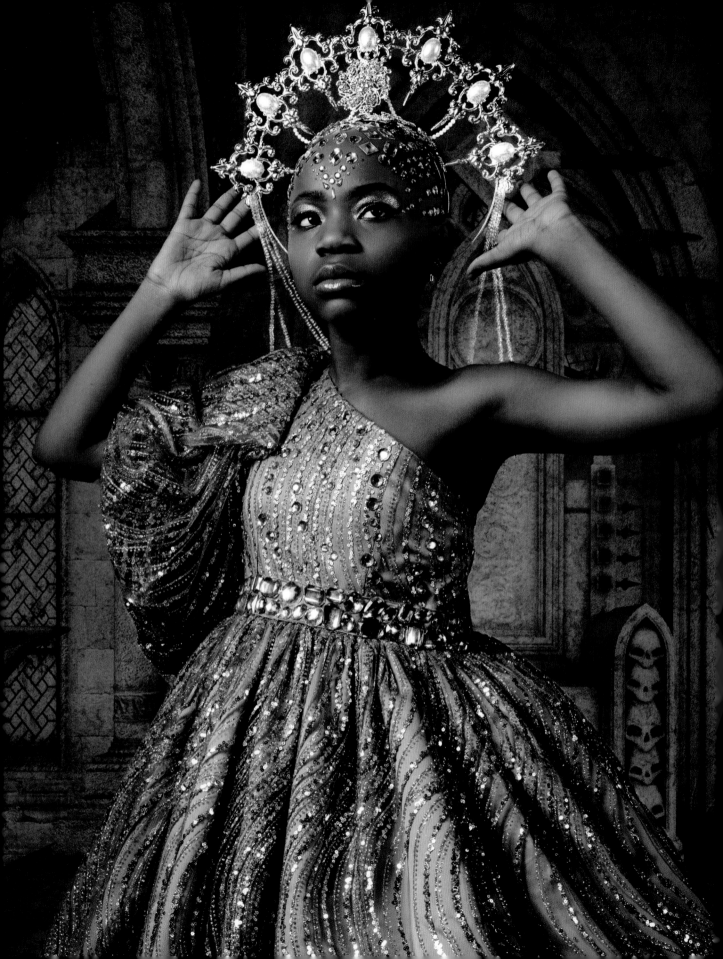

THE PRINCESS
WHO LOST HER HAIR

A long time ago in a land far, far away, King Oshun and Queen Kali ruled a glorious kingdom rich in minerals and precious stones. On this very special day, their beloved daughter, Nia, turned ten years old and a magnificent celebration was at hand. Almost everyone was invited, from across the land.

The castle glowed gaily with candlelight as the musicians played a merry tune. There was singing and dancing, and laughter that filled the room. Suddenly the air crackled with electricity and thunder boomed, then the door blew open and a shadow loomed. It was a woman both regal and fierce, in a headdress and gown of glorious plumes. The guards rushed forward, ready for the king's command, but Queen Kali stopped them with a wave of her hand.

The woman strode toward them until she stood but an arm's distance away. "Ah, sister," she said. "You have been remiss, to not invite me on an occasion as special as this."

"Dearest Yemi, it has been many moons since we parted, you in anger and I in grief." Kali held out her hand. "You are here now, sister, will you join us and celebrate your niece?"

"I cannot, I will not stay, but to you, sister, I bestow this today. As you have taken from me, I will take something you hold dear in your heart, and leaving this dark gift I will now depart." Yemi then disappeared in a blaze of light and in her wake the king and queen clung to Nia in fright.

That night, as was her ritual, Queen Kali brushed her daughter's thick hair until it glistened in the candlelight.

"Mama, why is Aunt Yemi so angry?" Nia asked.

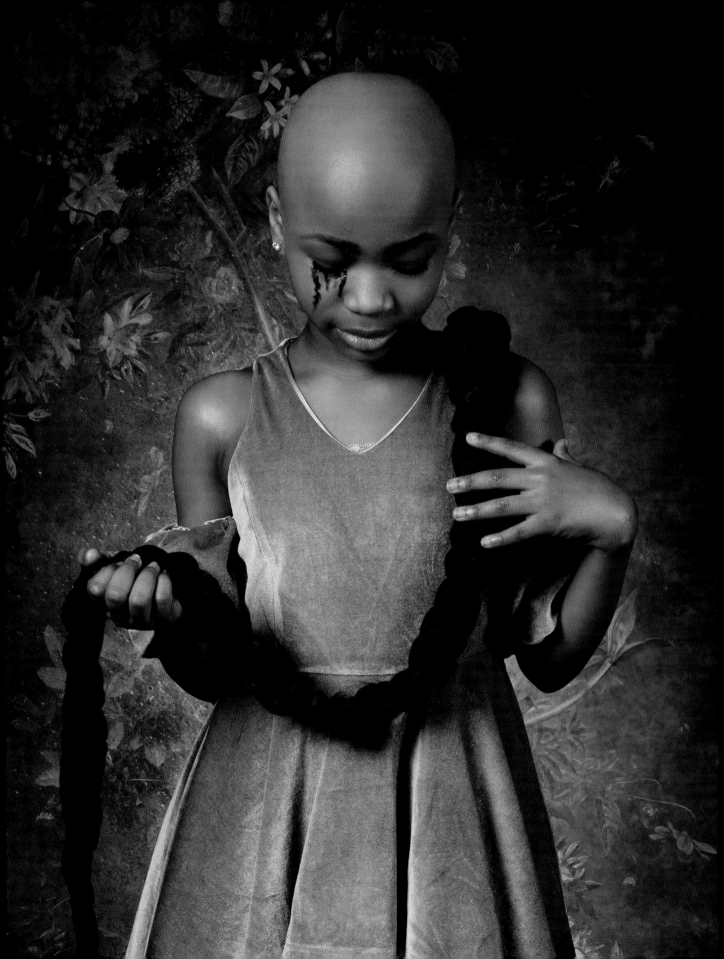

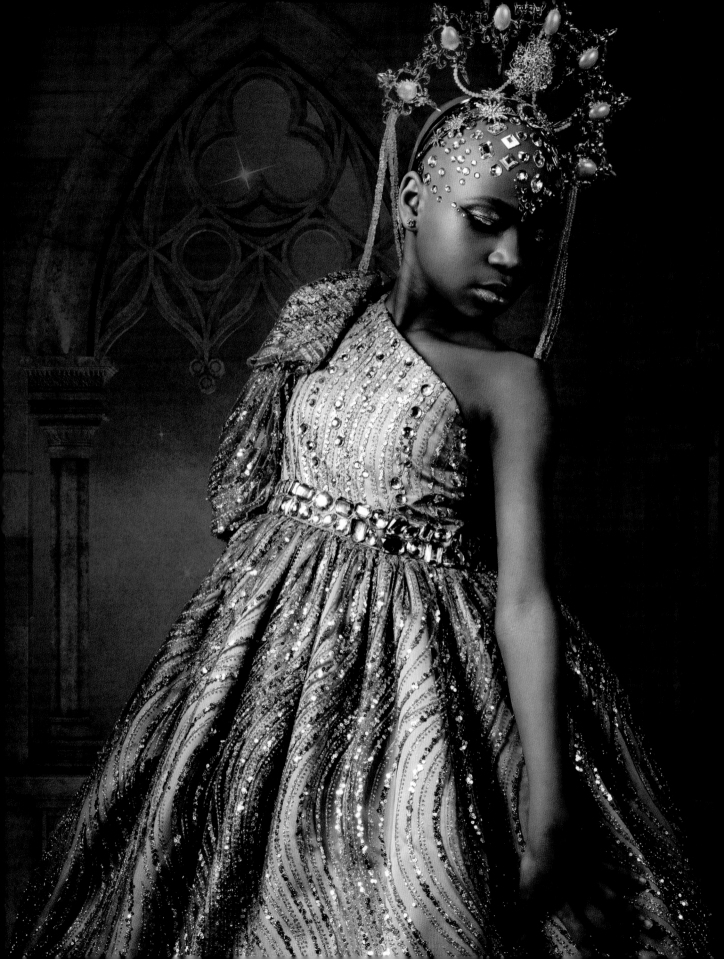

"When we were young we were as close as two sisters could be. But on the day she was to be wed, her betrothed instead chose me. Our love could not be denied, it was there for the world to see. But Yemi felt betrayed by her chosen one, and also by me." Kali sighed deeply. "I left our home with your father on that fateful day twelve years ago. Although Yemi's power was felt throughout the land, I had not seen her since that day he asked for my hand."

The next morning, the nightmare of the previous day seemed like a dream. Nia woke and sat up in bed, then she cried out when she felt a strangeness on her head. A moment later the king and queen burst into the room and looked at her with dread, for she was now as bald as an eagle with not one single hair on her head.

Nia grabbed her cloak and fled the castle. She ran and ran, until she was quite lost. As she made her way through the thick foliage, she heard thrashing and panting. Not far ahead she came upon a pit, and inside was a massive panther, inky black with eyes glowing red as though lit. The sun beat down and the beast was parched and filled with dismay. If he could not get out he would surely die that day.

Nia spied a broken branch and with all her might she pushed it inside. When the cat scrambled up and sprang out of the pit, Nia closed her eyes because she knew that this was it. A moment passed, then her face felt wet. To her surprise, the panther had licked her and now purred like a pet. Then the beast nudged Nia onto its back. She scrambled up and the cat bounded off with a great leap. After some time, they came upon a stone tower, hidden behind trellises of hanging vines. The cat pushed the huge iron door open and ushered her inside.

Nia saw a winding staircase and as she crept slowly up she heard someone crying. At the top of the stairs she entered a room. Inside was Yemi, who was filled with gloom. Her massive headdress lay at her feet, her head cradled in her hands as she sobbed with grief.

"Why are you crying, Aunty?"

"Nia, what are you doing here? Please don't look at me!" Yemi covered her head with her hands. "I am bald and ugly, that's why I'm all alone," she sobbed. "My bitterness and rage gave me my power but it has taken my hair, and it can never be undone."

"Ugly? Oh no, Aunty, your presence stuns like a lightning strike. You are the most magnificent woman I've ever seen in my life."

When Nia touched her arm a warmth spread through Yemi's body. It pushed away the bitterness that had lodged in her bones, and she began to feel not so very alone. Yemi pushed back Nia's hood and gasped when she saw that her thick, glorious hair was now all gone.

"Oh, Nia, forgive me, I meant you no pain. I will lift the spell and you will be beautiful again."

"Aunty, my hair isn't what made me beautiful. I am kind and brave and I want to be strong, and fierce, like you. Mama says that real beauty doesn't come from what is on the outside but what is on the inside. And it's true."

All those years ago, what Prince Oshun fell in love with was the light that shone from Kali's heart. Although Yemi was indeed the fairest in the land, her sister was the kindest. Yemi now understood that their love wasn't meant to hurt her, and she was transformed. As the sun rose higher in the sky the shadows lifted. Yemi covered part of Nia's head in diamonds, which represented the beauty that radiated from her heart. She then created a new headdress for herself that didn't hide her baldness but accentuated it.

When Nia and Yemi returned to her village and entered the castle hand in hand, King Oshun and Queen Kali embraced and welcomed Yemi without hesitation. Kali told Nia that she was as beautiful without her hair as she was with it, but now she was as magnificent as her aunt. Yemi's heart was full, and her bright smile bathed them all in a glorious light. Their rift was mended and they began again, together as a family. And they lived very happily ever after.

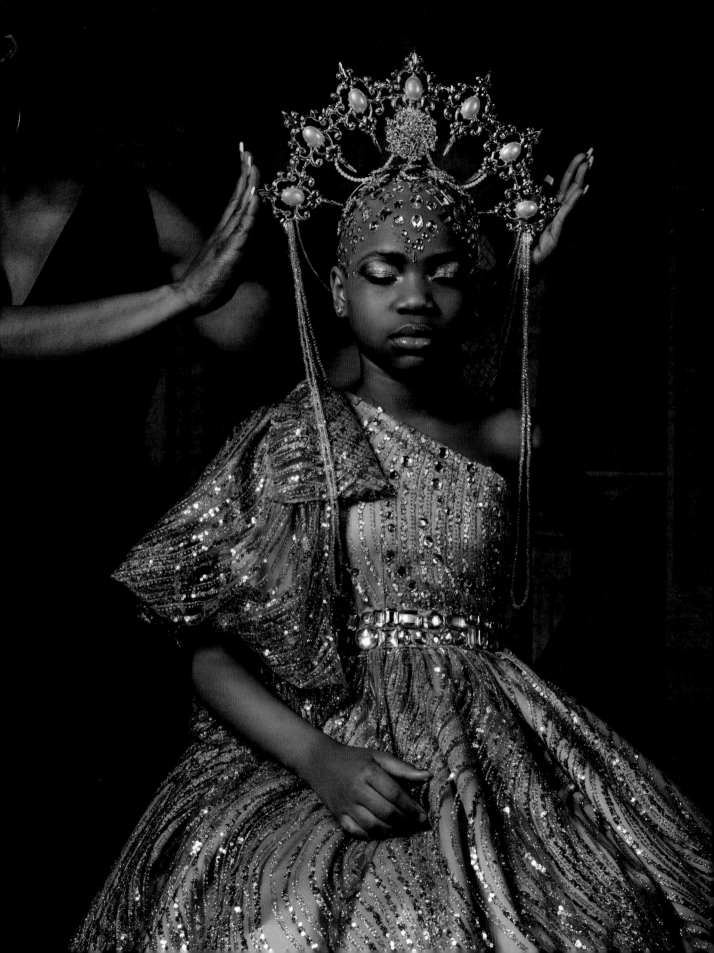

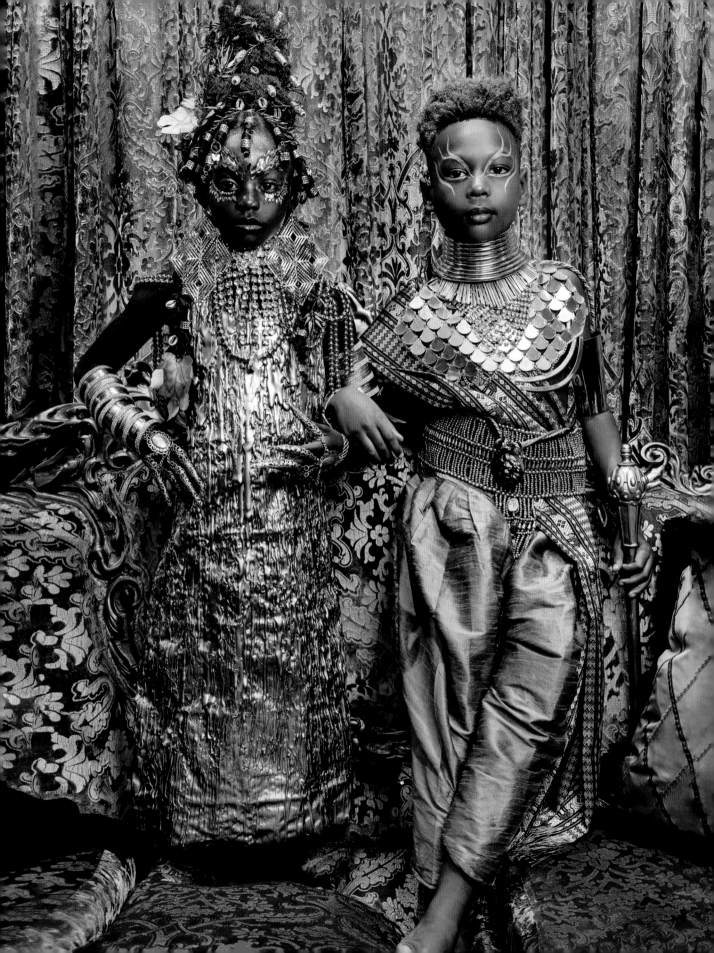

Brother and sister Marcus and Mara Gold lived in a small cottage—little more than a hut really—in a poor village that sat on the edge of a vast woodland. They had lost their beloved parents to illness years ago and the villagers had taken care of them, bringing them food and checking on them daily. Although they didn't have much, they shared what they had with the children. Times had been quite difficult for the Gold children, but the love and care of their neighbors helped them get by.

Early one morning Marcus and Mara were scrounging in the woods for flowers and herbs to sell. Their mother had been an herbalist and had taught them about the different types of herbs and their uses. Their father had been a woodsman and had shown them how to find the most beautiful flowers in the forest. This was a way for the Gold children to make money. Selling herbs and flowers and doing odd jobs for the people in their village was how they now survived.

A moment later they heard a thrashing sound coming from deeper in the woods. Marcus took Mara's hand and they crept forward to investigate. They soon came to a large tree and saw a bird caught in a snare. But this bird was unlike anything they'd ever seen before. It was gold in color with yellow eyes that shone like the sun. And when the bird started talking they almost ran away.

"Hello, little humans. Please free me. If you do, I'll change your hut into a mansion," said the talking bird.

After a moment Marcus said, "What good is a mansion in our poor village? Everyone will see and there will be many questions." He then said, "You are already caught, bird. We can sell you to a nobleman. Someone will pay a pretty penny for a talking golden bird."

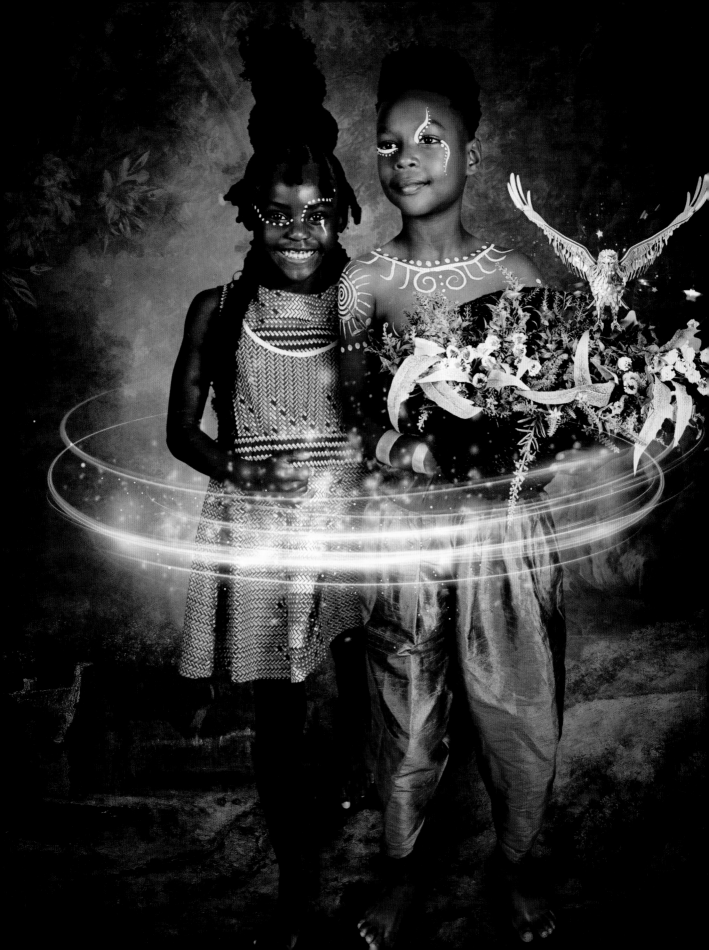

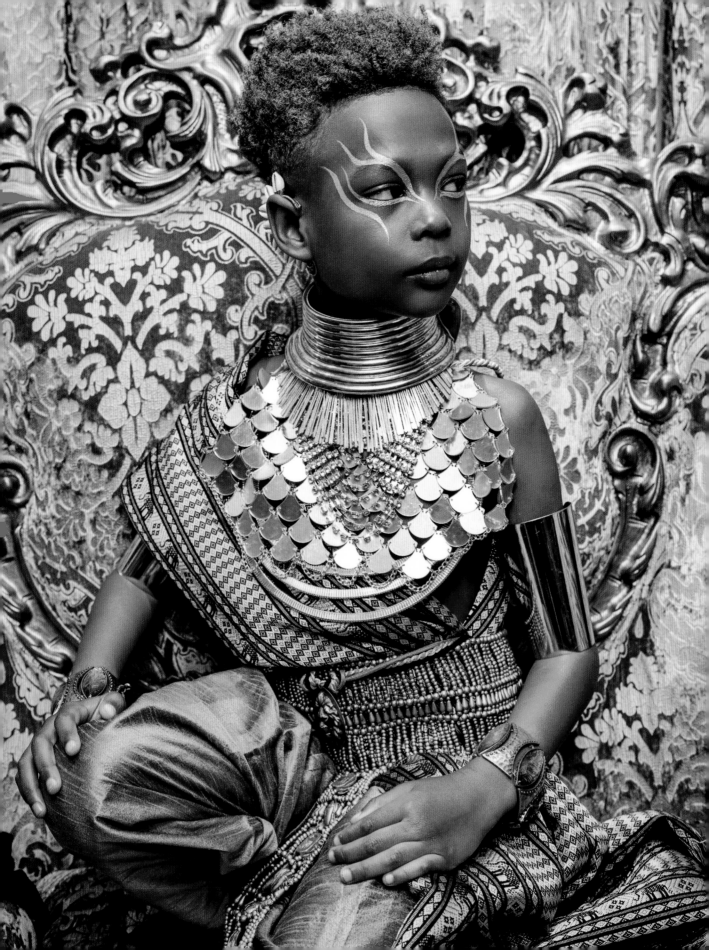

"Wait, I can offer so much more than a pretty penny," said the magic bird. "Your hut will look exactly as it does now, but inside it will be a mansion filled with treasure."

"But what good is a mansion if we have nothing to eat?" Mara asked, peeking out from behind her brother.

"Inside will be a cupboard filled with delicious treats, and you can eat to your heart's content," said the crafty bird. "However, once the cupboard is empty and all the treasures in the mansion are gone, there will be no more. But there will be plenty to last you for a very long time."

Marcus and Mara looked at each other and came to a silent agreement. Marcus then said, "You have a deal, magic bird. We'll release you if you promise to do as you say."

"I promise," said the magic bird.

Marcus freed the bird, who flew happily away. They then returned to their little hut, which seemed exactly as they'd left it. But when they stepped inside it was three times the size and filled with riches. There was grand furniture covered in fine fabrics, with fluffy pillows filled with down. Silken draperies hung in the windows and pooled on the ornate rugs. Golden candelabra graced the ornate tables and illuminated the richly woven tapestries on the walls.

They spied a magnificent cupboard and ran to it. When they opened it, it was full of delicious food, enough to last them for many years, just as the magic bird had promised. They whooped and hollered and danced around. Then they ate as much as they pleased, lit a fire, and fell asleep quite content.

The next morning, they woke and were delighted to see that it hadn't been a dream. They were still surrounded by piles of treasure. The siblings had a delicious breakfast of porridge and fruit from the magic cupboard, then they covered themselves in silk and lace, and gold and jewels. There was even a towering headpiece encrusted with gems and gold filigree. When Mara saw their reflection, she said, "We are truly the Gold children now."

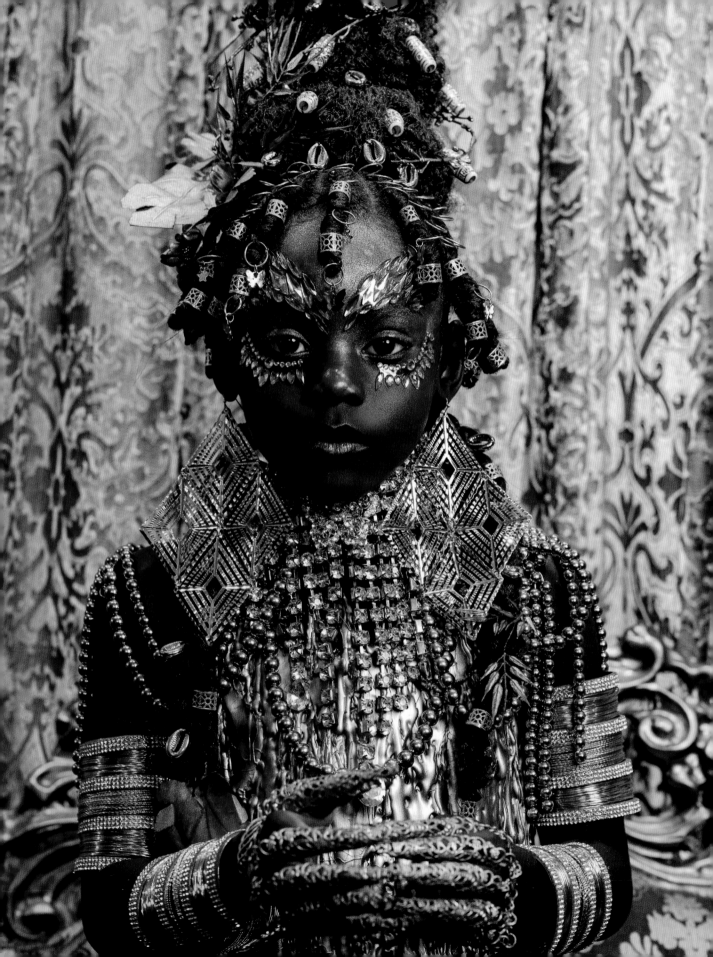

When they heard a knock on the door, they quickly removed their finery and Mara said, "What if someone sees all our gold and jewelry? We'll have a lot of explaining to do."

"We won't let anyone in," Marcus said as they hurried to the door and stepped outside.

It was Mother Alma, who often brought them a meal to make sure they had enough to eat.

"Hello, Gold children," she said. "I've brought you a stew with some of my vegetables and I even had a bit of meat to add. I've also made you a pie with some apples from my tree."

As they stood there Dominic the farmer walked over holding two jugs of milk. "Hello, children, I brought you some fresh milk from my cow."

Before they could thank them, Mother Alma said, "Let us know if you need anything, children, anything at all, and we'll try to help." They then walked away.

Marcus and Mara went back inside and closed the door. They stood there holding the food and jugs of milk as they looked around at all their splendor.

"What do you think Mother and Father would say if they saw all of this?" Mara asked.

"I don't think they'd be very proud of us," Marcus replied. "Dominic and Mother Alma have shared what little they have with us, yet we are hoarding more than we could ever need."

"But if we share it, when it's finished, there will be no more," Mara said, but she was also quite torn. The villagers had always looked out for them and helped them whenever they could. This was no way to repay a kindness.

Father used to say, 'When we share what we have, it is multiplied ten times over because it also helps others,'" Marcus said. "We can take care of the people in our village, as they have cared for us, and they can in turn help others. Then our abundance enriches the whole."

And that's exactly what they did. They shared their bounty with all the villagers and anyone in need. And when it looked like the riches were almost gone and the cupboard almost bare, a wonderful thing happened—it didn't run out. Instead, it multiplied. For that was the real gift the magic bird had bestowed on the Gold children for setting him free. If they had kept their bounty to themselves it would indeed have eventually run out, but if they shared their treasures, it would multiply.

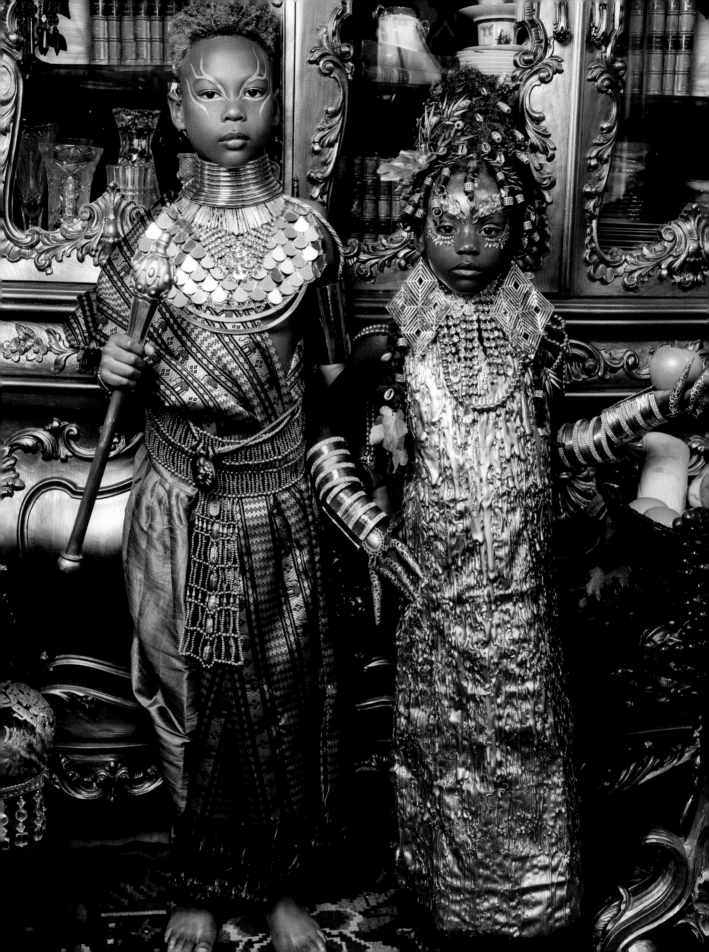

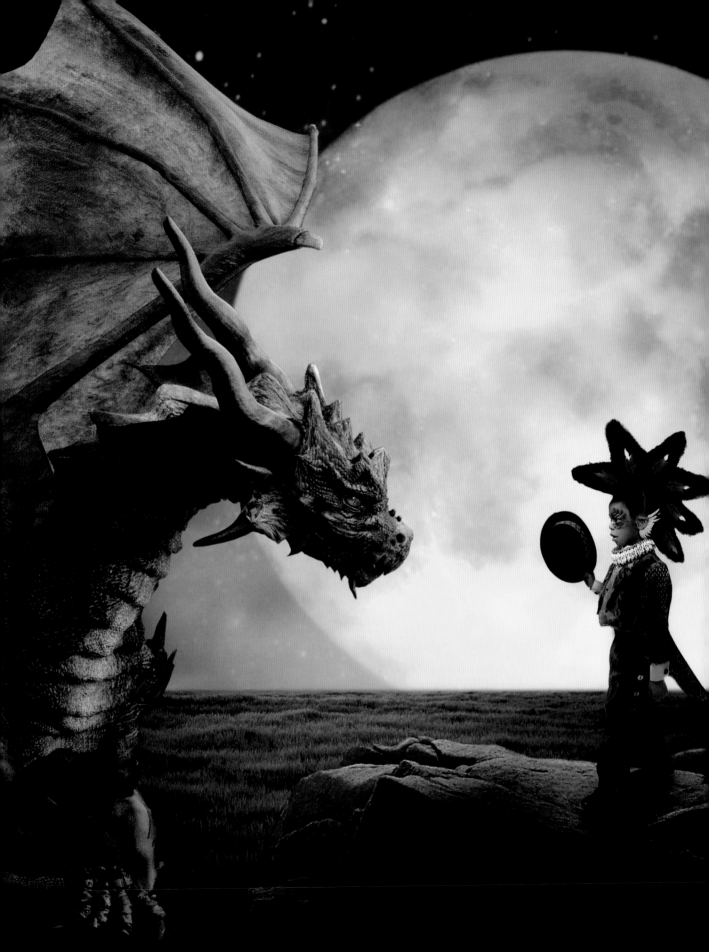

Joka was a sweet little boy who, at ten, was quite small for his age. His mom and dad were born in Tanzania, a place he'd left when he was three years old. His parents were taking him "back home" to their village for a rite of passage ceremony where Joka would become a man. The thing was, Joka didn't want to go. He barely remembered Tanzania and he certainly didn't feel like a man or even want to become one. In fact, he still slept with his furry friend Dragon because Joka was afraid of the dark.

An only child, Joka had never made friends easily, and he often retreated into his imagination. There, he created a friend, one only he could see, and he named him Dragon, just like his furry friend. But this dragon had horns, scales, a spiky tail, and awfully big feet. He was more wild than tame, more fun than fierce, though he protected him just the same. And with him Joka felt less afraid.

They'd skip rocks together, laugh, and play together, and go for long walks and explore. They'd make up stories and pretend to sail a ship and fight pirates on the high seas, and they'd even steal their gold. Or they'd ride wild horses and climb mountains and then they'd swing from the tallest trees. Today Joka and Dragon were scaling a great mountain. When they got to the top they planted their flag and surveyed the land. That's when Joka heard a knock on his door.

When Joka's mom entered his bedroom, she found him in his favorite blue tuxedo pajamas, playing make-believe. He'd built a makeshift tent out of a sheet and hung it across the bed and his desk chair. The lights were off but Joka had his night-light on, which projected stars on the ceiling of the room.

"Hi, Joka," Mama said. "Are you having fun?"

"Hi, Mama, I am!"

"Are you ready for your trip back home? We leave tomorrow."

"I don't wanna go, Mama. I don't remember 'back home' and I don't want to do a stupid rite of sausage. It'll be dark and I'll be all alone."

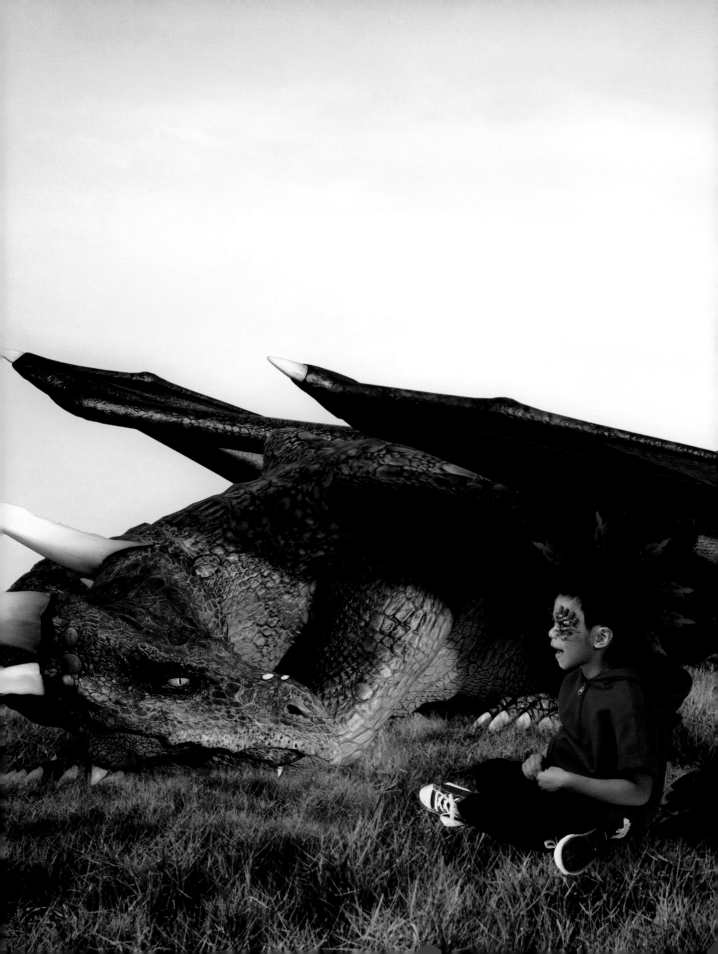

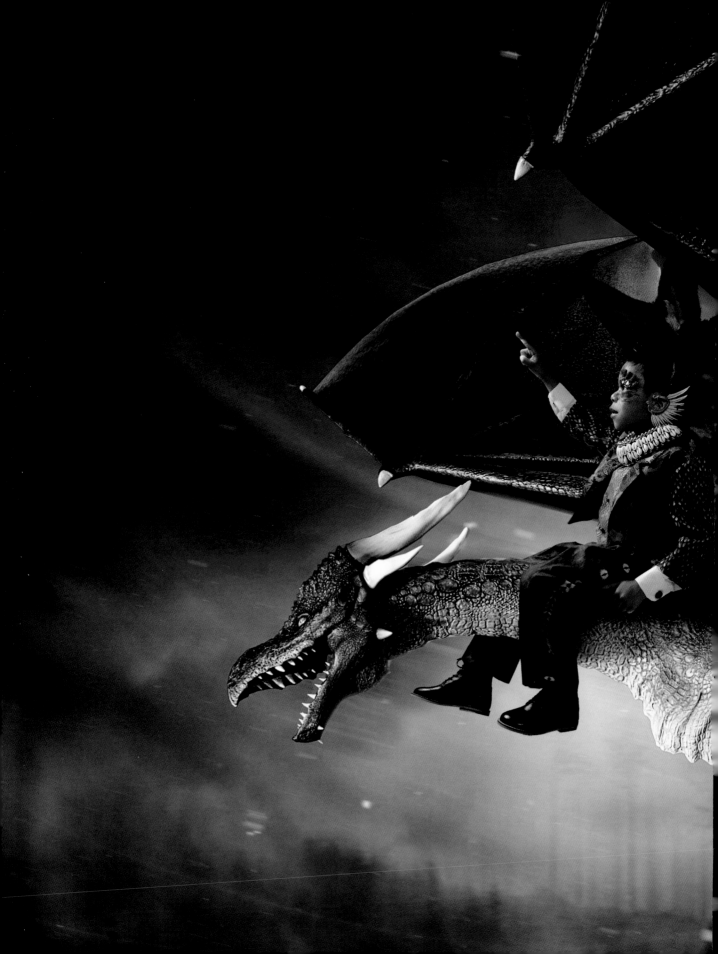

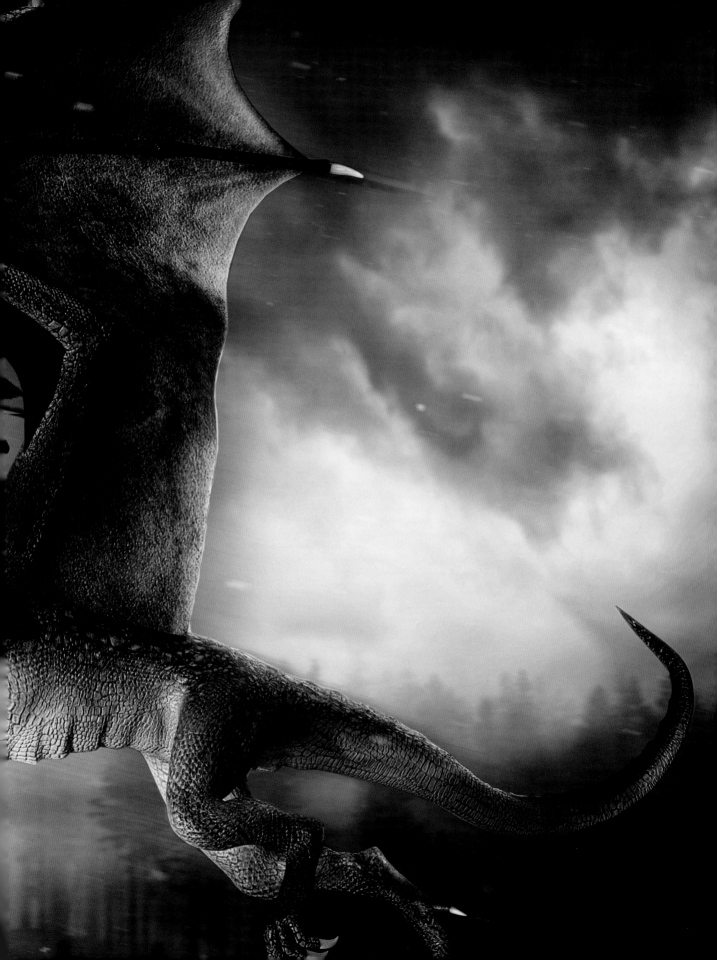

Mama chuckled as she sat on the bed next to him. "Yes, you'll be alone, that's part of the rite of passage, but you'll be perfectly safe. The tent is in a campground and is completely enclosed, and we won't be far away. Your dad did it, and his dad before him. It'll be just for one night and the next morning you'll be a man!"

"I don't want to be a man!" Joka said. "I'm only ten! And it'll be dark. I don't like the dark, Mama."

"It will be like camping in your room, but the stars will be real and they light up the sky at night. You've never seen them shine so bright here, but you will, back home," she said, ruffling his curls.

"Please don't make me go, Mama. Please!" he cried.

She took his face in her hands. "Don't cry, Joka. It's okay. We won't make you do anything you don't want to do. But it would mean so much to Papa and me if you'd do it." She wiped his tears away. "Think about it, okay? Whatever you decide, we'll still love you." She then kissed his forehead and left the room, closing the door behind her.

"Are you there, Dragon?" Joka whispered.

"Of course I am. Where else would I be?" Dragon asked, peeking out of the tent.

"I don't want to go to stupid 'back home' or sleep outside all night in a tent. I don't want to be a man. Why can't I stay a boy?" He sniffled.

"Sometimes we do things for the people we love, even if we don't really want to. It's a part of growing up. Think of it as an adventure," Dragon said. "Turn off your light."

"But it'll be dark."

"You'll be fine."

"You promise?"

"I promise, and have I ever broken a promise to you?"

Joka shook his head. "Will you protect me, Dragon?"

"We'll protect each other."

Joka crept closer to Dragon, then after a few minutes, he turned off the night-light. The room became inky dark. He couldn't see a thing, not even his hand right in front of his face. And every sound was magnified.

"You there, Dragon?" he whispered.

"Right here, Joka. I'm not goin' anywhere." He scooted closer to Joka. "If you wait for a bit, you'll see it's not that dark. Look, you can see the bed, and the dresser, and there's the chair."

Joka tried to stay calm. He was glad Dragon was there. And after a while his eyes adjusted to the darkness. "You're right, Dragon. It's not so dark and scary after all."

"See, I told ya. And when you're sleeping under the night sky, the stars will be just like your night-light. They'll light up everything around you. And I'll be right there with you."

The next morning, when Mama went to wake Joka she was surprised to see him up and all packed.

"I'm ready to go 'back home,' Mama. I'm not afraid anymore!"

"I'm so proud of you, my brave big boy. That's why we named you Joka," she said. "In Swahili, it means 'dragon.' And you're our brave and strong dragon. In our culture, your name tells the story of who you are. And you, little dragon, always make your mama and papa proud."

Joka smiled big and wide. Behind Mama, Dragon was smiling too. He was also ready for their great adventure back home.

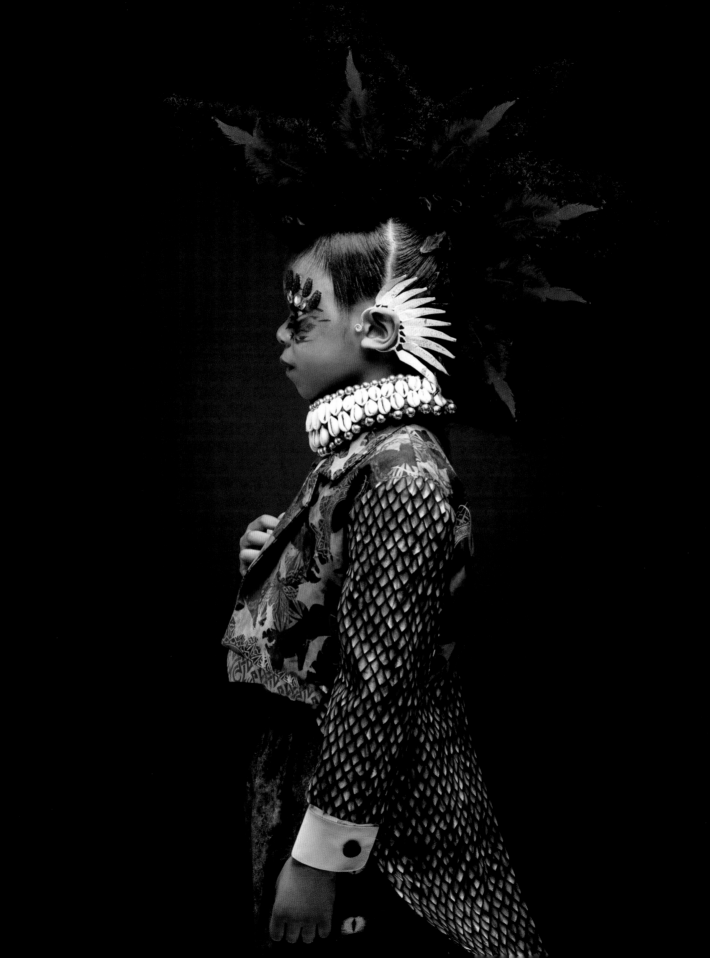

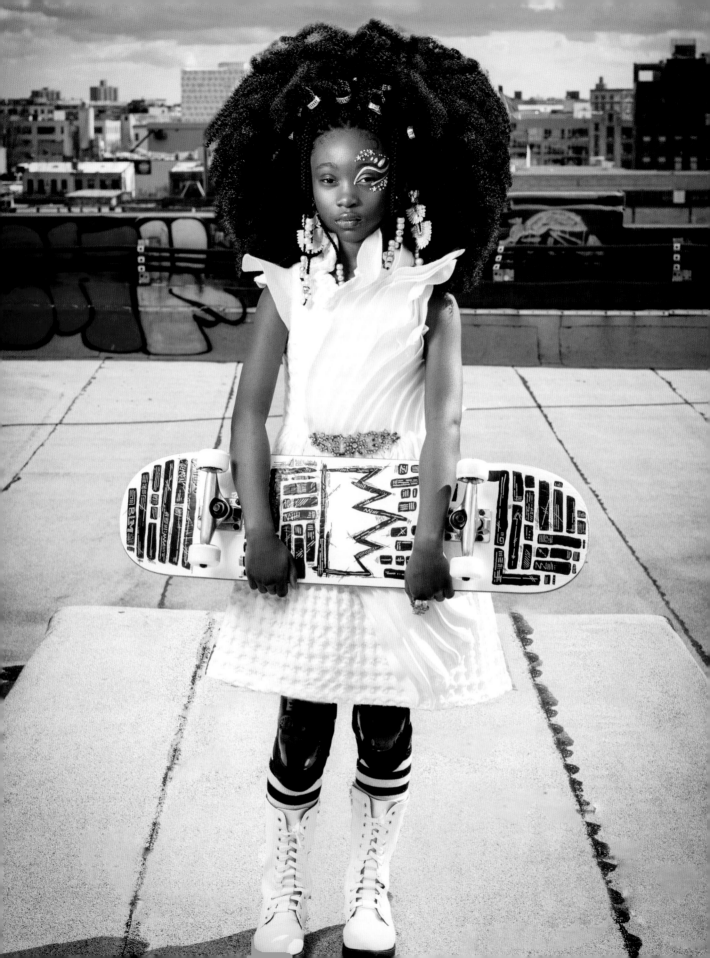

Not that long ago in a magical place called New York City, there lived a girl named Keisha. Now this was no ordinary city; it had buildings that stretched up to the sky, music wafted from windows and cars, and sometimes there was dancing in the streets! And New York was filled with different kinds of people from all over the world, and any kind of food you could ever want. It was a truly wondrous place!

In her family, Keisha's mom worked while her dad stayed at home and took care of her. Her mom was a film director and was away for weeks and sometimes months at a time. Although Keisha missed seeing her every day, she and her dad often visited her on set for the weekend.

Keisha's dad was a former skateboarding champ and he'd taught her how to skate and at ten, she was really good at it. "A natural" is what he called her.

One day her dad dropped her off at a princess party at a neighbor's house, not too far away. Keisha wore her favorite skater skirt and knee pads, which she hadn't yet taken off. And she carried her skateboard because she had just come from the skate park with her dad. There were four princesses in pink party dresses. They all looked at her in surprise when she walked in.

"Do you skateboard?" Princess Indira asked.

"I do, and I'm good!" Keisha answered with a big smile, but she stopped smiling when all the other princesses frowned. "Don't you?" Keisha asked.

"Oh no," Indira answered as the other princesses shook their heads.

"We don't skate," Princess Ana said. She was the hostess of the party. "Princesses are sweet, graceful, and dainty." She then took a sip of juice with her pinky stuck out. "We sit on our thrones and wait for a prince to find us."

"That sounds boring." Keisha chuckled. "I want a prince who also likes to skate."

"But princes don't want a skateboarding princess," Indira said.

"Why not? We could go on adventures together," Keisha replied.

There was a long silence before Princess Daisha answered. "Princesses don't skate. I mean, what if we fell down and skinned our knees or worse?" There was a look of fright on her face.

"I've fallen plenty of times." Keisha laughed. "I have a scar on my chin, but you can barely see it." Keisha lifted her chin for them to see. "That's why I wear my gear. It protects me." She held up her helmet and pointed to her knee pads.

"You have a scar . . . on your face!" Daisha covered her mouth.

"Yeah, my dad says scars show that we've been on adventures and that we're tough," Keisha said. "Plus we're not made of glass, we won't break."

"Of course not," Princess Skylar said.

Finally, Keisha thought, *a princess who gets it.*

"We're made of sugar, spice, and everything nice," Skylar finished, waving her magic wand.

Good grief. Keisha rolled her eyes. Here she sat in a room full of pink princesses but she couldn't be a princess who could skateboard?

"If we had scars why would a prince want to slay a dragon, or save us from an evil witch?" Daisha asked. "Or wake us from an enchanted sleep with a kiss?" At that they all giggled.

"Uhm, yuck!" Keisha said. "And why do I need a prince to save me?" she asked. "I can save myself. And, if my prince can skateboard, or at least wants to try, we can go on adventures. We can slay dragons and evil witches together. Anyway, anything a prince can do a princess can do," she said, picking up a cookie. "Plus skateboarding is fun and 'awesome' like my dad says. I can go really fast in the skate park and feel the wind whizzing by me. That's way cooler than sitting around waiting to be saved."

"But you can't be a princess and also a skateboarder, you have to choose. I've never heard of that before. It's just not done," Princess Ana said, taking another delicate sip of juice while the other princesses nodded.

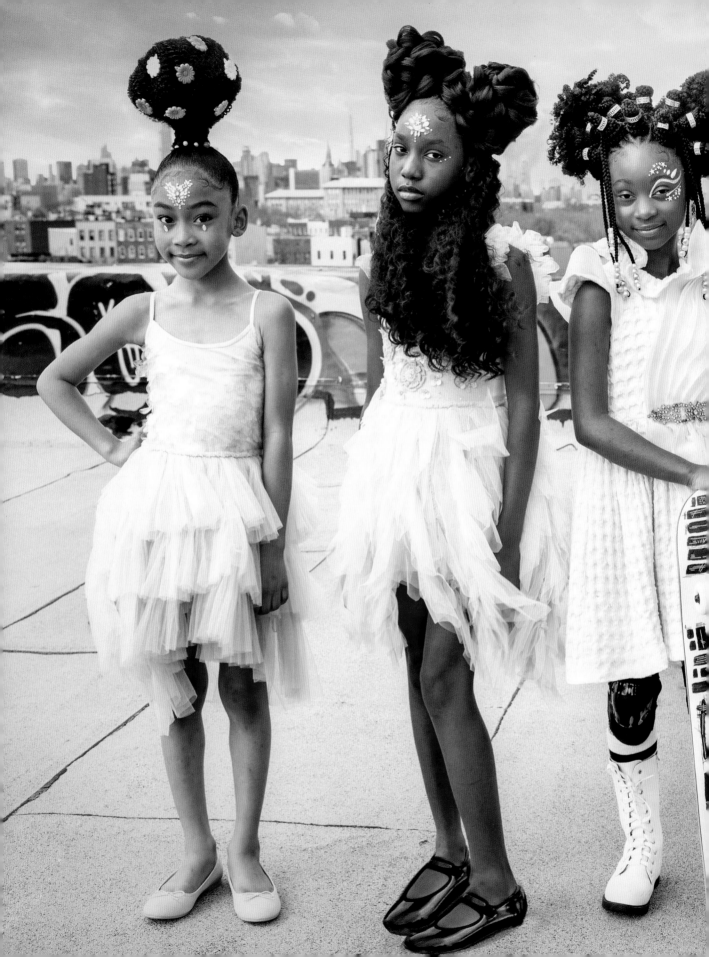

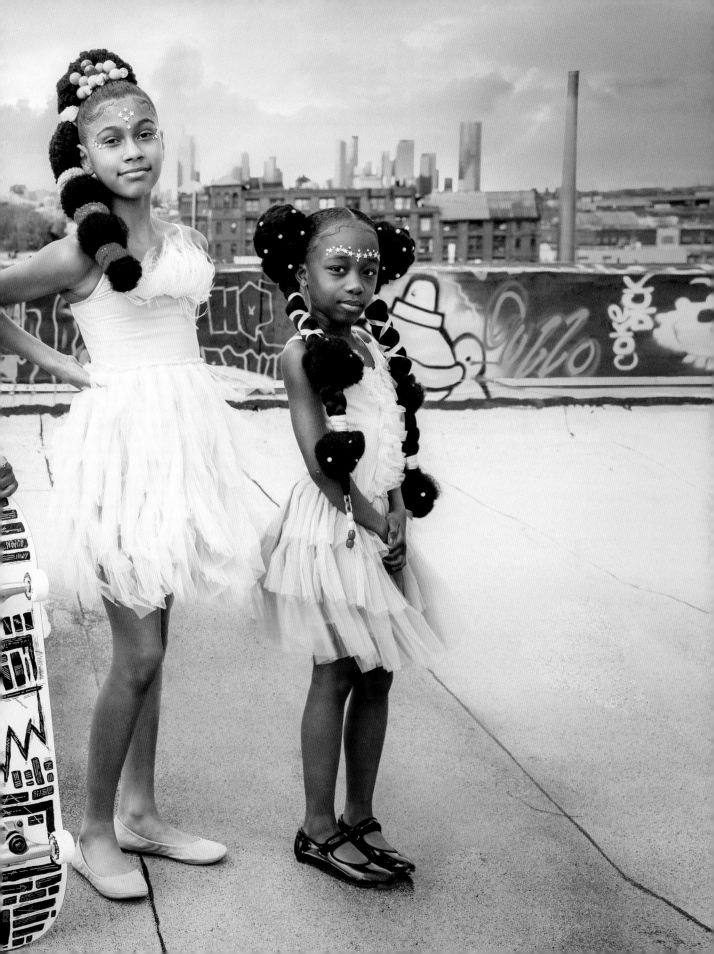

Keisha was silent as she ate her cookie and thought about what they'd said. She was still thinking about it when her dad picked her up. As they headed home she told him about what the princesses had said.

"But why do you have to choose?" he asked. "I can skateboard and I can cook, clean, and take care of you while your mom works, and I'm a guy."

"But they said they've never heard about a skateboarding princess before. I haven't either, have you, Dad?" Keisha asked.

"Just because something's never been done doesn't mean it can't be done." Dad chuckled. "There were plenty of people who said that we couldn't put a man on the moon, and now tons of people are going into space." He pinched her cheek. "And your mom is a big-time movie director. Years ago, she couldn't do that as a woman and definitely not as a Black woman. So who's to say what can or can't be done?" he finished.

"So, I don't have to choose? I can be a princess *and* a skateboarder?"

"Absolutely! If you want to be a princess who can skateboard then that's what you'll be. And by the way, that's what you already are."

"So, I'm a skateboarding princess!"

"And so much more. You can be whatever you want to be and you don't need me or anyone else to tell you that," Dad said. "Now let's get your tiara on and head out to the skate park and crush it!"

And that's just what they did.

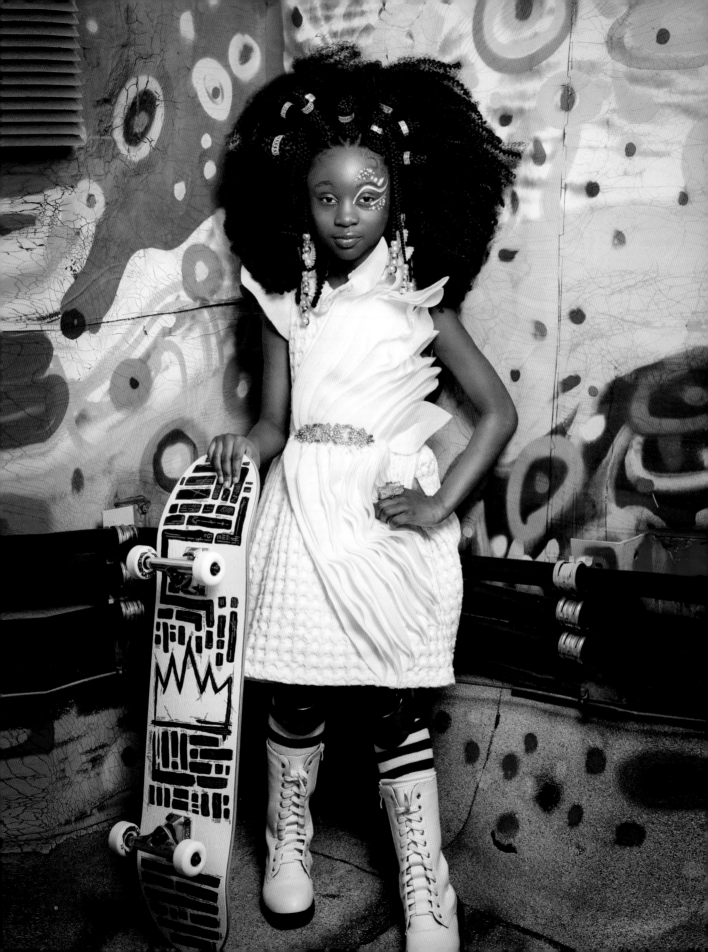

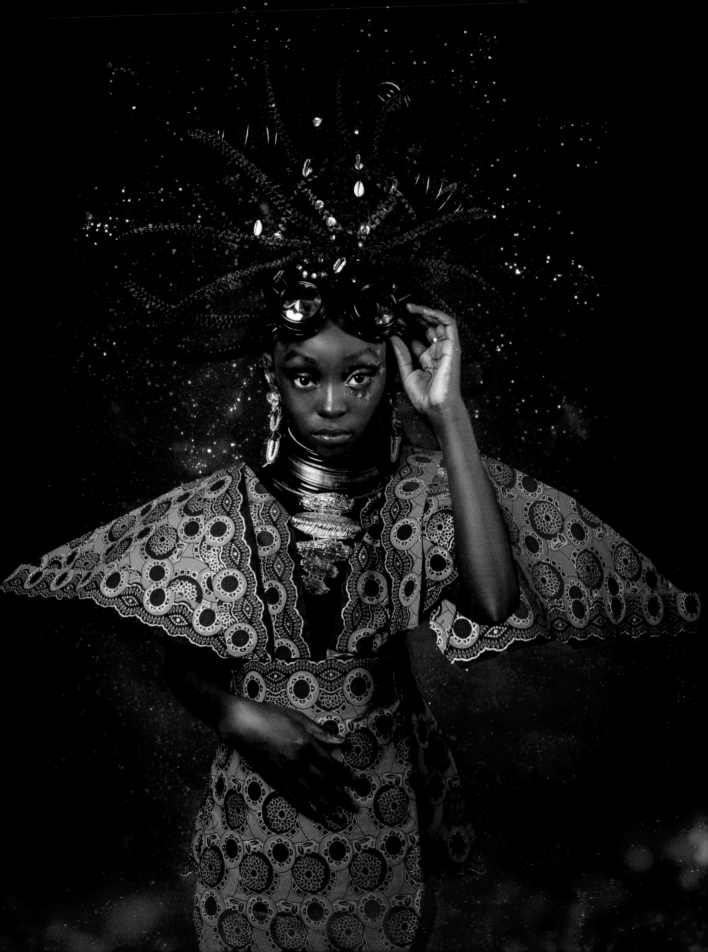

THE GIFT

Once upon a time, on a planet far across the galaxy, there lived a people who were divided in silly ways for silly reasons and no one really knew why. All they knew is that it had always been this way and it seemed it would always be this way. For this reason their children didn't all play together, or talk to each other, or laugh together, and they certainly weren't all friends.

One glorious night, as the moon shone brightly up high, a young girl arrived and she came from the sky. Princess Luna had a special gift for the boys and girls. She knew not what the gift was, but she did not question a task as important as this.

Luna set down on the edge of a forest and walked toward the twinkling lights of a town. When she arrived the sun had risen and the children were playing. They wore all-white clothes made of different fabrics; some plain, made of muslin, and some fancy, made of lace. They all had the same lovely white hair and bright and shining faces. The only difference was their skin in many glorious shades of mocha, ebony, and caramel. But these children did not play with each other and, to Luna, that was quite rare.

As she approached, the boys and girls stopped and stared in awe, for they had never seen anyone quite like her before, and they knew she'd come from afar. Luna wore a bright purple padded tunic, her hair braided on her head like a crown. She was sweet and kind, and her smile was so enchanting it could turn a frown upside down. She looked at the children who had gathered 'round and said, "Hello, my name is Luna and I am happy to meet you all."

They looked at Luna in confusion. *What a strange girl,* they all thought.

"What an odd name you have. What does it mean?" asked a girl, inching closer for a better look.

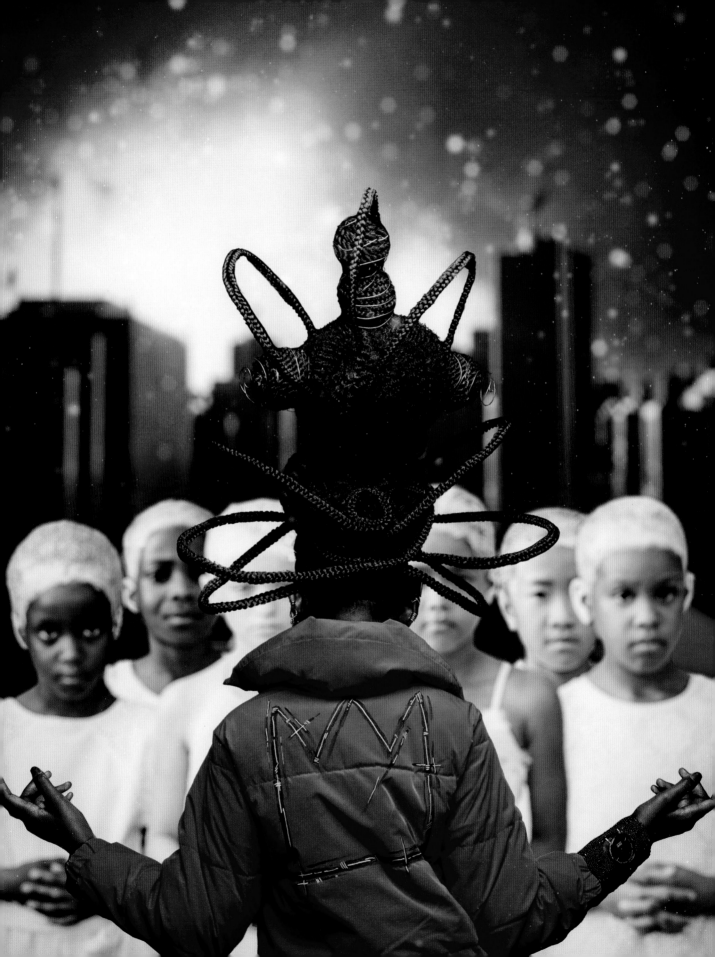

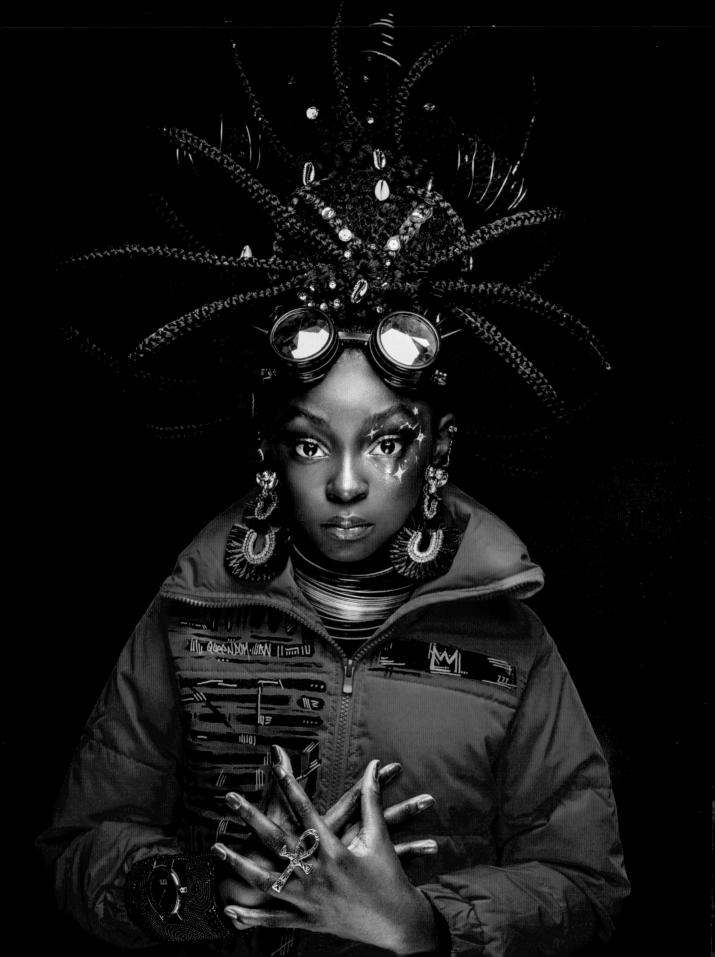

It means that I shine as brightly as the moon in the midnight sky," Luna said. "What seems odd to me, and right from the start, is why don't you play together instead of apart?"

"Because we are not the same," said a boy. "We are different. Where should I begin? Just look at our clothes, our height, and the color of our skin."

"Different doesn't mean better or worse." Luna laughed. "It's what makes us special. The moon would not shine as brightly if not for the night sky that surrounds it. Our differences amplify our strengths, they do not detract. That's what I see when I look at you. You're special, in every shade and hue, from the lightest caramel, and the warmest brown, to the deepest black. None is more or less, and each makes up for something the other lacks. We are a rainbow of shades and tones; we should wish for nothing else. Where I come from all colors are celebrated. None is more and none is less."

"But look at our fine dresses and shoes," said a girl. "Don't you see? Their clothes are quite plain, no frills or lace. That makes us better, surely you agree."

"What good are fine shoes at play?" Luna laughed. "Once you take them off, we're all the same anyway. Go ahead, try it, you'll see."

They shed their fancy shoes and when they were done, they looked like the other kids, but now they could run, and they did. Then they all played and laughed and it was quite

We can have so much more fun together than apart. We all have gifts to share, we all play a part. We know different songs to sing, and different games to play, and we all contribute, in our own special way." Luna then looked at each boy and girl and said, "But answer this and be true, how can you learn and grow, if everyone you know is just like you?"

The children fell silent as they contemplated her words. You see, they'd never thought of it that way before.

"Happiness does not come from what we have, but from what we do," Luna said. "When we accept each other, we bring joy to our lives. And when we practice this our communities grow and thrive. Let's hold hands," Luna said, "and I'll share a secret well known in my land." When the children huddled in close she said, "When we are as one there is nothing we cannot do, or overcome."

The children looked at each other anew, and they held hands tightly as their love grew.

As Luna watched the children together as one, she knew that her work here was done. She no longer wondered why she was sent or what could be her gift, for she now knew that she was it. Luna had given the children empathy and unity, but the greatest gift of all was she had given them a sense of community. This could not be denied, and she would go and spread her gifts far and wide.